OIL PAINTING
Traditional and New

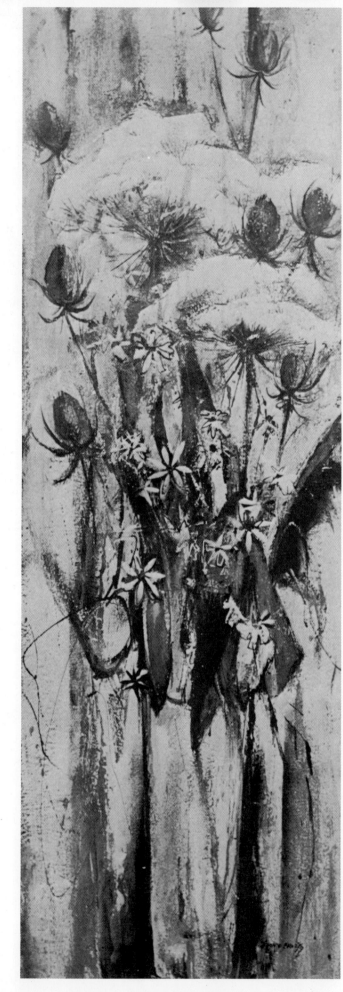

WEED BOUQUET

(See Page 94)

OIL PAINTING
Traditional and New
LEONARD BROOKS

 VAN NOSTRAND REINHOLD COMPANY

NEW YORK CINCINNATI TORONTO LONDON MELBOURNE

First published in paperback in 1981
Copyright © 1959 by Van Nostrand Reinhold Company
Library of Congress Catalog Card Number 59-11376
ISBN 0-442-26427-5

Van Nostrand Reinhold Company
135 West 50th Street, New York, NY 10020

Van Nostrand Reinhold Ltd.
1410 Birchmount Road, Scarborough, Ontario M1P 2E7

Van Nostrand Reinhold Australia Pty. Ltd.
17 Queen Street, Mitcham, Victoria 3132

Van Nostrand Reinhold Company Ltd.
Molly Millars Lane, Wokingham, Berkshire, England RG11 2PY

Cloth edition published 1959 by Reinhold Publishing Corporation

Six cloth impressions

16 15 14 13 12 11 10 9 8 7 6 5 4 3 2 1

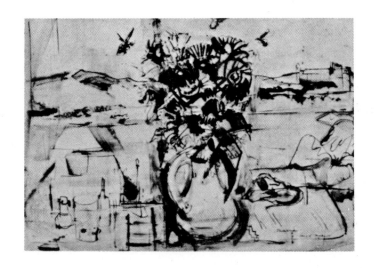

For Reva, once again

ACKNOWLEDGMENT

I would like to express my thanks to all those who have helped to make this book a reality. To the artists, friends, to the collectors of pictures who have allowed me to reproduce my work owned by them, to all who have aided me in putting down these pages, my gratitude.

To my wife Reva, special thanks for her labors in the photographic darkroom. To the artists who kindly provided their pictures and comments; to my publishers and their art editor, William Wilson Atkin whose enlightened encouragement provided needed impetus in times of doubt; to the readers of *Watercolor — A Challenge* whose warm response made this volume possible — to all of these, my thanks.

CONTENTS

"I must also caution the young artist against
supposing that these modes of arrangement are given
for his imitation; I merely wish him to be acquainted
with the advantages any particular composition
possesses, that in adopting any invention of his own,
he may engraft upon it those or similar advantages.
A design that has nothing but novelty to recommend it,
is a conceit, not a composition. The student in painting
can hope to derive advantage from theory only when
rendered obvious by ocular demonstration. One great
cause of the obscurity which envelopes the art,
is the criticism of those whose ideas on the subject are
obscure; — to free the world from their influence is
perhaps impossible; but the artist must free himself."

JOHN BURNET

Practical Hints on Composition in Painting

London, 1822

INTRODUCTION

This is a book about oil painting and as such is concerned with some of the many ways of mixing and applying pigment to canvas. It is also intended to be a book on creative, pictorial technique, for *this* is the important theme and the only reason why we should bother to learn the mechanics of the painter's craft.

Picture making and the knowledge needed to produce pictures has gone through many changes in the last few decades. New ways of thinking and seeing have brought about new technical devices to interpret contemporary conceptions. The Sunday painter and amateur cannot but be aware of these changes and feel the excitement in the air as he visits exhibitions of modern painting or ·studies the many reproductions of pictures appearing in books or periodicals. Whether he realizes it or not, his taste and vicarious visual experience is far different from the amateur painter of fifty years ago.

Nevertheless, when he is confronted with brush and palette, he must make a start somewhere. He cannot take up where Picasso left off. It is necessary for him to go back and work his way through the elementary processes, to study the traditional ways and methods which are the basic foundation on which a personal manner of working is predicated.

L Hote states that "... synthesis is not produced by emptiness, but by a complete remodeling of the plastic and factual elements which have been carefully studied. ..."

Some of the basic techniques will be found in these pages. They are as fundamental to you as a painter as words are to a writer. These methods and techniques are directed to one end only—to help the student reach, as near as his talents will take him, that elusive goal called "creative paint-

ing" wherein he may interpret his feelings in his own way.

Today, when many diverse styles and conflicting philosophies on "what is Art?" confuse both amateur and professional, the student must make his choice of a manner of working with much thought and with a strong conviction in his beliefs. He will be told by some to turn his back on the visual forms of nature and to limit himself to inventions drawn from his inner self, to reject all "figurative" painting. Others will tell him that pure abstraction is finished, that it has run into a dead end and that the artist will now return to a more humanistic convention and communication. Fashionable modes and stylizations assail the student on every side, and he is a brave man who can surmount the capricious and momentary tastes while learning and searching for a personal expression which will not necessarily be the accepted and popular one of the moment.

Whatever the student decides is going to be *his* way, the problem he faces is clear enough. He has a space to fill with colors, lines, and masses. He is fortunate if he finds delight in making marks and forms on paper or canvas, whether his impetus to perform this activity comes from the contemplation of objects and visual facts or some inner and intuitive vision. To make his statement within the limitations of paint, however, he needs a vocabulary and a language. The greater his painting vocabulary, the easier it will be for him to select, choose or eliminate, and the sooner he will make his statement with authority and directness. Then the problems of technique take their rightful place in the background.

In a former volume, *Watercolor—A Challenge,* I

addressed myself to an audience of "intelligent and enthusiastic amateurs" who deserved, I felt strongly, better fare than that provided in most "how to do it" books. I have tried to keep such readers in mind while assembling this book on oil painting. It would be a presumption to tell such people "how to paint," or to suggest to them that the way to the enjoyments and satisfactions of painting is full of easy shortcuts or "secrets" and simple recipes for making pictures.

Certainly a teacher with experience and years devoted to the full-time pursuit of painting can be helpful with the practical matters of stretching a canvas or suggesting a useful sketching outfit. He may impart too, a spark of inspiration and enthusiasm when needed, or make a useful critical observation, but his real function as a teacher begins, I feel, when he is able to point out the many roads to independent creative work, and then give his student a helpful push down one of them.

It is here that the teacher's difficult moment comes. Looking back he remembers a helpful word or a verbal flash of insight someone once gave him. "These are some of the things which helped my understanding," he reflects, and inwardly admits that many of them are so subtle and so difficult to put down into words.

A number of the things "which have helped" have been discussed in these pages. You will find them interspersed between facts about turpentine and pigments. You will also discover provocative ideas in the pages contributed by the nineteen artists who have provided illustrations and comments on their ways of thinking and working.

In the section on *New Media* I have gathered together pertinent information on some of the techniques which are rapidly gaining favor with many artists. These are closely related to oil painting, and many beginners as well as professional painters have found exciting possibilities in working with the new pigments, binders, and emulsions which have appeared in the last decade.

Many of these new media are, as painting techniques, in their infancy, although enough experiment and serious work has been done with them to warrant their inclusion as permanent and accepted media. These methods are not, for the most part, too involved for the amateur and it is hoped that the brief descriptions included in this book on oil painting will encourage the student to explore the many variations of modern techniques awaiting his use.

Of prime importance, whatever the means we use technically, are the intangible pressures and mysterious impulses which move us toward self-expression in terms of paint and canvas. To nurture and understand this inner spirit is just as important, if not more so, as the development of facility and brilliant technique. How to extract from our daily life significant meanings which are translatable into paint—this is the problem before us. To do this, filling a space meticulously or with careless abandon, we employ means and method, even if it is nothing more than that of dribbling paint from the end of a stick. What kind of paint will dribble? What kind of stick?

Some of these practical matters are discussed in this book. But we must never forget that these are only the means to an end. Combined with a sensitive eye and a growing creative maturity they will, it is hoped, help you find *your* way to better painting.

San Miguel de Allende,
Mexico

THE BASIC FORMS

Whether oil painting, watercolor, pencil or pen, the basic problem we have to face is always the same. Painting is *drawing* with the brush, and a sound understanding of some of the problems of draftsmanship is essential for the beginner.

Drawing, of course, in the sense referred to here, is not the mechanical rendering of an object, literally and photographically. Such "freehand" drawing is of value when it is necessary to judge relative proportions and to render a likeness of a solid form with some ease and facility. Drawing in its *creative* sense, though including this ability of a mechanical nature, is for the artist an expressive means of realizing the beauty of form by composing his basic elements—planes, lines, and tones—into a harmonious and integrated whole.

This concept of drawing is far removed from the skillful and isolated *mechanical* interpretation of a visual fact. It is concerned with subtle relationships of form perception, demanding from the artist a specialized way of seeing. A line or object by itself for example, lacks identity until it is related to other lines and objects on the picture plane on which it is drawn. In the transposition from the reality of the object—a three-dimensional solid— to the two-dimensional surface of the canvas lies the secret, and more important the *difference* between the mechanical assessment of the camera lens and the human mind and eye.

This definition of drawing includes, as we have said, many of the mechanical aids to form perception. When, in the fifteenth century, science and the artist combined their discoveries and knowledge, perspective, as we know it today opened new worlds for the creative artist. Its theories and laws became an aid to the great men who needed at that time, further means of interpreting reality in their pictures. The application of geometry to picture making (which was to renew itself and bear fruit in a different way at a later date with the Cubists' experiments) provided a new impetus to the work of the great masters of the Renaissance and for many generations later.

With the advent of the camera, color film, and other technical devices to aid the rendering of physical fact, the artist became more and more interested in the world of "pure" painting. What could paint express, in color and form, design and texture, that would justify its use, other than as a means of interpreting a visual truth?

In searching for the answer many artists have abandoned the traditional training which for centuries was considered essential to the artist and student. Today, the bewildering results of this search for new ways of seeing, the hodgepodge of fine, mediocre, and bad paintings confronting us on all sides, have left the serious art student in somewhat of a dilemma. What is *good* and what is *bad?*

The answer to this is, naturally, a highly debatable one, a question which you, as an art student, must inevitably decide for yourself, every time you weigh and assess your own work as well as the work of others.

But back to drawing. A line cast around a solid such as an apple and drawn on a flat piece of paper, or a smudge of gray to indicate roundness of form, is obviously a poor imitation of a real apple. Even in full color, it is a symbol at its best. Why pretend? Why the illusion of reality at all? Why not a clearer statement, a summing up of the *idea* of an apple, a *painter's* apple?

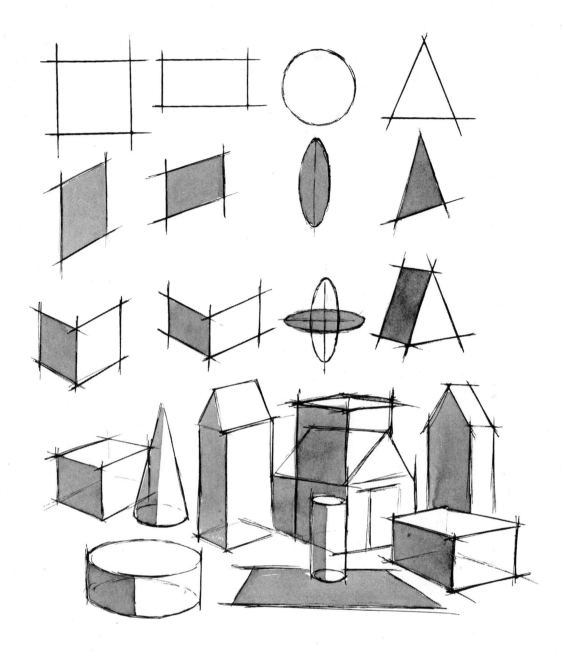

If you study the drawings above you will find several of the problems you must consider when transposing reality to paper. Here are some of the basic forms on which most objects are constructed. If you look at the top row you will see square and rectangle, circle and pyramid drawn flat to the picture-plane surface. The second row takes these same forms and turns them at an angle—creating depth—*if you wish to see them at an angle*. If we say to ourselves, "these are irregular shapes—*flat* surfaces (we could cut the shape out of a flat piece of paper and place it over the space we have drawn) they will suggest *flat* planes to us, without depth.

In the third row we can imagine that the two planes have been indicated as having depth—or are they again *flat* surfaces? You will note (and this is important) that the rectangles have been drawn without the use of the perspective device of lines growing closer together as they recede. They are in isometric, not perspective form.

The bottom row takes all the forms, develops them, sets them against each other and uses some freehand perspective laws. Depth relationships are set up. We have used the perspective theory in a loose and not too mechanical way to aid the illusion of three-dimensional objects drawn in space on a flat surface. How would we indicate these volumes and space relations *without* perspective?

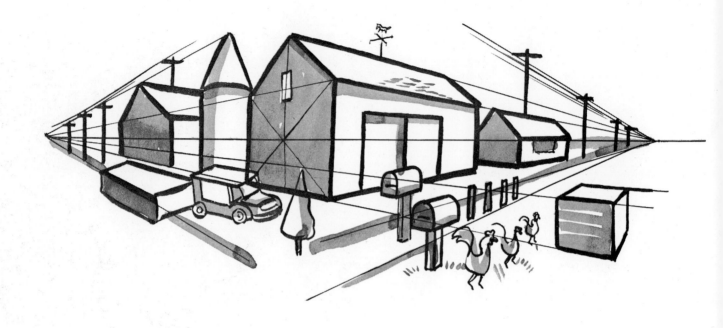

MECHANICAL PERSPECTIVE OR DISTORTION?

Here, basic forms are assembled and grouped on the flatness of our paper to represent a barnyard. Both drawings use the same elements, in proportion and number. The top drawing, drawn on a perspective grid, exaggerated somewhat but following the law of parallel lines vanishing at eye-level, gives the illusion of depth. Objects seem to grow smaller as they recede in the distance.

The drawing below disregards the perspective theory completely. Forms are placed *in front of* and *behind* each other to give the illusion of space. The objects, too, have been distorted, i.e. the car and the silo are not accurate copies of what the eye sees. Strangely enough, the *idea* of "barnyard" is all there, stronger, if anything than the routine and more representationally correct drawing above.

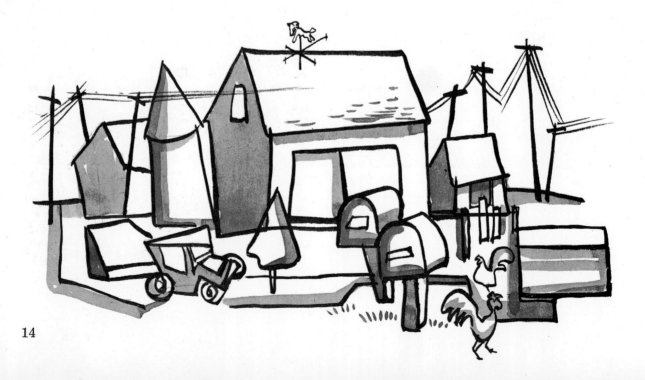

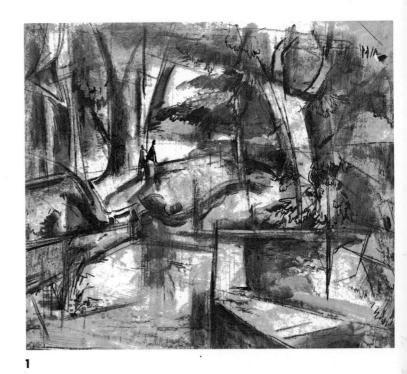

Figure 1. A sketchbook drawing made as a preparatory study for a painting. Depth and space have been created by the use of overlapping forms, volumes, and solids stressed in strong black and white patterns. Accurate mechanical perspective has been disregarded and a controlled and reordered space created on the flat surface of the paper. The flattening out of the vertical section of the wall in the foreground ties up with other strong vertical movements in the sketch.

1

The implications behind this simple demonstration are many and a whole book could be devoted to this subject. It is not always easy to define the point where emphasis and clarification become distortion. The impossible proportions of a Cranach nude or an elongated El Greco figure are easily acceptable to us, though we may not yet be conditioned to appreciate a Picasso showing profile and front view of a head in one drawing. A Cézanne "distortion" of a tree and landscape may seem quite right to us now, but several years ago few could understand his insistence on "significant form" and the simplifications and stressing of volumes which went with the theory.

The realization that there are many different ways of looking at the world about us and countless variations of what each sees and feels is very important to you as a painter. For somewhere, before *your* eyes, you may find a vista more wondrous than any in a world that is all your own.

Figure 2. An experimental line and wash drawing of a panoramic subject using flat areas of tones and interlocking space.

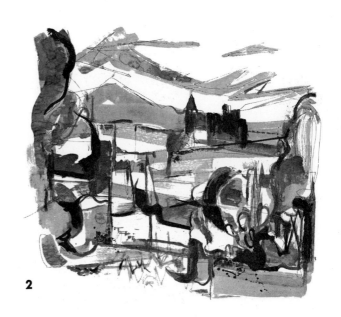

2

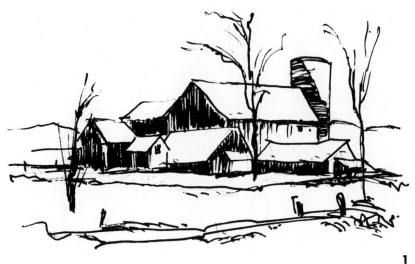

COMBINING THE FORMS

The underlying motivation beneath *all* painting, in any media, is the creation of a new object, subject to all the laws and ramifications of its own inherent form. "Its own form" implies that this form will have a respect for the surface it is painted on, the brushes it is painted with, and more important, will respect and use the two-dimensionability of the plane it is projected on, though it may be using three-dimensional objects as its theme.

Most contemporary painters go further than this. L Hote states in his book *Figure Painting* that "the essential thing in painting is *transposition,* that is to say the transformation from the solid modeled object, overloaded with meaningless details, to the painted object, that is into an abstraction which, over and above the circumstances in which it was created, retains an intrinsic value independent of the religious or sentimental value with which its creator endowed it." Such philosophic musings, though seemingly out of place in a book on oil painting techniques, are more closely related to *how* we paint than many of us realize. If we have a clear idea of what we want to say in paint, and have spent some time thinking about it, many of the practical and technical devices will take care of themselves.

Faced with the overwhelming array of shapes, colors, and impressions in front of him, even the beginner must come to terms to some degree with his subject matter. He cannot put it *all* in; he must sort out, select, and emphasize *plastically* because of the very nature of the material he is working with, pen, wash or oil. After much experience, he will discover for himself, that some things lend themselves better to his purpose—the transposition from reality to a painting—than others. For each individual this choice is different, and it is this difference which gives us the variety of fresh vision, the personal individualized world of the true artist.

Whether you realize it or not, you are faced with such matters when you venture out to choose a subject to use as a basis for your picture making. Choosing a theme, selecting meaningful elements and assembling them into a harmonious compressed statement which might breathe a new life—this is not the task for the casual eye or superficial mind. It will take your concentration, and knowledge, and humility. On top of all this, you will need the boundless enthusiasm and true belief in yourself which will give you courage to try again if many of your efforts end in disaster.

Breaking away from the literal fact of what he *knows* is there in front of him is one of the difficulties of most beginners. How can a sky sometimes be green or snow blue? Snow is white and the shadows on it gray; trees are brown and the leaves on them green. To forget the clichés of seeing, to discover subtle nuances and relationships of new forms and colors, requires a combination of the mature and trained eye with that of the fresh unspoiled vision of a child, a *conscious* evaluation plus *instinctive* feeling and selection.

Renoir told Matisse; "After I have arranged a bouquet to paint, I step over to the side I had not planned on."

What is there, interesting though it may be, is the raw material from which we, as artists, must select, eliminate, underline. Our creative abilities

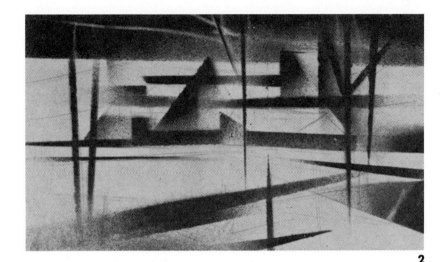

2

MATERIALS FOR THIS
EXERCISE

One can of "Krylon" flat black
spray enamel, one can of flat
white; cardboard strips and
scrap paper for stencils and
masking areas of paper while
spraying color; and colored
paper. A spatter effect can also
be obtained by using an old tooth
brush and India ink. Sketches
are approximately eight inches
wide.

must be exercised to the utmost if we are not to become mere copyists or a human camera.

Here is a rapid scrawl made from a group of farm buildings. Something about the lines, the leaning walls and assorted shapes appealed to us. There are design possibilities in the subject. Can we take this simple note and develop it, strengthening the movements and relationships of the original sketch into a better composition, give it more impact, fit it to our flat surface of the canvas in an exciting fashion? Can we, while doing this, retain the original germ of the composition which stopped us in the first place?

By limiting ourselves to the large essential design forms, emphasizing the movements of interlocking planes, and by exploiting the contrast of horizontal and angular repetitions of line, we may develop our rapid pen sketch into a more meaningful statement, pictorially speaking.

The two drawings were made by using scraps of paper as stencils and spraying black enamel on the paper. White areas are left, and the strips of card or paper moved about to break the space of the picture plane. Try to fill the spaces with a variety of line and mass which pleases your instinctive sense of balance. It is not necessary to follow the actual details of the pen sketch. Large movements will be suggested, and one strong line will demand another. Notice how the fundamental forms of pyramid and rectangle provide strong pattern-making qualities when they are combined and inter-locked around each other.

Experiments of this nature will free you from a too conscientious rendering of a photographic kind.

3

By using the limited means of a spatter or spray you will be forced to simplify. Small air-pressure cans of "Krylon" black and white spray enamels were used for the exercise shown here.

Figure 3 is a semiabstraction derived from the snow and barn motif. It was made without any reference to former sketches, its design being made from memory after the original contemplation of the subject.

The use of a tinted or off-white paper in combination with the spray is very effective.

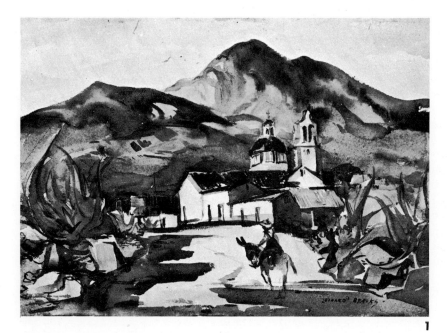

Figure 1. If the large areas have been well planned, details can be added without spoiling the unity of the broad black and white pattern. The basic structure is there, supporting the lesser elements which are added at the last.

1

SIMPLIFY

Another variation of the spray exercise which will help you to compose large and basic forms is shown here. The reduction of numerous tones and details of a landscape is aided by the use of cut paper in three tones—white, medium, and dark. With this restriction it is not possible to fuss with details. The big areas can be cut out to roughly approximate the objects in the landscape. These can then be moved about until the pattern seems satisfying and then pasted down. In this way, only the large essential forms are used and the translation from the reality of the landscape to the flat silhouette shapes will help you to understand more fully what is meant by the "picture plane" and its two-dimensional limitation. You will be forced to forget the slavish imitation of your subject and to interpret it with the simplest means possible.

If you can keep this structural skeleton when you start to paint, later adding qualities of texture, developing the tonal and color scheme on it, the composition will hang together with much more unity than before your analysis and strong pattern making.

Further on in these pages there are some brief

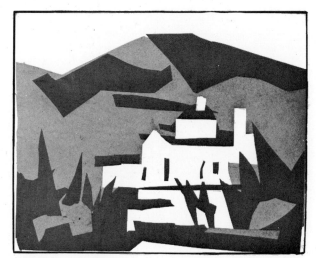

2

notes about "collage" which is a more sophisticated outgrowth of this simple exercise. In this initial stage of paper cutting do not spend too much time in fussing with small details or in bothering to cut out accurate silhouettes. The *process* is the important thing, the self-enforced discipline of transposition from the reality of the scene to a new and *illusory* creation on the paper.

If you feel this exercise has too much of the kindergarten approach to it, you might be well advised to look up the later work of the great colorist and painter Henri Matisse. It is significant that in his last years much of his output—including designs for the decoration of the chapel at Vence and several published portfolios of "painting" such as the noted one on "Jazz"—were all conceived and worked out with scissors and colored papers. This might be useful for you to remember when someone comes into your studio and catches you "cutting out paper dolls."

Over the years, in my painting classes, I have found that one of the greatest difficulties for the beginner is to extract from the complex world of his seeing, the elements needed for picture making. Unless the eye has been trained to see beneath the outward appearances of fact, there is always the conflict between the knowledge of what we know— a vast fund of details and specialized reactions— and the knowledge we need to know as artists.

In my former book on watercolor, I quoted André L Hote on this difficulty. I quote it here again, for it sums up the problem succinctly and profoundly. "Everything you want," he says, "is to be found in nature but you have to be educated enough to want to find only what is required."

Unfortunately, many of the things we need for an artist's education are not easily acquired, nor can they be absorbed superficially in short order. These are the unwritten feelings and intuitions which can only be infused into the blood by long years of trial and error, by constant awareness and wonder of the world of form and color so lavishly displayed by nature. This is an education of a high order, compounded from the sensitive living core of the creative individual.

The use of white areas playing against the rich tones of gray and black—the "chiaroscuro," is an essential part of picture composing. Small studies, such as those in Figure 2 and 3, will help you determine how to play light areas against dark, medium tones against white. Thinking in large areas of limited tone will be easier for you after making drawings or collages of this kind.

Err on the side of simplicity rather than overworking small separate patches. Limit the scale of tones to three values. Try building your composition in crosshatched lines, or add washes of gray watercolor or opaque tempera.

Figure 3. A pen and ink rendering made with the same number of limited tones. The limitations of this exercise will help you train your ability to reduce complicated subjects to strong controlled tonal designs.

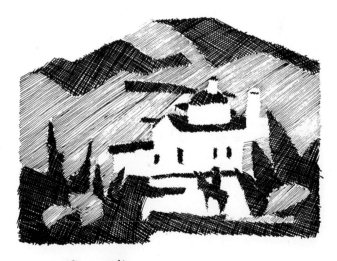

← *Figure 2. A simplified design made by using two colored papers and white. The numerous tonal values of the original subject are reduced to a light, medium, and dark scheme.*

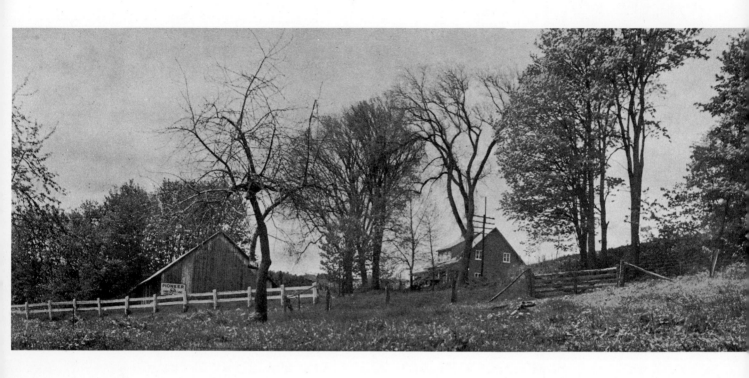

DEVELOPING A THEME

One of the essential differences between the student and experienced professional is that the professional knows how to extract the most from his subject. The experienced artist is not intimidated by what is in front of him and has learned long ago how to discard the bits and pieces which will confuse the larger statement he wishes to make. "Taking what you need" and leaving the rest is one of the secrets of successful composing.

The landscape with trees (above) was chosen with this in mind. It was taken on a spring day in Quebec when the leaves were budding and the decorative branching of four or five species of trees could be seen.

At this point it may be well to mention the photographs of landscapes scattered through this book. These were taken to help illustrate the *difference* between the mechanical eye and the

painter's vision. In every case these photos were made merely as records of a spot, *after* the sketches and paintings were done. No drawings were made *from* them. It is always surprising to me to see how dull a subject can look when the films are printed and looked at later. Part of the reason for this is *that the camera puts in everything and leaves out nothing.* Even with selection, (there is some control of balance and compositional make up) the camera lens coldly catalogues what is before it; better anytime (for the artist) a scribble or two of the dominant line and a smudge or two to indicate form. For this reason I have never carried a camera in twenty five years of sketching until I started to gather material for this book, for here, I believe, it has its value as a teaching device.

Consider then, the photograph above. Plenty of content for drawing, the shapes fall into varied

patterns and repetitions which lend themselves readily to design. Let us take the morning to study our subject and to see what we would like to take away from it. The three drawings following were made on the spot as demonstrations of a way of planning a painting.

Figure 1 was purposely done without much thought to composition. As a drawing it is somewhat competent, as the foliage, branches, etc. were rendered with some suggestion of the various textures and linear movements. Shapes and size relationships have been drawn almost as the subject appears to the camera lens. There is too much clutter of tree branches and the white spaces do not function with much regard for pictorial space.

Figure 2 is a livelier version. Drawn more rapidly, the break up of forms and accents have some relationship with each other. It is less timid—and less "accurate." With carefully selected accents and movements of lines and masses it lends itself as an exciting painting subject. With more time and thought, this could be developed into a full-fledged color sketch.

Figure 3 is a diluted India ink wash drawing made to establish tonal relationships. The second drawing has been used as reference and adjustments have been made to bring about a more integrated composition.

Many artists treasure their quick notes and exploratory sketches, guarding them jealously from the collector and art dealer. A story is told about Georges Braque and his sketchbooks (which were reproduced in part in a beautiful facsimile edition called "The Intimate Sketchbooks of Georges Braque"). These contained many of his jottings and first rough pencil notes for his compositions. When the volume was in preparation the artist insisted that the sketchbooks could not be taken out of his studio. They could be photographed on one condition—in his work shop. And they were!

Figure 1. A tight and unimaginative rendering made on the spot. Very little is left out and even less put in. The filling of the page, compositionally, has not been considered; a rather uninspiring note for later reference and picture making.

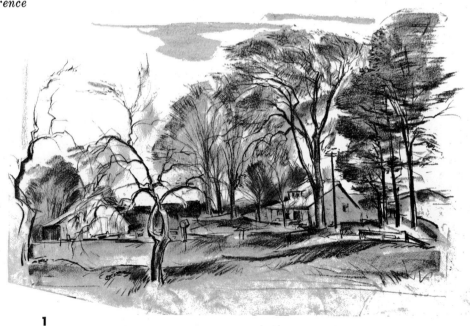

1

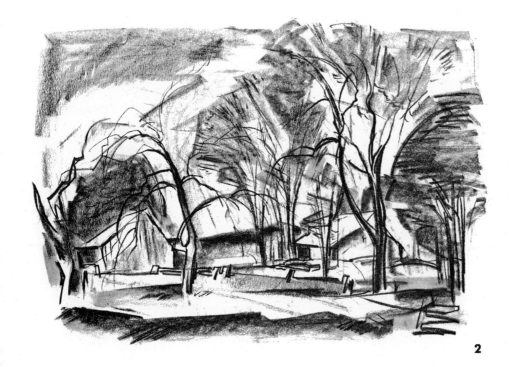

Figure 2. Some effort has been made here to put down a livelier version of the tree forms and landscape. The germ of a painting begins to emerge from the confusion of details. Notice the use of strong darks and lights to help the linear pattern.

2

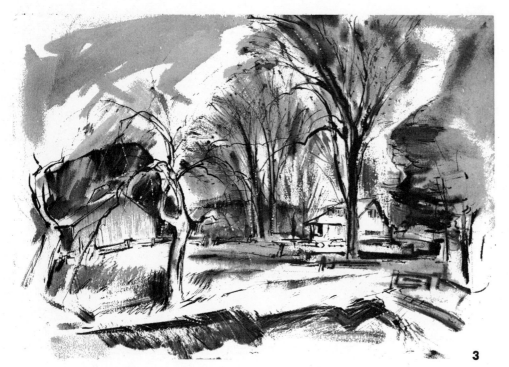

Figure 3. A further study using some tonal washes of grays and blacks. Forms are indicated more fully and the volumes suggested. This is the stage where a painting could begin. The structural design is secured. We are able now to concentrate on the further problems of color, texture, and mood.

3

SKETCHBOOK SUBJECTS

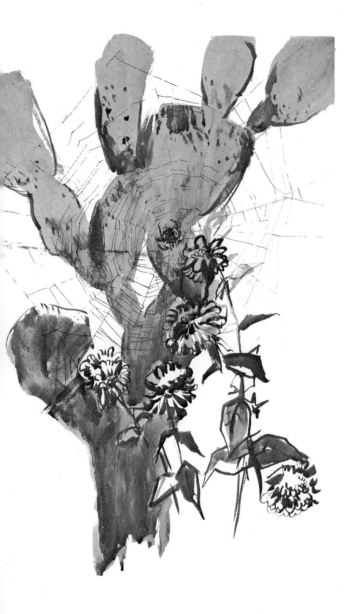

mobile, fashioned by nature! The more I watched, the more the movement became the graceful turning and dancing of a ballet dancer. I rushed for my sketchbook and was able to catch, working rapidly, some of the turns and rhythms of the suggested figure, before the wind snapped the cobweb cable.

Several days later I caught the spider himself, waiting sinister and still in the center of his web strung from a cactus plant. I made several careful drawings of him, and later developed the theme into a decorative painting.

Notes jotted down while waiting in the bus depot, or even watching television—free models here!—will help you to record fact quickly and suggestively for later reference. Informal sketching of this type will develop your facility for putting down movement and detail rapidly.

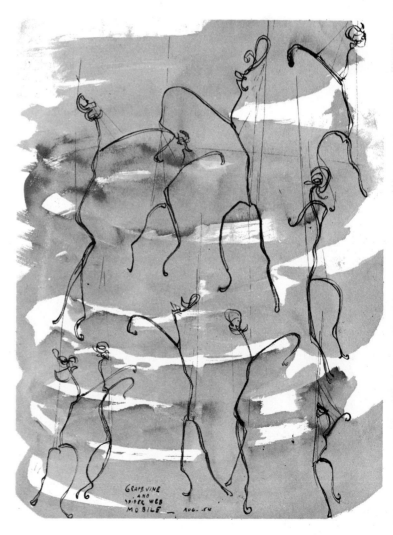

Make it a habit to carry a small sketchbook with you at all times. You are likely to come upon an idea for a drawing or composition in the most unusual places. Once you learn to see with "the artist's eye," subjects will spring at you constantly, crying out to be recorded.

Several examples of unusual sources of ideas I have come upon are shown here. One day while idling in a hammock beneath a grapevine, I watched the fascinating perambulations of a grapevine twig curling and swinging in the breeze, suspended from a length of almost invisible spider web. A

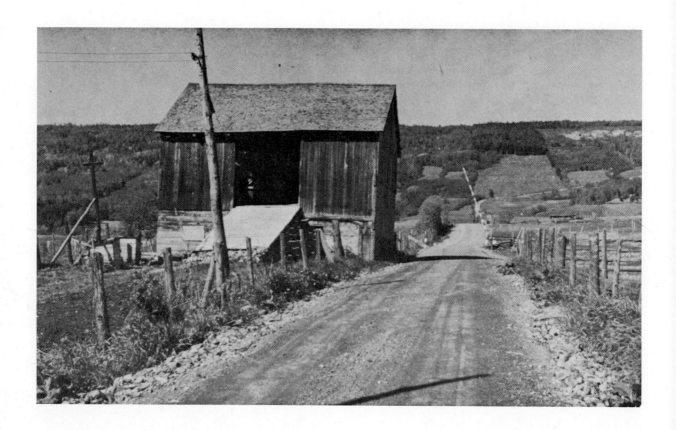

BLACK, WHITE, AND GRAY

How dark is the road compared to the sky, or the middle distance compared to the shadows cast on the barn? In the photograph above is it not too difficult to make a rapid judgment, for the confusing detail and color of the actual scene has already been reduced to black, white, and grays. The *tonal values* have been scrutinized and projected through the camera eye. Realistic painters of the nineties used to carry a black piece of glass on which a scene was reflected minus the color to help them in assessing tone values. It was called a "Lorrain" glass after Claude Lorrain, the great landscapist of the seventeenth century.

Most painters today are not very interested in reproducing exact measurements of the values— black and white or color—in the subject before them. The artist knows too, that the limitations of pigment itself will not allow him to reach the full range and intensity of a brilliant sun, although at the other end of the tone value range he could produce a blackest "black" if he could look at it in a blacked-out room. He has only a limited number of graduations with which to express light and colors which will give the *impression* of light falling on objects.

The study of this phenonema, how to give the effect of light falling on the same objects in varied times and atmospheres, came to its high point fifty years ago when the Impressionists forsook plastic design and the formal values of structure in the search for a scientific method of painting light with colored pigments.

The Postimpressionists took painting back to what they considered the fundamental constructive elements, disregarding the painting of atmospheric effects, naturalistic renderings of nature, and the painting of pictures predominantly "tonal."

What, then, is important about being able to sort

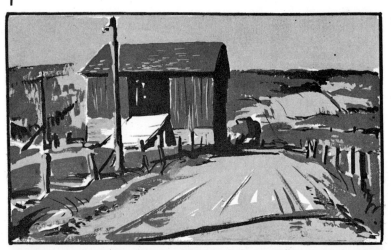

out "tone values" and to put down the approximate corresponding pigment? If we are no longer seduced by natural appearances of the objects themselves, why bother? The difference is, of course, that the end we have in sight is a far cry from the imitation of the photographic image. We still must have at our fingertips the ability to sort out and mix a note of the right value *when* we require it. We still use the same notes of the scale, but the music, as that of a contemporary composer, comes out differently. In fact we must know and use these controlled mixtures of pigment even more wisely and creatively, for we no longer use the subject and replica of nature as the main prop to retain interest. We have stripped away many "stock" elements from our pictures and rely more on the direct appeal of the color form, and its plastic development for the picture's survival.

Training the eye, in such simple exercises as shown here, will help you to understand monochromatic tonal values. Judging the complex world of color is more difficult. How *dark* is this red? What is the green of contrasting exactness, in tone and hue—the balancing complementary? How would you render both colors using only black and white?

Black, white, and gray—in the hands of an experienced artist, such limited means can be a powerful technique. It is significant that Picasso, in one of his most expressive paintings, used only a few grays and black and white. "Guernica" uses no color whatsoever.

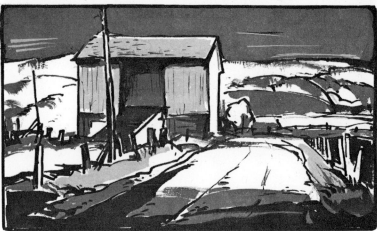

Figure 1. The infinite number of tones in the photograph have been reduced to five steps from the black and white scale—black, white, and three intermediate grays.

Figure 2. The same grays as in Figure 1 are here used in a different relationship. Disregarding the photographic values, selecting and rearranging the pattern of black, white, and gray, we have made an elementary start at picture making. A number of schemes could be worked out, from the quiet to a more dramatic mood. We still have a long way to go to take the sketch beyond a weak and derivative interpretation.

Figure 3. A small oil panel made in close tone values of middle grays. Such a subject, with large simple elements—sky, house, foreground—is excellent training in controlling light and dark areas of paint—the "chiaroscuro"—the illusion that objects are on all sides surrounded by space.

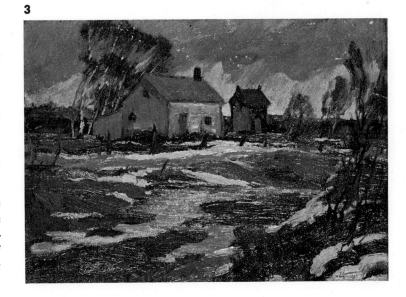

MONOCHROMATIC SCHEME

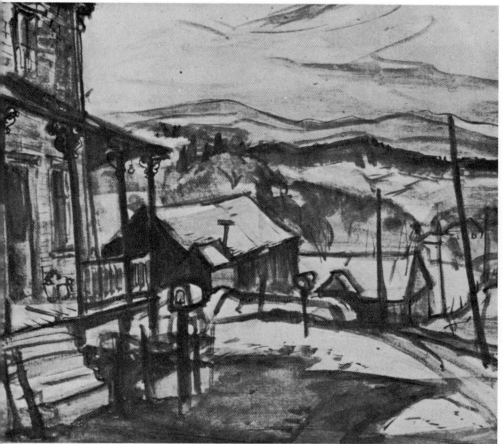

Figure 1. A 20" x 16" painting made from the subject as an exercise in studying tonal values. The panel is stained in with turpentine and transparent pigment only, using Raw Umber or black. Try this on a warm spring day out-of-doors when melting snow patches provide a full range from lights to darks. Do not worry about "impact" or whether you make a "picture" or not. This exercise has one purpose only—to make a tonal translation from the colored objects in front of you. Try for a complete scale from white to black, with many intermediate tones.

1

2

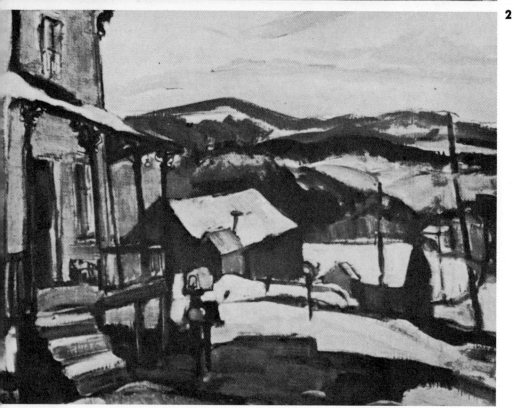

Figure 2. The stained-in panel will dry quickly and is then painted over with thick paint using white and Raw Umber or black. Brush in the large areas freely, saving the touches of detail for the very last. There is no need to use fine canvas for such experiments. A page of canvas-textured paper is quite suitable.

Figure 3. Here the details of tree branches, figures, and all refinements of form are touched in with a smaller brush. For this exercise, look for a subject which contains plenty of large areas, strong contrasts, and a variety of textures. →

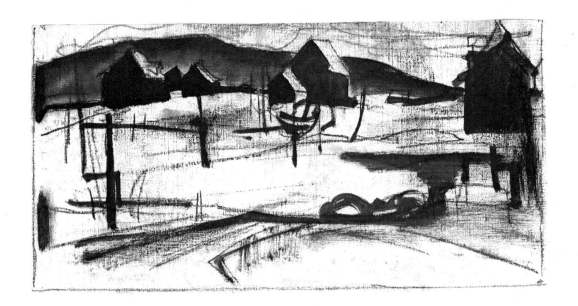

THE TONAL CONCEPT

A landscape, roughed in on location. In it we have summed up the foregoing notes on drawing and composition, before we plunge into the section devoted to oil paint and full color.

Working rapidly from the subject in front of us, we have tried to keep in mind the following: to fill the shape of the picture plane with a well-planned series of shapes and lines, avoiding monotony and repetition of equal spacing, endeavoring

2

to keep all areas alive and functioning in relation to neighboring areas. We have tried to take from the landscape the vital rhythms and movements.

Why did this particular stretch of mountain and sky appeal to us, attract our eye? The quick scribble in Figure 2 was a trial note to find out "why?" Was it the long horizontal of the foreground repeating the hill line, the houses like deep bass notes accenting the flow of the line; what was the main theme and melody, in a design sense? Such trial notes will often help to pin down the essence of a composition. Slight as they are, an analytical scribble will help you fasten in your mind the skeleton composition which must be preserved as tone, color, and brush work are superimposed upon it.

Figure 1 is a photograph of the panel after the initial lay in of the stained drawing is made. Make sure that you have put down the large structural lines, accents, and masses. Even at this stage, the rough-in should suggest what will be there when the picture is finished, fully clothed, textured, and colored.

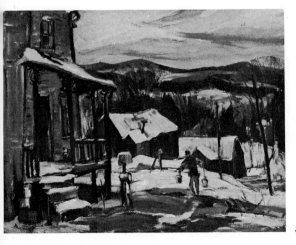

3

BASIC AND TRADITIONAL METHODS

There are many ways of applying paint to canvas. There is, obviously, no *one* or *right* way. Rules and recipes—"the cookery of art"—are of dubious value in the final assessing of the world of creative art.

Having made this statement I hasten to add that there are, nevertheless, traditional and tried procedures of applying paint, and that these proven and lasting methods *can* be helpful in mastering the pure mechanics of painting. Knowing what has been done before and *how* it was done will provide a basis for forging a system of one's own.

Certainly, if you are a beginner, you will save yourself much time and energy by finding out the ways and means by which other painters have worked. Distrust the instructor who tells you that "this is the way you must do it," as much as the one who tells you "go ahead and express yourself, you are lucky—you don't know anything." Both really know better. Draw the line somewhere in the middle and the chances are you will not end up caught in a net of inhibiting rules *or* find yourself bored to death by your own short-lived conceits, retreading the weary road of incompetence over and over again, with total lack of a direction.

If you feel these elementary principles of technique are behind you, there is no reason why you should not skip the next few pages and go to work on the more adventuresome and contemporary ways of painting, further along in the book.

Well equipped with the sketching outfit shown on Page 146 we are ready to venture outside to a favorite spot which we long ago decided was paintable. Luckily it is not in the center of a busy native market but a quiet retreat back in the green hills, where we can work peacefully.

Some of the spade work has already been done, for we have made some analytical drawings of the subject in our sketchbook. Now we are ready to paint; make yourself comfortable in a nice shady spot—a folding chair with a back to it is a luxury —hook the sketchbox around your waist and set the box firmly on your knees. Let's paint!

Experienced painters will often draw in and stain the white surface of their panel with a diluted mixture of turpentine and paint, using a thinned-out mixture of Burnt Sienna and Ultramarine or some such neutral stain. A rough transparent monochrome of the subject is first brushed in, approximating the tone values to come later in thicker paint, leaving the white ground of the panel for the lightest tones, much like a watercolor. This thin veil of transparent color, "imprimatura," will establish the large design. If you feel unsure about working directly with the brush you might lightly indicate the drawing with charcoal, dusting it off before painting, or spraying it with a fixative.

In the first stage of blocking out your composition try to put in the big areas of tone simply and broadly. Concentrate on the organization of the areas in the rectangle of the panel. You are erecting the scaffolding of a structure for further development and little if any of the underpainting will be seen when you are finished. Unlike working in watercolor, you are free to wipe out the whole thing with turpentine and a cloth if the pattern does not seem to work. Do not be in too much of a hurry to get to the thick paint, but do not spend too much time on the first staining in. Twenty minutes or so should be plenty to rough in the general conception of what you intend to paint.

Most standard tubes of oil pigment are of the right buttery consistency to go on the panel without too much addition of medium over the imprimatura. Use a few drops of turpentine if need

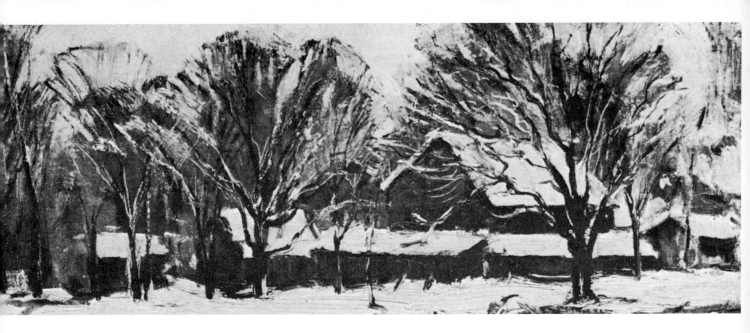

be to thin the thick color. A touch of linseed oil in the turpentine cup is sometimes useful to dilute the pigment and to give it a thinner and smoother consistency. Some painters use a medium based on a copal concentrate with turpentine and stand oil (a sun-thickened linseed oil)—especially for a thin but rich coat of paint. Too much turpentine added to the color will weaken the oil content and consequently the binding ingredient of the pigment. This can be disastrous with some colors, resulting in a flaking off of the paint coat later, particularly if it has been painted over a thick oil-impregnated surface.

Use your largest bristle brushes for painting the large areas. Do not stint with the amount of paint but pick up a generous brushful, twirling the brush on the palette to mix a color, being careful not to overmix the pigments to a "dead" color. Letting the stroke "break" on the panel will give a liveliness of color as the miniscule touches of pure pigment vibrate within the brush stroke. Wipe the paint from the brushes constantly, *and do not get too much white paint in every color.* This is a common fault with most beginners who lose the intensity of the pigment by letting white get into *every* color they mix. Keep a separate brush for the darks, middletones, and lights. Rinse them out from time to time in the extra medium cup or dipper and you will avoid the muddiness which comes from dirty brushes. Remember, too, that it is easier to *lighten* an area in oil paint than to *darken* it. This is the exact reverse of the watercolor limitation.

When you are laying in the thick paint, look for the middle values first and put them in broadly. A passage of foliage is handled in this way—the large middle values first; into this the darkest touches of shadow and the lightest areas of light are painted.

Try too, to paint with a "juicy" brushful of pigment, painting *into the paint,* rather than painting up to the outline of objects, leaving a white space between touches. Painting *into* paint will give you an opportunity of controlling your edges—soft or hard, fuzzy or linear, and will help to avoid the cut-out-look which is one of the marks of the amateur's unpainterly qualities.

Brush stroke directions are important too. Make your first broad blocking in follow the form of objects. Say to yourself as you draw—here is a *flat* field, here a *round* rock, here a *slanting* plane of a mountain. This will help give your painting the true sense of the landscape before you.

When you are satisfied that you have the drawing and main areas designed to please you, step back from your sketch box and try and see the sketch as

THREE BASIC TECHNIQUES DEMONSTRATED

SECTION ONE: Here a drawing of the subject has been traced on to the canvas with charcoal and sprayed with fixative. Make the tracing by rubbing the back of the drawing with lead rather than using carbon paper, as this will bleed through the paint later. The main areas are then washed in with a diluted neutral tone, blue and Burnt Sienna or Umber. No white is used and the large masses are blocked in transparently with some detail indicated. This thin wash, or "imprimatura" can help the vibration of final color if carefully planned beforehand. Sometimes a cold or bluish wash showing through the thicker painting, or a warm wash through a cold overpainting will enliven the color by contrast, giving a sparkling vibration of pigment. This "veil" of the first wash will dry quickly, ready for the thicker, more opaque painting.

SECTION TWO: This was painted with thin oil paint, using a turpentine medium with a few drops of linseed oil to give a smooth, flexible brush stroke. Sable brushes (square) were used to model paint into paint with a soft edge, and a pointed sable was used for the detailed branches. This was painted in one sitting, working from large masses to details in the traditional "alla prima"—(all at once)—manner.

Most direct transcriptions from nature are made in this fashion and it is an ideal way of completing a sketch on the spot. If an area gets out of control or becomes too heavily loaded with paint a palette knife will soon remedy the situation—scrape down to the canvas and the offending section can be repainted.

SECTION THREE: The painting knife has been used throughout. The paint is put on thickly and directly with no attempt to hide the knife stroke. Large areas are painted first and gradually the smaller touches of details. Mould the paint to the form of the object and do not overmix the pigment on the palette. Let the pure colors "break" and mix on the surface of the canvas. This will give a "broken" color which is one of the characteristics of the palette-knife technique.

A fair-size canvas, 20" x 16" and up, is easier to handle in this technique than a small panel, as the palette knife calls for a broad and unfussy handling. Your choice of size and style of knife will come with experiment.

SECTION FOUR: A style of working better suited for studio than on-the-spot painting. A heavily textured impasto is built up over the transparent veil using white and a neutral color. For rapid drying, a special underpainting white can be bought which dries sufficiently in four hours or so for glazes to be painted over it. Shiva also makes an underpainting black which is rapid drying.

The section shown here was modeled in varying thicknesses to indicate textures of foliage, foreground, etc. Thin washes of oil paint in a medium of turpentine, linseed oil, and a touch of Damar varnish were applied as transparent stains over the thick impasto of underpainting. Final details were added in opaque touches of oil paint.

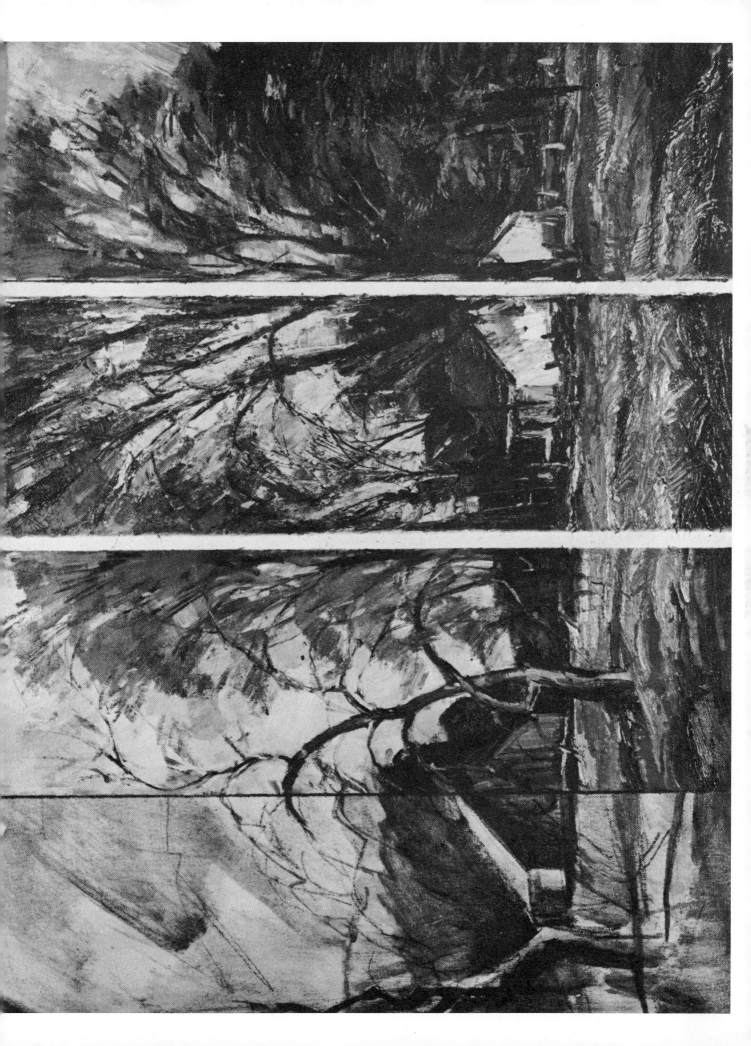

a whole. At a slight distance, even without color or texture, it should contain a hint of the finished picture; even without details added it should have some unity, the broad appearance of what the final picture will look like.

If, after scrutiny, you see something radically wrong—a light area jumping off the panel, a color too bright and raw—make these corrections by scraping off the offending area with the palette knife, and repaint it. As this panel is to be completed in one sitting, "alla prima," work broadly, from the general to the particular. Do not attempt to start in one corner and finish it, moving on to another spot. Work all over the panel, leaving the details to the very last—and as a general rule—the less of them the better. If the panel lacks finish, or the drawing gets out of hand, do not worry about it too much. You are solving one problem at a time. If you can bring back a crisp fresh study, not overworked, with some suggestion of harmonious color and lively form and even *some* of the feeling you were after, the painting session will have been worthwhile.

You will have learned one of the basic techniques.

Later we are going to try working over paint which is dry, laid in as a textured foundation ahead of time, ready for glazes and "scumbles." Meanwhile bring the sketch you have done back with you, slip it into a trial frame and see what it looks like in the lesser light of the studio or ordinary light of your room. Perhaps you should have forced your color more; what may look colorful outside in the glare of the open sky loses much of its intensity when it is brought under an indoor roof. Blues, especially, have a way of graying down. Remember this next time; force the colors rather than underplay them.

A critical study of your sketch will help you learn what to avoid next time. Have you killed the brilliance with too much white, are your colors sour and muddy from lack of experience with color mixing? Is the brush work patchy and meaningless, the strokes not functioning to help explain form or texture? Are the areas too broken up, is there enough interest to warrant such a space for your foreground? Are there lead-in lines moving in and through your composition or do the thrusts and movements end in a jangle of visual conflict? How about more accents in that dull passage on the left?

Quiet study of what seems good and what fails to function pictorially, will help you develop your own critical sense. A fresh glance, at some later time, will do much to help you see where you have succeeded or failed and will spur you on to try once again.

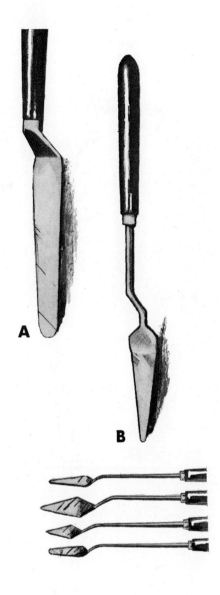

A. A palette knife used for scraping the palette, or when necessary, surplus or unwanted paint from the picture.

B. A painting knife used for painting and shaping paint on the canvas. There are many shapes and sizes to choose from. A selection of one or two in your sketch box is valuable for texture making. In combination with the brush, it is useful for touching in clean accents of color. (See reproduction in color, Page 93, and the portrait by Cleeve Horne, Page 109.)

PALETTE KNIFE PAINTING

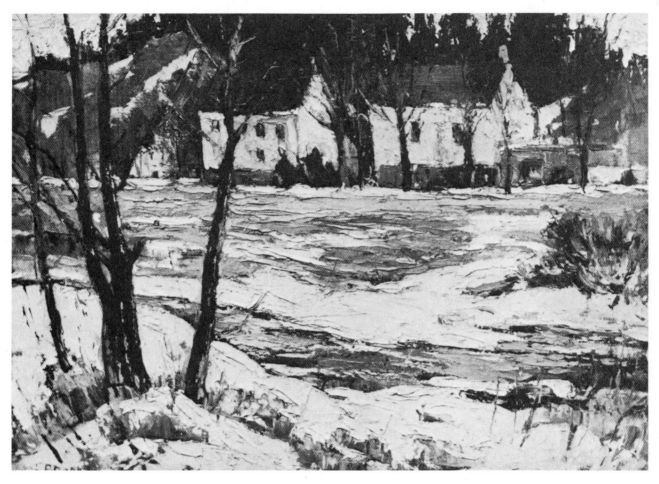

Shown opposite are a number of knives used for painting. There are many shapes and sizes from which to choose and only by experiment will you find the ones you prefer. The one marked "A" is generally used as a scraper to clean off the palette or to mix batches of pigment, but it can also be used for painting. "B" is designed for painting only and is made from a spring steel in diamond and spatula shapes.

Palette knife technique demands a bold handling. The paint is applied directly, not overmixed, and the frank expressive strokes of modeling should not be overworked or muddy.

Palette knife painting is also used as an adjunct to brush work, or combined. It is useful in building up thick impastos of rough pigment or for smoothing out passages and areas where the brush marks are not wanted. Used as a sketching medium it is ideal to broaden your technique. Its inherent "clumsiness" will not allow a fussy or detailed handling, but will call for a direct simplicity. It is better to work on large panels when learning to use the knife, rather than small panels.

The painting shown here, "Muggy January," was done many years ago on a 20″ x 30″ canvas in one session out of doors. Painted directly over a thinly drawn brush and turpentine "stain in", the thick paint was not touched in the studio later. When seen recently, the paint looked as fresh as the day it was painted and showed no signs of cracking or fading.

WHAT KIND OF BRUSH STROKE?

It is fascinating, when visiting a gallery or exhibition, to make a study of the many kinds of brush strokes artists have used in their pictures, or to see, at times, what pains have been taken to *conceal* brush marks.

If we stand before a late Rembrandt and look closely at the thick impasto and glowing golden color, we can realize how this rough granulated surface of paint must have shocked the solid burghers of Amsterdam who liked to have their pictures and their lives meticulously neat and glossily smooth. Here was a startling new and seemingly crude manner of applying paint and it was many years before such a technique was accepted completely by the ordinary picture lover. Even as late as fifty years ago, the coarse, frankly unconcealed brush stroke of thick paint was anathema to the public gallery goer and stones and epithets were hurled at the pictures of the so-called "wild beasts" of painting—the Fauves.

Today, the battle has been long won, and the public not only accepts, but delights in the thick tempestuous strokes of pigment on a canvas, even demanding *all* the strokes well-embossed on a first-class reproduction or facsimile of Van Gogh's and other popular painters' work.

To the painter-student, the Impressionist period is particularly rich in technical interest. In the search for new sparkle and brilliance of color which would suggest the sensation of outdoor light on landscape and objects, the Impressionists and their followers tried every variety of brush stroke—dotting, spotting, scumbling, and texturing their canvases. These experiments have had a strong influence and the repercussions permeate present-day

painting, where every technique is exploited to its ultimate. The latest "ism" which has absorbed some of these theories calls itself "Abstract Impressionism," a combination of the abstract and nonobjective idioms with the broken strokes and color so beloved by the early Impressionists.

Thus the cycles of art turn. The original abstract movement, turning its back on the lack of formal values which had swallowed the Impressionist in hazy soft edges, sought the structural backbone of "significant form"—hard edges and lines, intellectual synthesis. Gradually, tiring of the mathematical formalities of cubism and searching once more for enrichments and color sensations, the painter returned to the past and discovered anew that perhaps the old boys did have a thing or two worth looking over and using. Suddenly, a huge Monet water lily "impressionist" canvas finds itself hanging side by side with the most avant-garde painters in the foyer of the Museum of Modern Art—and looking very much at home!

Brush strokes, in many ways, are like handwriting, and it would seem to follow that the character of the individual painter would be revealed by the manner in which these brush strokes are put on the canvas. But it is not quite so. Brush work is a form of handwriting but it is *not* handwriting. Handling a brush is the manipulation of a conscious style, often changing completely with the artist's growth and development.

If for instance, you are entranced with the translating of nature's light into a painting, you would find the paintings and theories of Signac and Seurat influencing you—and to paint in this style you must control every dot and dash in a scientific manner. Van Gogh and Gauguin tried working this way in their early years and it is interesting to compare the later brush strokes of both of these artists as they reached their artistic maturity—the frenzied churning impasto of Van Gogh with the controlled rich surfaces of Gauguin.

A comparison between the early efforts of Cézanne with the canvases of his old age, on the other hand, shows him forsaking the thick, heavy impastos of palette knife and brush for the thin, painfully studied multiple touches of almost transparent color as he worked with ponderous concentration to put down his "little sensations" in front of nature.

What kind of brush work then, is something which you should not worry about. The style and manner which will be yours will come as you gain experience and a clear idea of *what you wish to say in paint*. Thick, thin, carefully manipulated or loosely automatic—the picture will demand its own technique.

Four varieties of brush work.

The reproductions shown here are slightly smaller than the originals and show a few of the many ways the same subject might be treated. They were painted with Raw Umber and white and you may find it fun to try such an exercise using these different brush strokes. Also study the variations of brush work used by the different artists in the section beginning on Page 101.

Figure 1. POINTILLISM

Dots or small strokes set side by side to give a broken vibration of color. Painters developed elaborate theories of this technical device. (Read John Rewald's fine book "Post Impressionism From Van Gogh to Gauguin.")

Figure 2. EXPRESSIONIST

The thick free brush stroke. Cleanly and freshly applied with strokes modeling the form. The work of Vincent Van Gogh carried this technique to its conclusion.

Figure 3. CÉZANNESQUE

Cézanne used the method of building up controlled directions and planes of brush strokes to indicate form and form relationships in space. A valuable source of study for the landscape painter.

Figure 4. ACADEMIC

A more "realistic" handling of the brush. Painted with soft edges, sable brushes softening edges into edges with a more fluid quality.

1

2
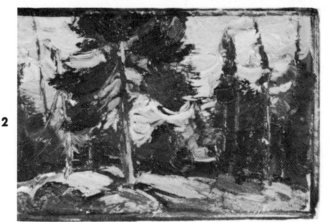

3
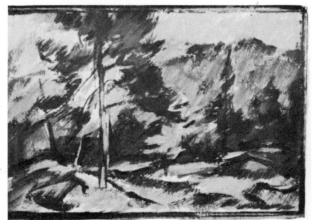

4
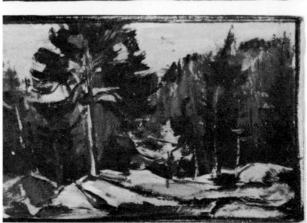

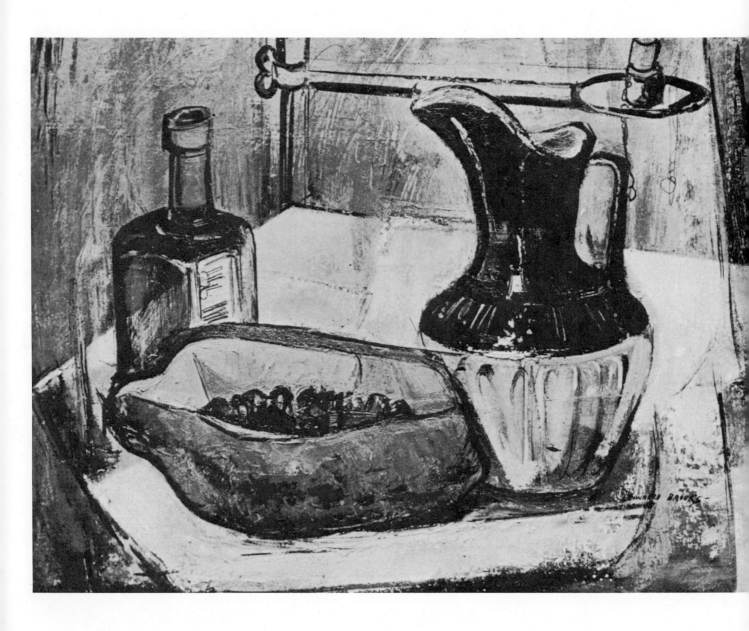

TEXTURES

During the last fifty years painters have tried many devices to add variety to the textural surface of their paintings. Experiments of every kind have expanded the materials and means of applying them to canvas or board. The once-prized patina of a velvety smooth oil-painted surface, though still entrancing to us, is not the pre-eminent and prized one today. The juicy, frankly undisguised brush stroke of the Impressionists and the direct vigorous Van Gogh impasto has become accepted, and is often preferred by many art lovers.

These thick encrustations of paint are part of a painting creed which is away from the weaker forms of literal imitation. The paint itself has its own vitality and life which the contemporary painter preserves and uses as he will. It is not that he has lost the "secrets" of the old masters' subtle touch, and cannot paint thinly and smoothly—some modern painters such as Dali and Koch still use this technique of concealed means—but that his aims and conceptions of picture making have entered freer and different fields of creative effort.

There are many ways of creating interesting surfaces and textures other than with the brush. Several are shown here in actual size reproduction.

1

Figure 1. Paint was rolled on to the canvas with a small rubber roller. A sponge was also used to dab the paint on the canvas before scratching areas with a sharp knife.

Figure 2. The use of inert material bound in paint or a binder to seal it safely is not new. It was used in many ways by the Postimpressionists in their early experiments. Mat surfaces, plaster-like or roughly corrugated may be formed. Here a fine marble dust has been mixed with white and gray paint and applied with the palette knife.

2

Figure 3. Here spatter and spray was used, plus the end of the brush to scratch through the wet paint to the underlying coat.

3

All of these techniques, when used with authority and not for a novelty, are part of the expressive means used today to gives liveliness and variety to the contemporary canvas.

With the invention of newer and stronger binders than linseed oil, egg, rabbit skin, and other animal glues, the artist has been able to expand his textural possibilities. Pyroxylin, casein glues, synthetic plastic resins, all of these allow him to assemble his materials with more leeway and safety from time's ravages. Knives, rags, sponges; fingers, rollers, cardboard strips, and rulers; string and spatter brushes, air guns and dribble sticks; these are just the beginning. Scraps of leather and papers, marble dust and sand, pieces of iron, glass, and marbles, all of these may find themselves embedded in the thick coagulations of the oil paint, or better still, tenacious plastic glue.

All of this is not as amusing as it may seem. Although sometimes the results may appear outrageous and ridiculous, it is still part of an intense and genuine search for wider and more expressive means. The enrichment of the picture surface with varied textural qualities is one of the important contributions of the modern painter and his influence has been felt through many of the materials and practical objects we take for granted and enjoy.

Pictorial texture is not necessarily the *imitation* of an object and its textures, although this may be the starting point for the picture's textures. Certainly there is a delightful visual enjoyment to be had from the contemplation of early nineteenth century still-life paintings with their loving cataloging of peach fuzz or the bloom on a purple plum besieged by a more-than-real fly! The recent revival of "fruit and flower piece" in many exhibitions is indicative of a continued interest in such things. The brushing in of a texture imitative of a fragile egg shell or the rough crust of bread has intrigued more than one great master in the past, as it still does the surrealists with their love of "super-real" renderings of objects.

The painter today carries his textures to the ultimate. Taken far from the limitations of what is in front of him he creates textural solutions which live a life of their own. His paintings create their own "timbre" demanding their own rough and smooth passages without slavish reference to reality.

Textures, as a legitimate branch of our painting technique can be an entrancing subject. There are numerous examples of varied ways of discovering *your* way scattered through this book. Also, the study of original canvases at first hand in exhibitions will be of great help to you.

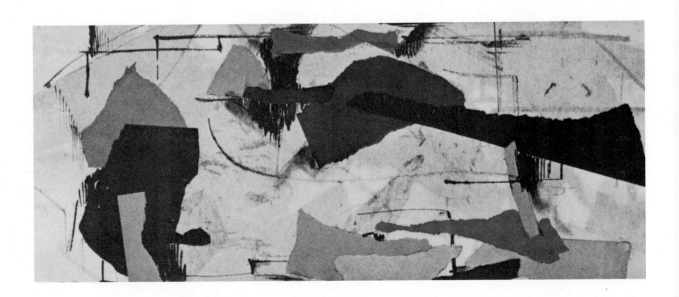

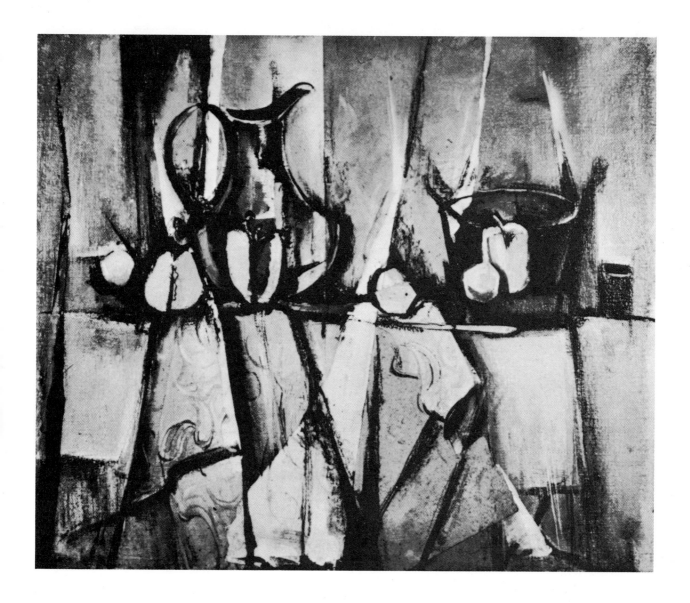

PAPER AND PASTE

← *A trial strip of collage textures using colored papers, transparent overlays of thin tissue, and pen and ink lines. Experiments with combinations of papers pasted down on cardboard or canvas will help you to try new means of handling design and space problems, as well as inventing new textures. Try this without reference to literal subject matter as a basis for abstract painting exercises, or use drawings and studies, redoing them in large patterns and simplified areas.*

Frequently, in contemporary exhibitions, you will come upon paintings which are not, in the accurate sense of the word, paintings. They may be made from pieces of colored paper, leather, or wood veneers and textiles, assembled on a surface which may be drawn and painted over, or left purely as a collage of textured materials. These collages are accepted as a legitimate branch of the painter's art. Sometimes the painter will use this technique in designing his pictures, moving patches of torn papers and textures about his canvas by the trial and error method until he reaches a satisfying composition. The final picture is then painted from this study in the traditional manner with paint alone.

I first saw this technique used to advantage when Rico Lebrun essayed a series of large paintings interpreting his reaction to Mexican themes. Pinned

TRIAL SKETCHES

Trial sketches made in a number of different media as preliminary studies for the collage on Page 39. Here the shapes and design

on his vast studio wall were strips and pieces of paper, some already textured by himself with crayon or paint, some blank, some carefully cut to pre-conceived shapes. These were moved and pinned, changed and altered until a complex organization of form and color sang on the walls. Often they were pasted down, rolled up, and used later as the basis for his magnificent paintings.

The illustration on Page 39 which was a development of the studies and drawings shown here was done in this manner. It is a combination of oil

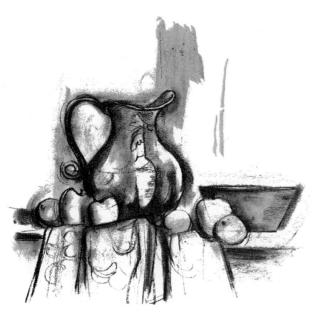

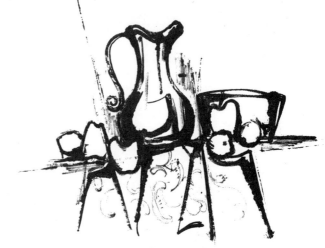

*forms are analysed before ex-
tracting the essential forms to be
used in the paint and paper
collage.*

painting and collage. Simple cut-out shapes were placed over a sketched-in background, pinned down and studied for their design value. Moving the pieces of paper back and forth was found to be much easier than putting in the passage with paint and then trying to remove it, or paint over it. When the composition seemed satisfactory the pieces of paper were sealed to the canvas with a strong transparent plastic glue. Further drawing of lines and accents over the paper followed, and then the picture was sealed once again with a final coating of a transparent plastic which dries to a hard surface, like a sheet of glass.

If you are using colored papers be sure to use papers which will not fade perceptibly or better still, expose them first to strong sunlight. One fine "painter" of collages I know, spends days collecting old posters which have faded to subtle off-tints on Mexican walls, for the basic material with which he produces astonishing works of art. Experiment too, with various sizes and glues, and backgrounds, such as Masonite, on which to assemble the collage.

41

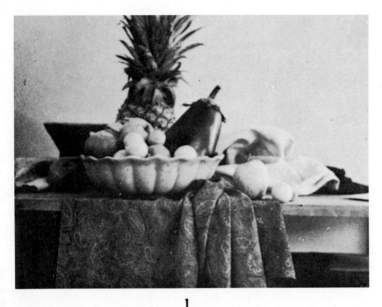

1

STILL LIFE

FRUIT

2

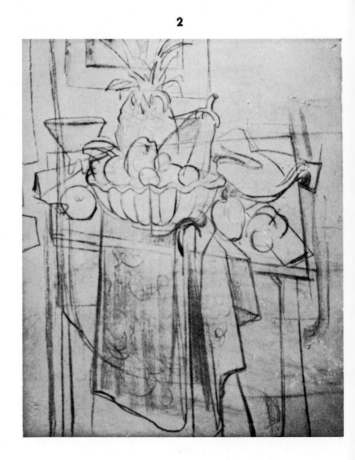

A 30" x 36" painting made in two direct steps and painted in polymer tempera on canvas.

Figure 1 shows a snapshot of fruit arrangement, bowl, and cloth. The rearranging of line and mass (as actually seen) into a livelier composition can easily be noted by comparing the two illustrations. The flat surface of the canvas or picture plane has been considered, planes flattened out and the composition carefully planned before the painting begins.

The canvas was prepared with a polymer ground, slightly textured with a clay powder to give it variety of surface. After a number of rapid drawings, (Figure 3) a charcoal outline was roughed in and sprayed with fixative (Figure 2).

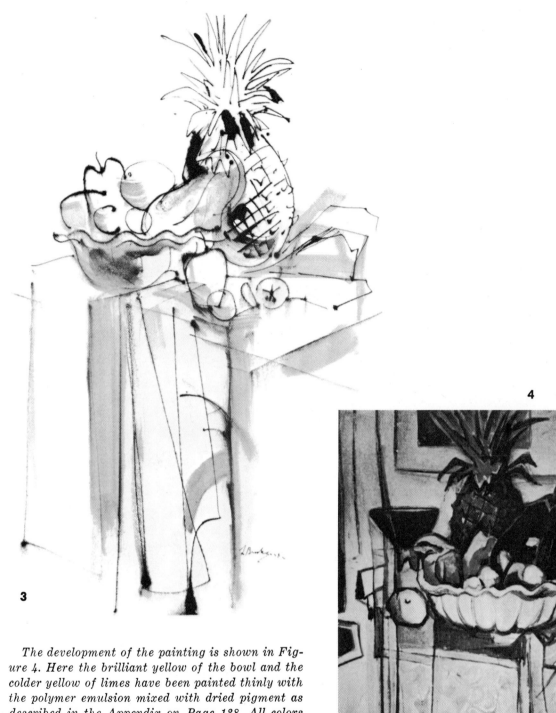

4

3

The development of the painting is shown in Figure 4. Here the brilliant yellow of the bowl and the colder yellow of limes have been painted thinly with the polymer emulsion mixed with dried pigment as described in the Appendix on Page 138. All colors were painted thinly and semi-transparently, and no effort was made to build up a thick impasto.

The charcoal drawing was allowed to come through the color here and there and helped to retain the compositional structure.

Notice the break up of spacing on the right-hand side of the picture, and the invention of frame and related lines to tie up the basic movements of the separate elements. Note too, the tipping of the table and the stress on the vertical and diagonal line pattern.

43

JUGS AND JARS

For a number of years now, I have kept my eyes open for jugs and jars which would serve as still-life painting objects. A collection of such objects alone, or combined with the brilliant colors of fruits or flowers will always provide an interesting subject for study when inspiration is lacking.

The three examples shown here were painted "from life" directly on the canvas without preliminary studies such as those done for the fruit bowl and table on the previous page.

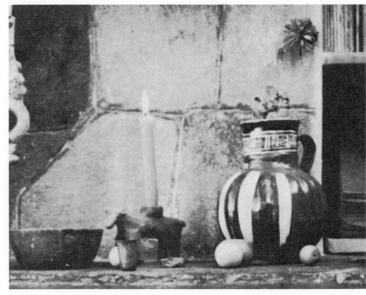

1

2

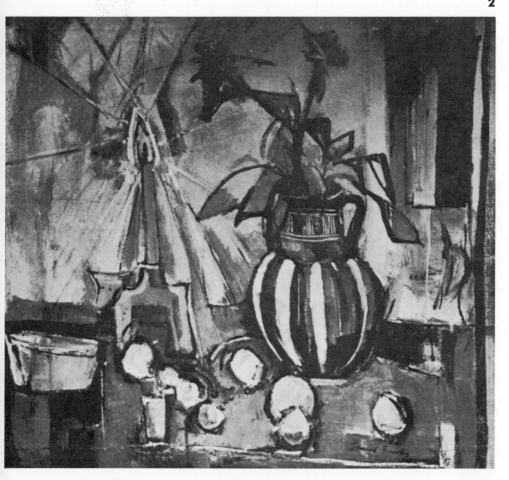

Figure 1 shows a photograph of the subject. Not much to start with, but the problem of painting a candle and its glow was tempting. Painted in strong blues, grays, and lemon yellows, the black and white reproduction does little justice to the picture. (Size, 30" x 36")

Figure 3 is in muted reds, blacks, and white, on a white textured background. The flat shapes of the jugs and bottle are emphasized and modeling kept to a minimum. (Size, 24" x 30")

Figure 4 is a more "realistic" study painted some years ago. Here the modeling of light and shade is adapted more literally, but the brush work is handled broadly and with a "juicy" sense of paint quality. The small color reproduction on Page 84 was a smaller trial sketch made before trying the larger canvas shown here. (Size, 25" x 30")

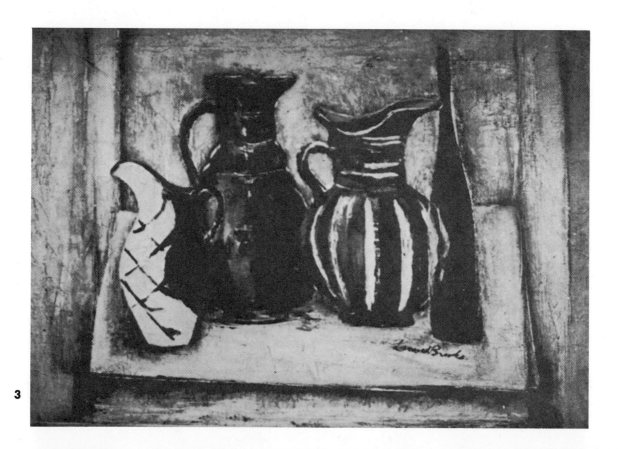

3

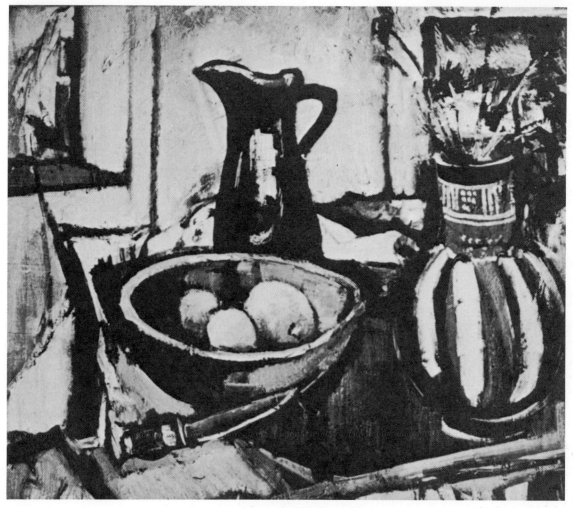

4

SUNFLOWER STILL LIFE

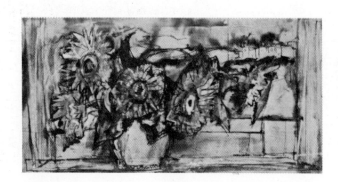

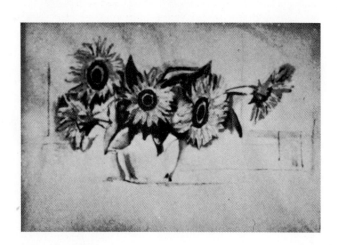

Figure 1. and 2.
Two of the many studies made before painting "Sunflower Still Life." Line and wash drawings such as these will aid you in visualizing the theme to be developed in the larger painting. If you make it a habit to jot down such beginnings for pictures, you will have a constant fund of ideas to work from when you feel inspired to paint a large and full-fledged painting.

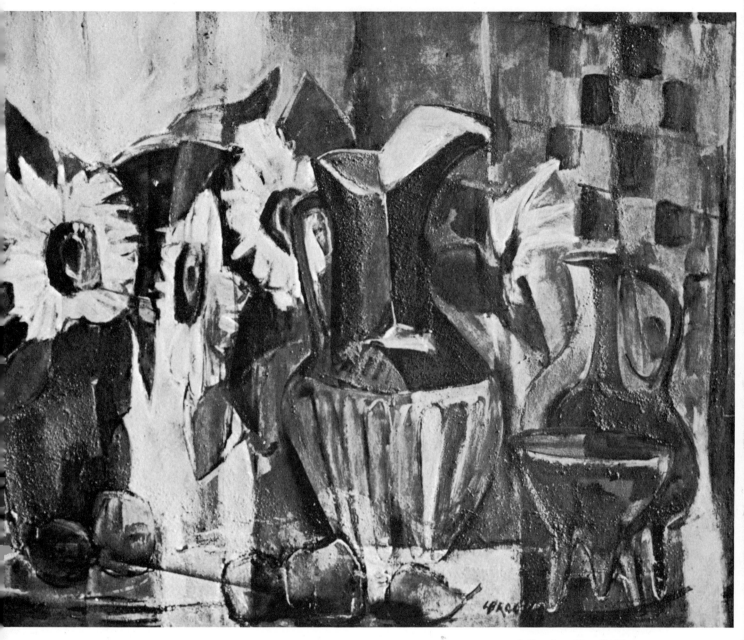

Collection Mr. R. Herman

A large (60″ x 25″) painting made on Masonite board. This was one of a series of paintings in which the movement of light through and around objects set up color and tonal relationships of an exciting nature. The effort was made to make each individual object and section interesting in itself—by means of design, shape, overlapping or distortion of form when needed—and at the same time locking each object into the large horizontal pattern. Light areas were carefully planned before painting in color, using a monochromatic lay in, and many drawings and sketches (Figures 1 and 2).

The painting was done in pyroxylin (Duco). Clear lac-quer, marble dust, and sand were used to provide the rough textures. A full range of color was used—ten colors in all, plus black and white. The apples and pears, not evident in the original drawings, were put in at the very last to give interest to the immediate foreground, which needed additional forms and space "break-up." Notice the variety of edges, from the thick outlines to soft or "lost" edge definitions.

The problem of juggling light and dark forms against each other, the placing of shape against shape with the relationships and movements alive and vibrant with color is one of the joys of painting. The actual beginning—the objects themselves begin another life as elements in a painting.

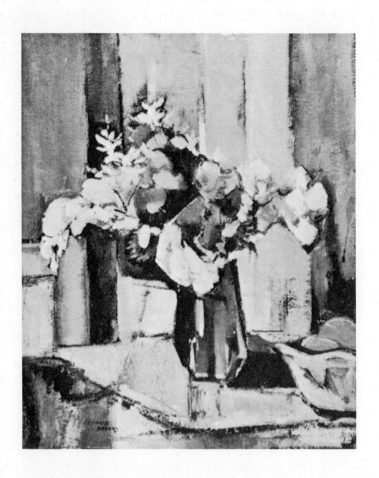

BACKGROUNDS

The unity of your picture will be helped if you make it a habit to move about the surface of your painting developing all parts at once. Do not be trapped into one section or corner, finishing it at the expense of other parts. Try to keep the large conception, stepping back from the painting from time to time to see the whole rather than the part.

Remember that not only the shapes of the objects themselves are important but that the shapes *around and behind* the objects are just as important and must function as part of the all-over pattern of the picture surface. *Backgrounds are not flat, dead areas upon which objects are stuck.* There is space and air surrounding the subject. Each inch must have its own interest and add to the unity of the large design. Broken areas, static flat spaces, planes, and textures; all of these must be controlled and add to the final impact of the picture.

The branch of a *Huisache* tree, painted in yellows and grays, was an attempt to use the spiky, decorative forms against a background which would move back and forth into space rather than to just paint the branch *on* a flat surface. Diagonal linear movements are interlocked on the flatness of the picture plane, with each area, between the spikes and yellow blossoms, carefully considered.

The background planes are built up and painted in and *through* the forms with special attention paid to the edges, that is, light against dark, dark against light. Note white lines here and there, around the forms. The painting was begun with an underpainting white and warm gray. Textures were built up thickly and allowed to dry. Thin "scumbles" and transparent drawing was then done over the blocked-out forms and the final details of thorns and leaf drawn with a small pointed sable and thin dark paint.

The smaller painting of flowers was a more direct handling but the same problem of making the background function as part of the picture surface was considered. Often these background spaces, as with large areas of sky in landscapes, take more work and concentration to bring them to a successful conclusion than the objects in the picture. There is little to work with, but each square inch—seemingly of no importance—must hold its own in interest yet "sit" well with the rest of the painting.

The background of "Mexican Chickens," the color plate on Page 88, was painted and reworked many times until the large warm areas of background became "alive," felt right, and surrounded, spatially, the chicken forms.

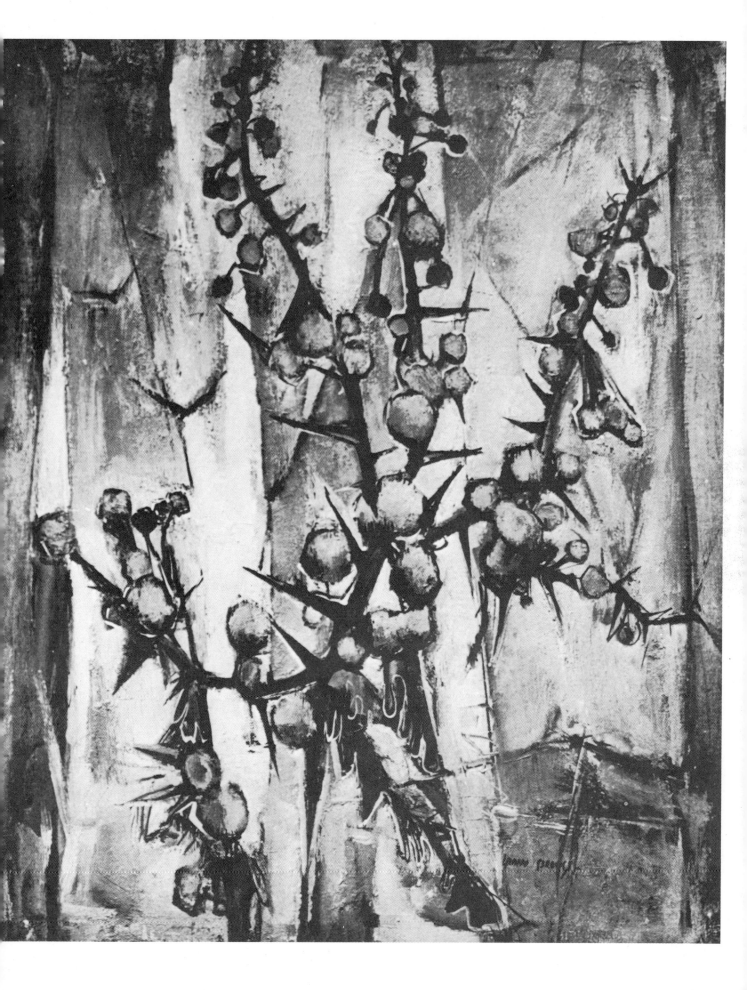

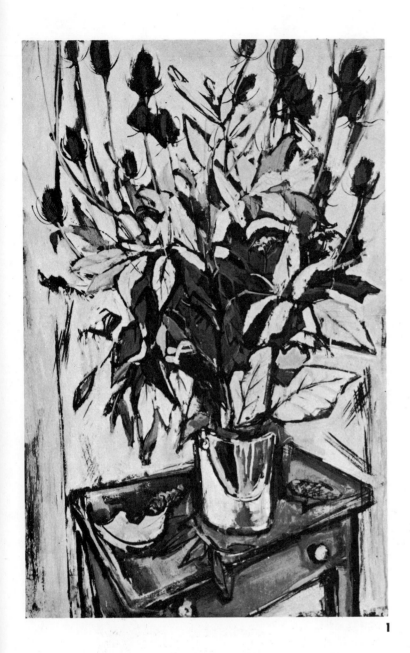

1

FLOWER GROUPS

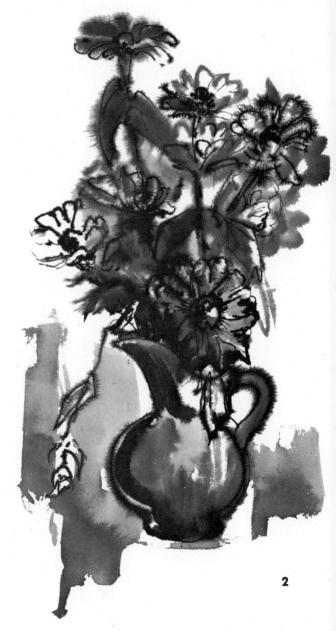

2

The time-honored flower piece is still a challenge to artists. To redeem the "prettiness" and obvious, to paint a fine picture with feeling using flower forms, is still a task worthy of a master painter. The infinite changes of form, color, and arrangement call for a keen eye and a sensitive brush.

Preparatory studies done in ink and wash, such as the one in Figure 2, are helpful in studying the basic forms of the flowers as well as laying out a composition within the picture-plane boundaries.

Search out the individual character of the particular flower. How does it differ from other flower forms? The problems of variety, repetition, massing of light and dark must be solved. After a number of drawings of this nature you can afford to turn your back on the actual subject and release yourself into a freer and more imaginative rendering. The color plate on Page 86, "Flower Tapestry," was painted from memory after a summer of study of groups such as shown here.

Figure 1 is a studio painting of autumn leaves in yellows and faded reds and browns, contrasted against a green table. A large canvas, four feet high, it was painted directly from the subject in one session with a quick-drying underpainting and superimposed linear drawing for definition.

3

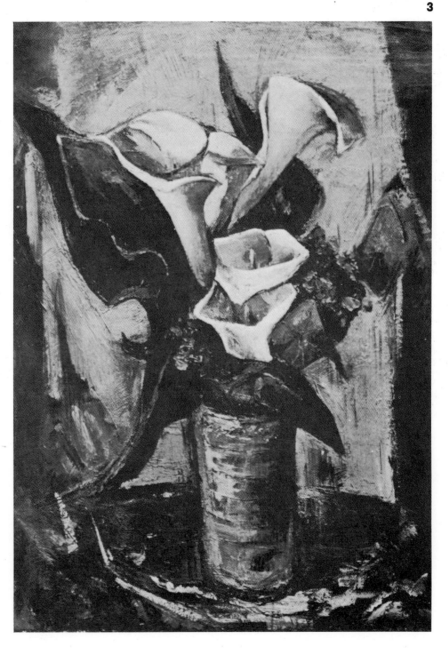

Figure 2. Line drawings in pen and India ink diluted with water will help in planning the composition as well as the study of detailed forms and design elements.

Figure 3. An oil painting on canvas of the careful studied-out kind which are so pleasurable to paint. Textures are considered carefully and built up with brush and knife. Scraping down the paint, glazing of rich color over underpainting, every technique is employed to give variety to the paint surface. This is a 18" x 24" canvas, painted on and off over a period of two years. Such paintings, started from the actual model can be painted on indefinitely as long as the interest is retained. Be sure that the underpainting is dry before putting on fresh layers of paint. When painting on a canvas over a period of months, an isolating coat of retouch varnish is valuable to freshen up the color and to seal earlier layers.

LANDSCAPE

LIGHT

Many of the most exciting moments for the landscape painter come to him when it is not feasible for him to sit down and make a careful sketch. Early morning, when the rapidly changing sun strikes objects in a golden radiance for a few moments before climbing higher in the sky; windy days, when the dust-laden atmosphere clothes the far hills in delicate neutral tints; late evening, just before the sun sinks below the horizon—all of these moments and moods are tantalizing, and difficult to capture.

The value of quick notes, in black and white or when possible, color, becomes obvious at such times. A few lines to capture the essential features of the theme, even written notes to bring back the memory of color and form at a later time, will often serve as the basis for important paintings.

There are days, too, when color seems to have deserted the landscape and it is almost better not to take out the sketchbox. Perhaps it is the wrong time of day, the sun directly overhead bleaching

1

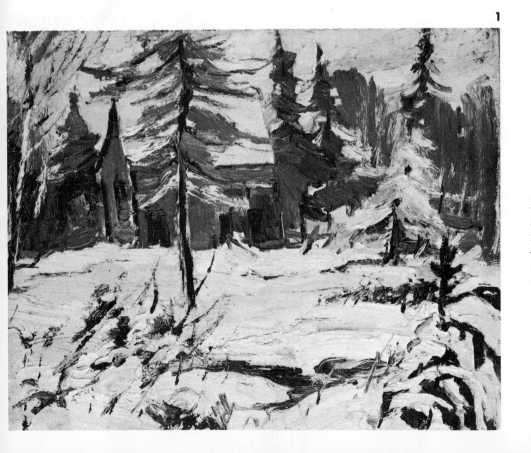

Figure 1. A rapid note made for color on an 8" x 10" wooden panel. Roughed in with broad strokes, it endeavors to capture the strong tonal contrasts of late evening with simple directness.

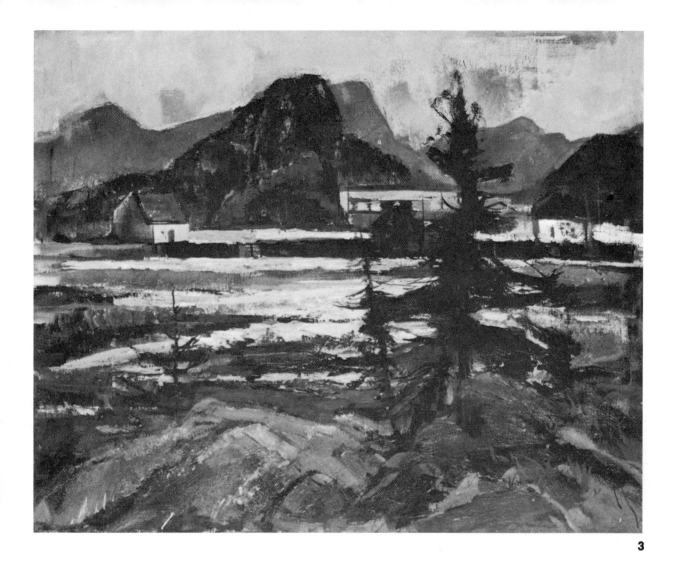

3

out all color or modeling of form through lack of contrast. The composition is attractive, but it is a black and white subject. This is the time to make a drawing, knowing that a return visit at another hour will probably provide needed color.

The sketch shown in Figure 3 was done on a gray, rain-laden afternoon when the mountains were lost in blue silhouettes and the sparkle of water came through the dark mud and wrack of the low-tide waters. Earlier in the day I had seen this spot and had rejected it as a painting subject. Flat and dull, the color values were flat and unattractive. I had turned my back on it to concentrate on a black and white drawing of some nearby rocks and trees (Figure 2).

Within a few hours the subject came to life color-wise as the sun broke through the flat sky and it proved irresistible. I took out my paints and started to work.

In "Watercolor . . . A Challenge," I wrote about the value of catching subjects "on the fly" and how watercolor was a useful medium for making rapid transcriptions from nature. The simplicity of means, the quick manner of putting down essential information for later study is an indispensable quality. For the oil painter, too, the pen and wash technique is an invaluable recording means. It is suggested, in the list of basic materials in the appendix that a small book and pencil be carried with the sketchbox. I have often, when in a rush, used turpentine and a thin color or two as a wash over the pencil sketch to indicate lights and darks.

If you make a habit of using your notebook to analyze your composition *before* you start to paint on the panel or canvas, or to jot down details, there will be no disappointing days when, searching for a painting subject, you give up, or sit down to paint something which does not inspire you. There are always compositions to note, objects to be drawn until the clouds break and the exciting world of light and shadow entices your paint brushes.

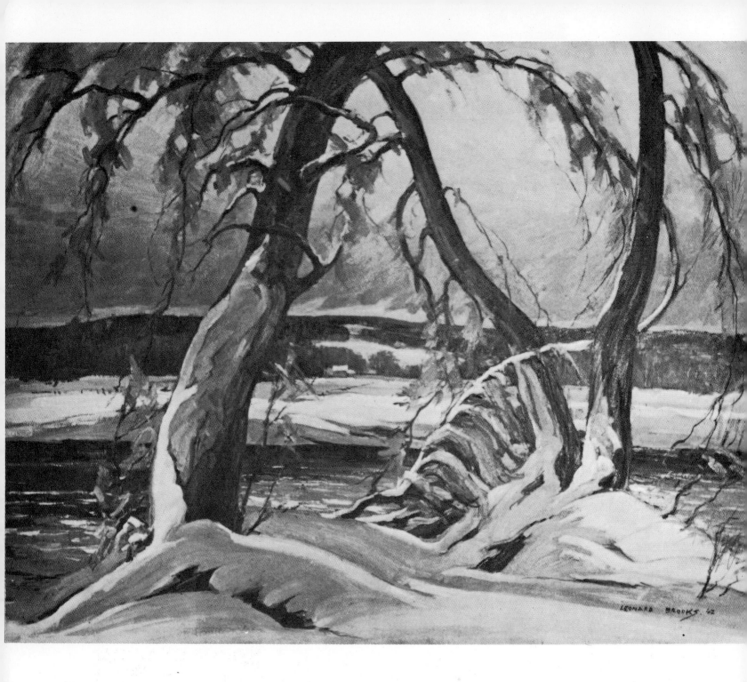

TREES

There are two ways of handling the difficult problem of painting trees, paint and draw them well — with knowledge, with feeling and love—or don't paint them at all. There is nothing that will indicate an amateur so quickly as the daubs of formless green and match-stick branches carelessly smeared over a canvas. To paint a tree well— especially if you are going to "formalize" it, giving it stronger structure and synthesis—requires many hours of studying and analyzing the basic struc-

tures and growth patterns of its countless forms and variations. Sketchbook studies, made to discover the rhythmic sequences of branching, color passages devoted to the play of light and shadow across the interlaced forms and volumes, and drawing of detail and leafing—all of these will help you to understand how a tree is put together so that you may perhaps put down some of its "treeness" on a flat surface.

If you are wise, you will investigate the drawings

of the classical and modern masters. How did they express the myriad details of leaf clusters, wood interiors, pine boughs, all the manifold characters of the growing plant world, from slim white birch to gnarled and ageless oak? How did the painters of the Barbizon School paint trees in all their romantic nineteenth century mystery? How did Courbet paint his unparalleled ranges of exquisite greens, drawn from the tangled deep woods where the deer and gazelle stood mirrored in silent pools; what secrets did Cézanne wrest from the hundreds of paintings of his beloved tree landscapes? What magic did John Marin find along the edges of his rocky Deer Island shores, or Winslow Homer in the bent, wind-swept palms of the tropics or the thick tangled bush of Maine?

There are no secrets or recipes that will help you draw or paint trees well. A prayer, perhaps, in the fashion of the Chinese painter, before beginning work, and long years of learning to see and feel deeply about such fundamental and primordial things as sky, and rocks, and growing forms. You may, with luck, manage to convey the richness of the jungle in a primitive and unschooled manner, much as Rousseau, who enticed from his imagination the frightening lushness of animal-filled tropical landscapes. You might, like Mondrian, carry your study of trees through years of careful delineation, long sessions of abstracting the skeletal

movements and forms, and finally dismissal of all "treeness," leaving only the oppositions of clean horizontals, verticals, and squares to serve the eye. Or you may just give up in despair after a few efforts, bringing home fluffy green balls on apple-stem trunks, poisonously verdant, or prettier than a corner-store calendar.

Drawing, drawing, and more drawing. This is the only real "secret." Add to this the interest and determination to progress to at least a capable statement, and you *must* improve. Dodging the problem by always ending up with a subject you know is easier and which you have painted with some success before will not help. Take time to tackle the job properly. Go out and look for a tree —a group of trees. Spend the morning concentrating on drawing them. Go back and try it the next day, varying the medium—thin pen line, thick brush and ink, Conté crayon, or a combination of two, or even all three.

On Page 113 there is a reproduction of a painting by the Canadian painter Paraskeva Clark. This is an interesting example of a difficult subject matter, such as wood interiors and landscape panoramas, made attractive through the sensitive use of design form and composition. Observe the searching out of planes and recessions of form, and the care with which the character of tree and rock has been drawn and painted.

BIRCH WOODS,
LATE EVENING

A small, direct oil sketch made on a chilly evening in the north woods of Canada. Sky is low-keyed in a sullen pink; snow is gray-green. The almost black spruce make a fine foil for the slender light birch trees. A rapid color note which was used for the basis of a large canvas painted later in the studio.

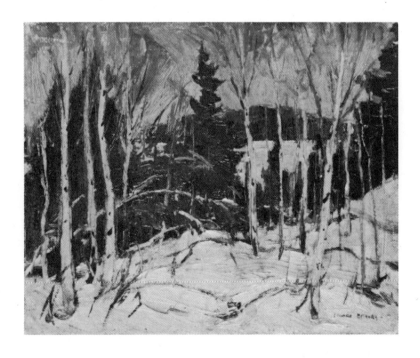

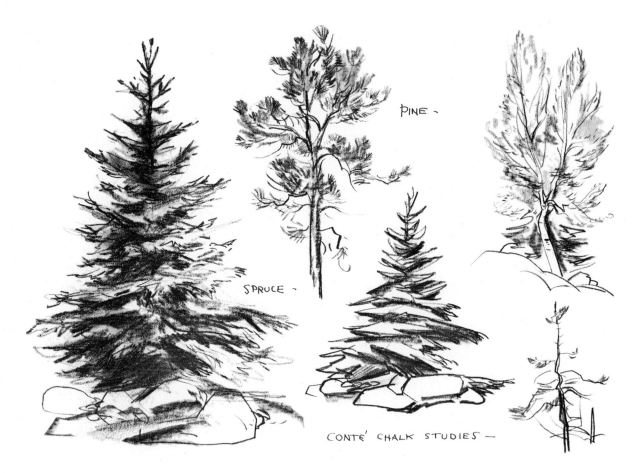

1

SPRUCE

PINE

CONTÉ CHALK STUDIES

TREE STUDIES

FROM NATURE

Figure 1. A page from a sketchbook of rapid drawings to note the main characteristics and decorative differences between species of evergreens, birches, etc.

Figure 2. Groupings of trees by river's edge or in forest interiors lend themselves to compositional spacing and interest. A Conté drawing using the chisel edge and flat side of the crayon.

2

Figure 3. A wash drawing done with diluted India ink and pen-line accents. Strong tonal patterns are indicated simply.

3

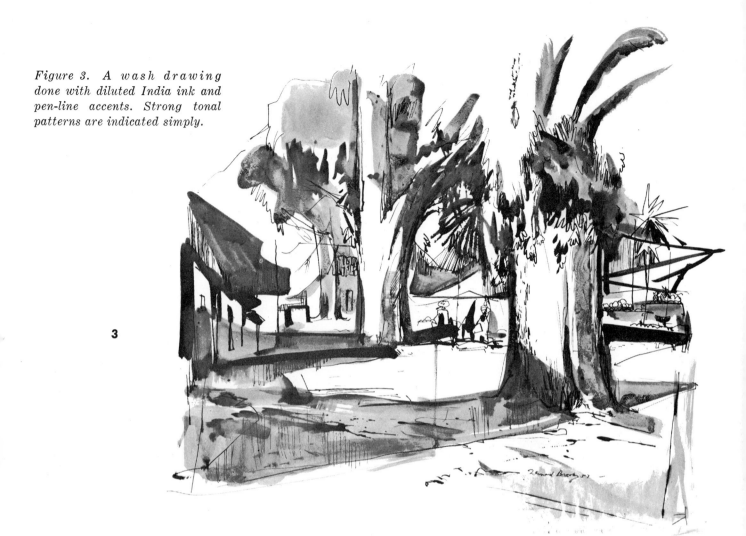

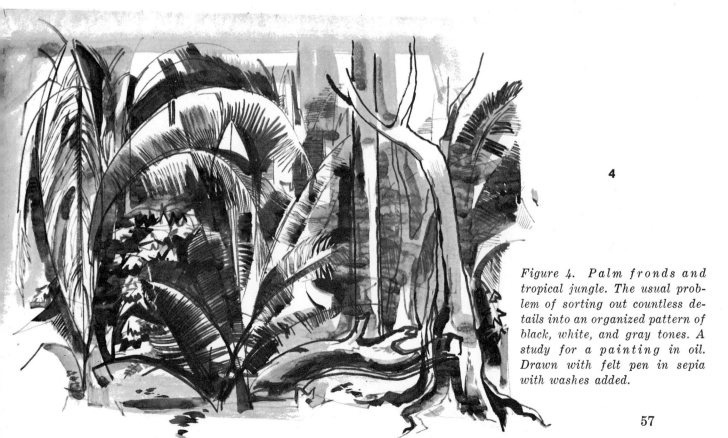

4

Figure 4. Palm fronds and tropical jungle. The usual problem of sorting out countless details into an organized pattern of black, white, and gray tones. A study for a painting in oil. Drawn with felt pen in sepia with washes added.

ROCKS AND SHORELINE

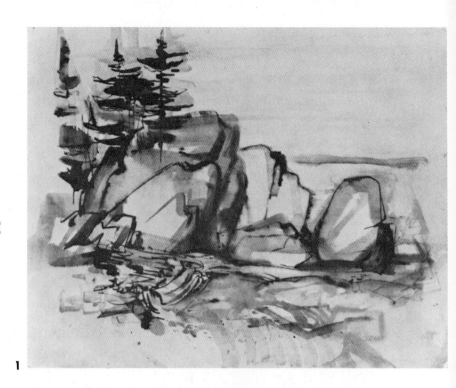

1

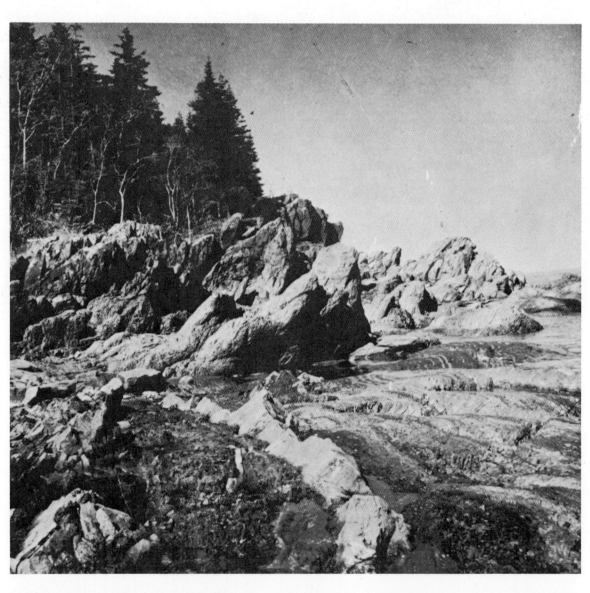

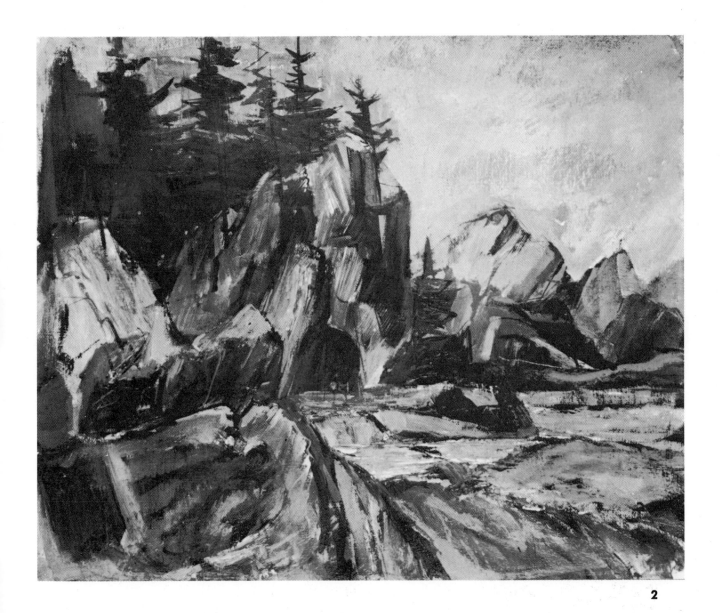

2

The dynamic convolutions of rocky and rugged shorelines provide a storehouse of subject matter for the sketcher. Shown here are studies made on the St. Lawrence river in Quebec.

Notice how liberties have been taken with the formations of jagged rocks, how the large forms have been emphasized and directional strokes following the rocky volumes have been strengthened to provide a flow of movement which is obscured somewhat in the detailed mottling and spottiness of the photograph, but is nevertheless there.

The black and white drawing (Figure 1) was done on a 20″ x 16″ sheet of paper to establish the composition. A second study, done in casein, was then painted during a three-hour morning's work to put down the pink-gray-green color vibrating in the clear bright light (Figure 2).

These studies are now filed away, ready for further development and simplification into a less derivative but soundly understood motif.

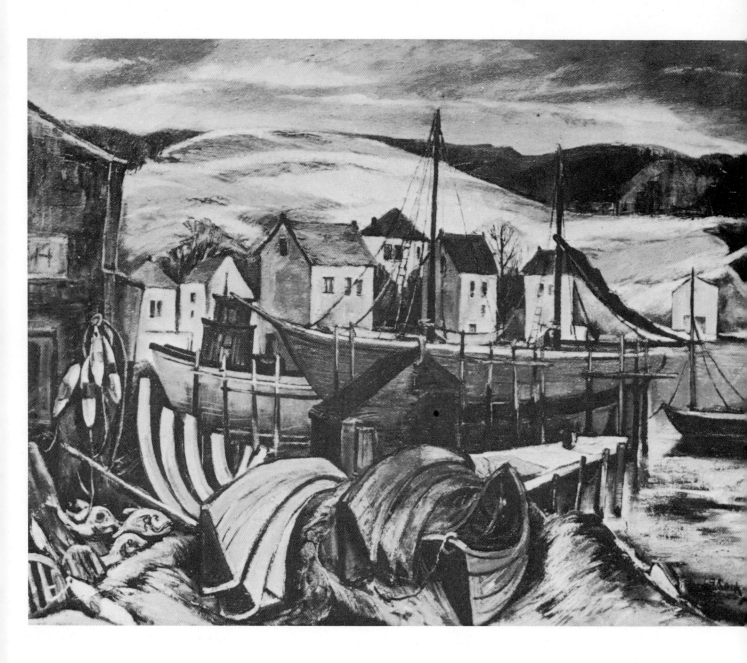

SHIPBUILDING

A 40″ x 50″ canvas painted from drawings and color notes made on the spot. I was interested, at the time I painted this picture, in modeling the toy-like boats and houses with strongly defined volumes, playing the blocked and curved forms against each other in strong rhythms.

Textures were created by overpainting and scumbling areas with semi-dry, thick impastos. Many details were left out (rigging of masts, etc.) and the strong, large forms of the ships, sheds, and wharf were defined sharply by the use of lights behind darks, darks behind lights to emphasize vol-

umes in space. The snow on the far hills helped the design of the picture by repeating the light areas of the foreground shapes and middle distance. Fishing gear and boats have many design possibilities for picture making, although the subject may easily end up too "picturesque."

As always, the redeeming features will be found in the successful selection from the subject of structural and significant forms, controlled color and "chiaroscuro." Elimination of detail which does not add to the large conception, or the emphasis of detail to its ultimate degree where needed, these are

decisions which must be made as the picture grows and develops. The choice of style is a wide one, and yours to make.

The photograph made at Tadoussac, Quebec, has all the material in it for an important painting. What would you do with it? If you analyse the grouping of buildings, boat, and rock formations you will find plenty of material with which to compose. How will you transpose it into black and white, into tone and color? Small sketches, similar to those shown here will help you plan the layout of your canvas before you begin to paint. Alter the relationships of shapes, accent or subdue the light and dark areas: the facts supplied in the subject are only a beginning for your picture making.

BARNS AND FARMS

A few sketches of the kind of subject which will provide study material for composing and painting are shown here. The use of the sketch pad and pencil will help make the decision of what you wish to paint much easier.

The pencil note (Figure 1) was made from a parked car in a few minutes. The next day a careful drawing was made in ink and wash, (Figure 2).

As you progress, save your early sketches and notes, no matter how slight they may be. Seen afresh, and with a more experienced eye at a later date, you may find that you have garnered more than you realized at the time you made them. These early efforts may often spur you to redoing the composition using the basic idea you were trying to capture.

DOG CORNERS ROAD XMAS. 51

1

2

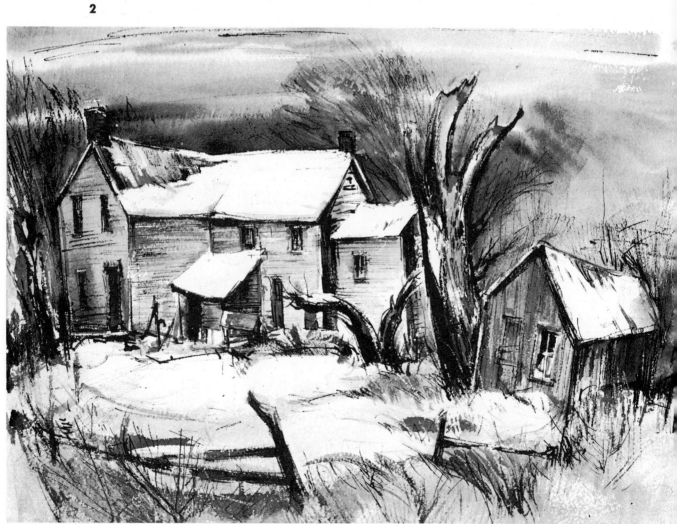

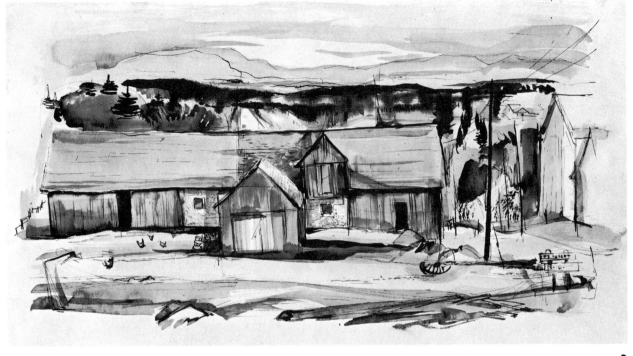

3

What is there about an old barn or farmhouse, weather-beaten and askew, which delights most artists' eyes? Is it because it lends itself admirably to the exciting rendering of broken color, silvery textures and decorative linear patterns? It would be enlightening and fascinating to see all at one time, the number of painters who are perched on their stools before a group of barns and landscape on a lovely July afternoon, everywhere in the bucolic regions of the United States and Canada. If we include fishing sheds, the number would increase considerably—and we'd come up with a large number of dedicated and serious artists in the bag, as well as beginners and students.

As a simple element, the shape of a barn lends itself to the sketcher who is confused with the countless details of tree foliage, skies, and other landscape forms. Here is something he can see simply and put down without too much trouble with

Figure 3. A typical "long" barn of rural Quebec. Let the subject determine its own proportion. Do not always confine your drawing or painting to the standard rectangular sizes. Tall vertical shapes, long horizontal spaces are exciting; try them all, even the difficult square canvas.

the drawing. For this very reason, I have used the barn theme for illustration purpose constantly in this book. For the tyro who ventures out for the first time, the barnyard can give him confidence and a chance to handle fundamental forms. Time enough for the complications of the vast panorama or detailed wood interior at a later stage.

4

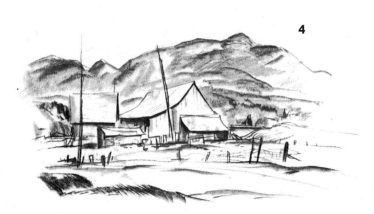

Figure 4. A rapid Conté drawing on smooth "china-finish" paper, with medium tones rubbed out with the finger.

STREET SKETCHING

Figure 1. A drawing made from a car on a windy spring day when highway dust filled the air making outside sketching an impossibility.

1

The drawings and sketches shown here were done on a recent sketching trip made to collect architectural subjects for studio paintings.

Drawings done in Conté and pen line on dampened paper set down the main lines of interest and provide sufficient detail for later reference. Look for the strong light and dark pattern and do not be too concerned about making a "finished" drawing.

Among my sketchbooks, is one filled with shorthand notes and scribbles made during the Mexican Christmas Posadas in our village. These quick notations, scrawled in rapidly in the half-dark and in

2

Figure 2. A study made from a Quebec hotel room overlooking the St. Lawrence River. A subject worth revisiting with paint and canvas and plenty of time to work in privacy.

The difficulties and inconveni-
ence of making paintings in city
streets or on dusty country roads
are many, yet often a subject is
irresistible and must be noted.
Learn to make rapid notes for re-
ference and drawings which can
be developed leisurely at a later
date.

Conté drawings, pen and ink
combined with wash—these are
invaluable source material. If
you are fortunate, you may find
your subject can be drawn from
the seclusion of a parked car.
Hotel windows may yield sur-
prising subject matter and com-
positions. "A room with a view"
is a must when traveling.

the midst of moving crowds of fiesta-goers, proved invaluable to me. From them I painted twelve large pictures in full color. The very act of jotting down a line helps to fix shapes and colors in the memory.

If you can find a quiet spot, or work from the comfort of a car, quickly brushed-in casein and

watercolor notes can often be made. These, too, can be finished in the studio.

Sketchbook notes and rapid transcriptions will often catch a meaningful essence of the scene or subject where overworked sketches lose the sponta-neity and vitality of the quick impression.

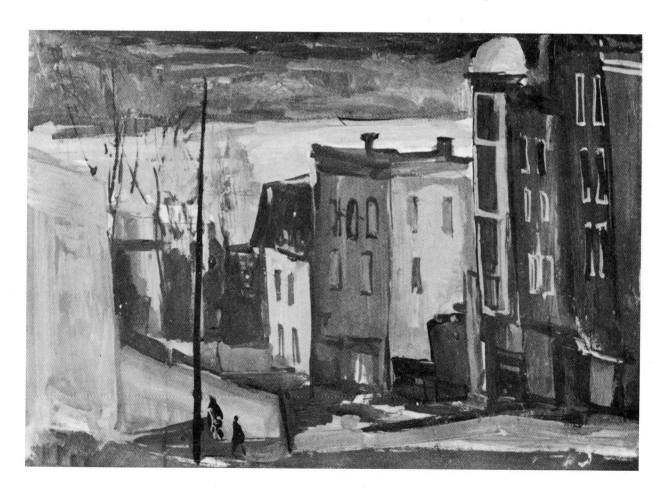

OLD WALLS

Figure 1. *India ink wash and pen drawing of a deserted street and store fronts. Detailed notes of this kind are kept for reference when painting later in full color.*

Deserted streets in old villages, decrepit bridges with steps leading nowhere; the early morning desolation of a big city—all of these will attract the painter who delights in what Joe Lasker sums up so well in his painting creed (Page 118)—"seeing something happen in paint."

Such subjects can often be found "right in your own back yard." It is not necessary to be in Italy or Mexico to discover provocative painting themes. The love and knowledge of your subject is what matters: from the things about you will often come your best work.

Study the work of Charles Burchfield. See what he produced in his early years with the subjects of his beloved Buffalo streets and houses! See what he has been doing of late with a series of nostalgic memories of his boyhood days when he watched dragon flies skim the "old swimmin' hole." It takes a brave and talented painter to take such stuff and redeem it beyond the obvious and sentimental. It takes courage and belief in one's convictions to work with such material and make it meaningful and artistically sound. How much safer not to try such things! The danger of failure is so great, the demarcation between a finely conceived picture and the mediocre often so slight.

Figure 2. *Casein underpainting with oil glazes brushed over built-up textures. Ochre, Venetian Red and black were the only colors used. A razor blade was useful in scraping down the thick textures to allow the varied layers of underpainting to show through.*

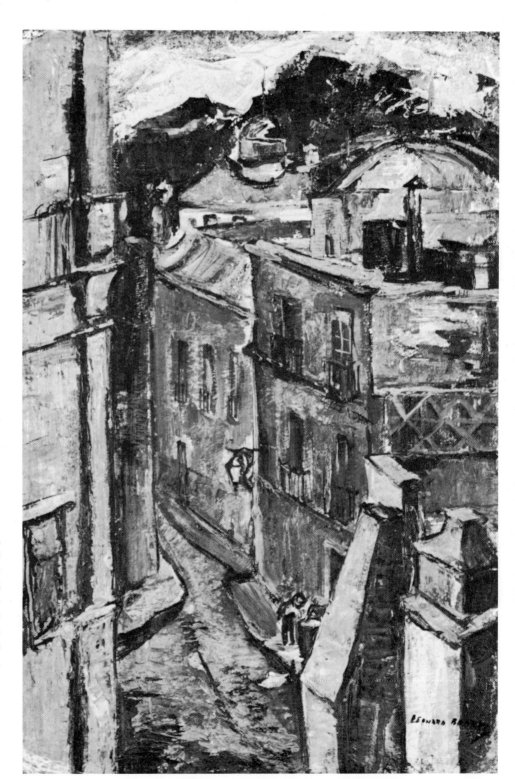

Figure 3. Calle Garcia Lorca, Mexico City. No longer extant since recent modernization, this narrow street was seen from a hotel window and painted directly in oil paint. Some palette knife strokes were used to suggest plaster walls. Painted in a restricted palette of umber, green, and ochre.

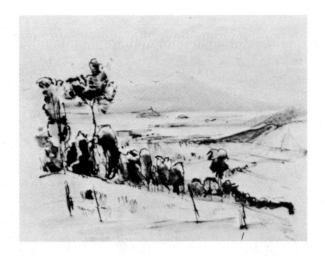

A CHANGE OF FOCUS

Changing one's point of view, deliberately, with a conscious effort to see anew, is not an easy thing to do. Old habits, accustomed ways of looking at the world around us, the re-doing of problems we have perhaps already solved—this requires much less of a struggle on our part. Yet, to do so, from time to time will often revitalize our seeing, and consequently our work.

I remember a cycle of painting I passed through where the distant vista, vast rolling mountains and landscapes, attracted me more than any other subject. Anything within a distance of a quarter of a mile became, as far as picture-making and composing went, nonexistent. Panoramas lured me to paint, and the close-up object was forgotten.

One day in the garden, watching a butterfly, wings pulsing, light on a flower, the focus changed. A play of sunlight on the green leaves, a slash of purple shadow, a patch of dark earth and multicolored stones—a subject for a sketch—leaped at

1

Figure 1. The distant view. Part of an early cycle of panoramic subjects where sky and rolling countryside became the theme.

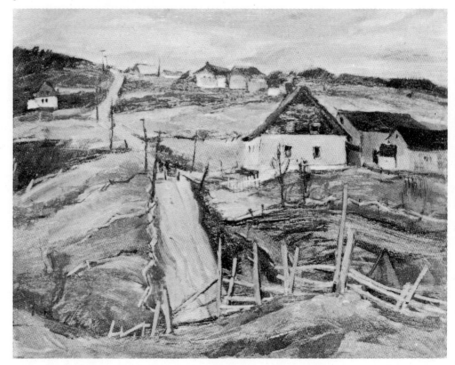

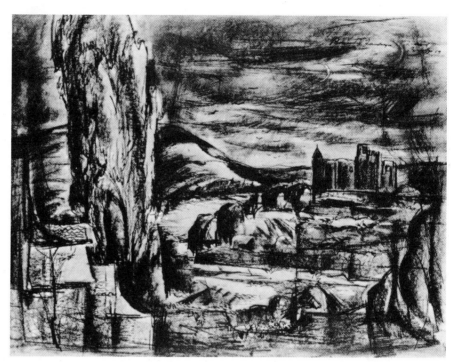

Figure 2. A black and white study for a painting. A combination of far landscape and close-up forms. A later effort in which the near and far subjects are integrated. "A double focus" bringing panoramic and near forms and shapes together.

2

me. I looked around the garden with new eyes. The peach tree, dappled with pink blossom, the red tile on the tool shed, the watering can and garden shears on the stone walk—the close-up view revealed itself to me as I had never seen it before.

This change of viewpoint, from the vast to the almost microscopic focus, is to me a fascinating phenomena, and one which should be of interest to the psychologist studying the workings of the painter's thinking. These cycles of ways of seeing which are changing constantly—what brings them about? Why do we sometimes find ourselves staring with wonderment at a few objects on a table and see the whole world compressed in the outline of a jug, or in the simplicity of form contained in the pale yellow modulations of a lemon? Why does an individual flower blossom suddenly take on significance, isolated, cut away from the million plants surrounding it, demanding that it be placed on paper or canvas, put in relation to other forms and made into a picture?

This world of close-up focus is often the basis for many a painter's work. Common objects, casual bric-a-brac of every day life taking on a life of its own, become redeemed beyond their utilitarian function. A broken jug becomes a glowing patch of golden color, a dead herring a scintillating jewelled design. Aldous Huxley has written a fascinating account of this magic of vision in a slim volume called "The Doors of Perception." In it he describes a magnificent moment when, under the influence of peyote he is mesmerized by the super-real burning intensity of his seeing the light, shadows, and intricate modeling of a crease and fold in his trousers.

Such vision was well known to oriental artists. Meditation and concentration brought their faculties to the highest pitch of perception and it was with a prayer they faced their paints and brushes.

All of this sounds mystical and perhaps of little concern to the beginner, struggling with his color mixing and drawing. I would suggest that it may help you to try such an exercise. To see afresh, or for the first time, many of the things you have taken for granted—in terms of paint—requires a sensitive and lively eye. Take time out to *look* and *think* about your subject before you begin. Your priceless possession—vision—needs exercise.

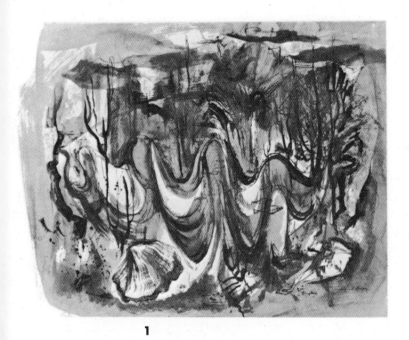

1

Cobwebs and driftwood, sand and water; here the close-up focus and viewpoint has been used. A walk along any beach will reveal a hundred themes as the sea tosses up new groups of form and color for our contemplation.

Paint it anyway you wish, but paint it. Here is your chance to select and reject. Perhaps you will find that carrying away the memory of the place, conjuring it up at a later time, free from needless detail, is the only way for you to work. Perhaps you must have careful drawings and studies on which to build your picture. You might, as I did, bring back beach treasures for later study—bits of shell, feathers, a broken piece of stained and rusty wood from a ship's door, a strand of seaweed.

The "Sea-harp" (Figure 2) was painted from a notebook drawing, some months after discovering it on the Vera Cruz shoreline. It was underpainted in casein and glazed with oil paint. It is a large painting, and hours were spent to build up the broken textures and colors of the sea-beaten driftwood.

The drawing heading the page is an imaginary study of an underseas landscape which began when I was presented with a large white Florida scalloped shell.

BEACH LIFE

2

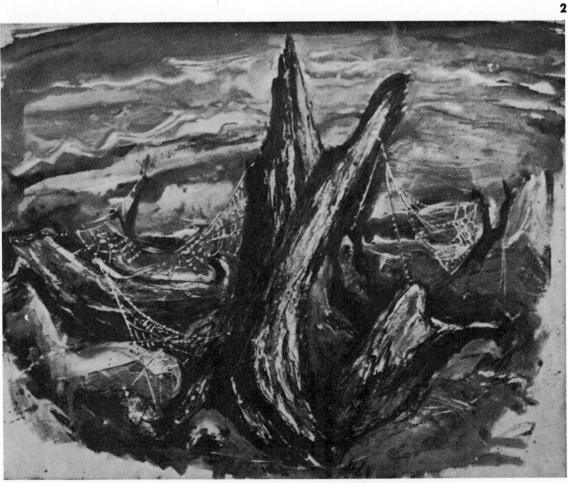

BEACH STILL LIFE—

Polymer Tempera on Canvas

A studio painting made from many observations of the ever-new arrangements thrown up on the tidal beaches of the Pacific coast: Driftwood, shells, feathers, bottle, and fish skeleton.

The textural interest in such a subject can be exploited at will using sand, inert clay powders and the polymer emulsion as a binder. Note how the all-over filling of the canvas has been considered; the planes and interlocking spaces move across and into each other. Observe also the use of many tonal values, the full scale of intervals from black to white.

71

TOWARD ABSTRACTION

So far, in this book, we have been dealing with more or less traditional ways of thinking and working. Space filling, using forms and objects which we know and can see, tangible forms translatable and communicating meaning to the onlooker; interpretation of things and places—these have been our concern.

What then of the abstract and non-objective approach? What of the pictures we see everywhere today which bear no relationship to what we *see*, but are concerned only with presenting slashes of color and texture, patterns controlled or the marks of an "automatic gesture?" What of paintings which are concerned only with lively plays of tensions of color against color, mystic personal worlds of dabs and smears, or nothing more than ten foot areas of white with black swipes of a dirty brush across them?

Many of these paintings are produced by sincere artists who have worked their way through from the realist point of view to the semi-abstract and finally to the "paint-for-paint's sake" philosophy. Content and such things as communication are then disregarded as the artist grapples with his private world of creation. What is he doing? What satisfaction does he derive from throwing over all restraints, all criteria of past values; what ego drives

him to the flaunting of all tradition, all humanistic values?

There is not enough space here to discuss these questions in full. Undoubtedly you have asked yourself these things, or perhaps have answers—for or against—the present trend of painting which has become so fashionable.

Whatever you believe—and there is no reason why you must bear tribute to what is pointed out to you as being the "best and most vital"—it is important that you keep an open mind and take from the world of contemporary painting what you find good. As a student you will soon discover that the only constructive approach for you is to look, think, and to come to your own conclusions of what is good and what is not. As you work, your judgments will change, your likes and dislikes will alter, as they should.

Hopping bandwagons has always been a lost cause, and there is nothing so pathetic as a young painter caught in the false dawn of a too early and modish success which changes overnight, leaving him with nothing but his little bag of tricks, or a beginner desperately trying to paint pictures which look "smart" and "up-to-date."

To paint freely and in the non-objective idiom is *not* easy to do. In the chart for self-study there is room for you to try it for yourself. Painting only with relationships of color, space and textures, with no reference to any object or existent form, and making something important from such limitations, is difficult. The excitement of the *paint* itself is all there is—and this can be a magnificent and moving creation.

Undoubtedly, as an exercise in liberation and exuberance, painting *away* from the constrictions of object or visual matter can be of value, if only as a contrast to the discipline and control you have exercised before the subject. If you have found yourself bogged down in the difficulties of drawing, tonal analysis, color mixing—all of the traditional techniques—try breaking away from it all. Perhaps you will find your way of working in the mysterious world of the non-objective picture; perhaps you will find renewed faith in what you are already doing, or hope to do.

1

Make a start somewhere. Face up to the canvas and make some marks on it; that is the beginning. Start, if you will, with the memory of a place or thing, or glance over your sketchbooks for a theme or design motif which intrigues you. Begin the canvas and let it make its own demands; a line or accent will demand another to balance it, a tension of empty space will call forth a decorated opposition or a static area. Work freely and loosely, moving back and forth across the picture surface. Do the same thing with color. A slash of cool green calls forth its opposite, perhaps a gay red stroke to cut the green. Texturally, a smooth passage may demand a broken coarse contrast to give the surface interest and liveliness. Allow the picture to grow to its own conclusion, which may readily find itself far from its initial conception. Try to make each part, each light and dark, each color and form, line and mass bear a relationship to the other so that if you moved one part away you would miss it and the "completeness" and allover feeling of an integrated surface would be destroyed.

Try painting a picture *without* reference to any motif. Limit yourself only to forms and colors, but see to it that they function, even without recognizable symbols.

You will soon find that this is not as easy to do as you thought. Forms have a way of suggesting images where you do not want them, strange animals and faces emerge unpredictably and the picture ceases to be "non-objective."

Sessions devoted to experiments of this kind will teach you much about the workings of paint. Even if you have no desire to work in the abstract idiom finally, the discipline of avoiding the literal or of depending on the subject matter to redeem a badly organized painting will be of value.

Figure 2 was made from memory after many studies and drawings of the plant called "Corona de Jesus." Its spiky branches and glowing crimson flowers became an excuse for covering a large canvas with shapes and forms which needed a "dynamic" manner of handling. The actual plant was finally forgotten as the areas on the canvas brought forth their own textures, colors, and interlocking spaces.

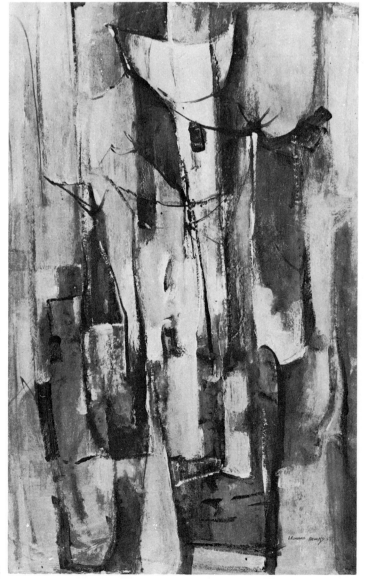

Collection Edwin Schier

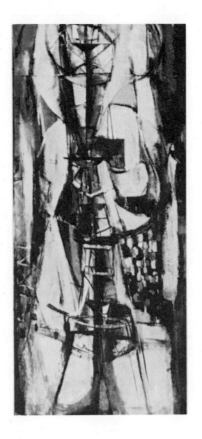

1

IMITATIVE OR IMAGINATIVE?

The two paintings shown here were derived from the same subject, the exciting tall structures of exploding fireworks known as "castillos," an essential part of Mexican fiestas.

In the lower sketch the size relationships of people and fireworks, the suggestion of buildings and whirring flares is more imitative of the actual scene than the vertical panel heading the page. It was made years ago from drawings made on the spot. It is more factual—and more ordinary. The vertical panel was made recently. It was painted without reference to drawings or notes in an attempt to put down only the impact of bright color contrasts and swirling movements which seemed to symbolize the feeling of excitement and fiesta. Even the crowds of people are indicated in pattern shapes of small squares, and no effort has been made to show the whole scene, but only a section of the tall spar and fireworks.

This difference between the more literal interpretation and the elimination of detail in favor of a more imaginative handling of the design, tone, and color will bring about stronger design and a more personal statement.

2

Two illustrations to show the difference between the free "dynamic" approach to subject matter and the more derivative and static interpretation.

Figure 1 is a large panel painted from memory of many Mexican "castillos"—bamboo shafts for fireworks. In it the movement and contrasting forms of light and dark have been organized and freely painted. Color, shape, and texture have been assembled less literally but with much more impact and feeling of the moment than in the more accurate and photographic version shown below. The long vertical panel itself is more suitable to the theme. Note how the crowd of figures has been symbolized in the repetition of rectangular color patches behind the shaft. The color too, was reduced to a limited warm scheme of brilliant reds and yellows with contrasting blacks.

Figure 2 is a literal panel painted from drawings made on the spot. A useful source of reference but a poorly conceived picture.

ON YOUR OWN

At this point we have reached the half-way mark in this book. If you are a beginner, new to the ways of painting, and have followed closely the ideas and suggestions in the foregoing pages, it may be wise to slow down, recapitulate, and clarify our direction. We have covered a lot of ground in a brief space and this may easily cause confusion, especially if you are studying on your own. Tonal concepts, picture planes, distortion, and *Basic Methods* of applying paint; free expression and disciplined drawing from nature; where do we start or stop?

For the student who is working on his own, without benefit of an art class or teacher, the difficulties of setting out for himself a course of study which will help him progress without too much waste of time or floundering in a sea of frustration, are many. There is so much to find out, so many intertwining paths to follow, so many different approaches to the mystery of creative painting.

Before venturing further into the pages devoted to new and more complicated ways of working, mixed mediums, plastics, etc., it might be well to consider the chart shown on Page 76. With such a guide, planned to fit your working time, it is possible to cover many of the important fundamental subjects systematically and with some hope of making progress. Such a guide, covering the basic essentials of your craft, will enable you to work in a rational manner, much as you would in a well-run art school.

Problems of learning are set up for yourself ahead of time so that after a number of predetermined periods of study you will have covered the required subjects. Consistent work, even if you have only weekends to devote to the paint box will be surprisingly rewarding compared to occasional spurts of enthusiastic painting-bouts every few months.

Assuming then, that you are a part-time painter I offer this "Working Schedule" as a suggested

means for rational study. If you have advanced beyond such things, a similar chart, pitched to a higher standard of accomplishment, would be of value as a means of re-assessing your work or to gain new insights into phases of the craft you may have skipped in earlier years.

The time shown is a minimum, a matter of four hours only per week. This minimum may appear infinitesmal to the enthusiast who paints all day or to the professional whose days and nights are paint-bound for a lifetime. Actually, if you see to it that for a whole year *without fail*, four hard-working and intense hours are devoted to study per week, you will have put in over *two hundred hours* by the end of the year. This adds up to approximately a full four-week course of seven hours daily. Double this, with more time, and you will have spent more than two *full months* painting. A concentrated course of this nature stretched over the year and directed to real study and progress, would compare very favorably with most amateur working plans which consist of dashing off "paintings" by the dozen in a summer spree, and finding that they are much too busy during the rest of the year to do much about it, in a serious and progressive fashion.

Such sessions as those indicated here are not intended to be followed consecutively. There is no reason why, for example, you cannot start with the adventure of color mixing, and then switch to composing sketches in which you explore tonal possibilities in monochromatic schemes. A chart drawn up and pinned on the wall will remind you what ground you have covered and a check mark will prevent too much repetition.

If interest wanes, and you find the disciplines of drawing too much for you, look the list over. Under the heading of *Free Experiment* you will find all the leeway you need to recreate excitement and interest. Here is the place and time to let loose, throw all restrictions overboard and go ahead and have fun—express yourself! A few sessions of splashing and scribbling will do wonders for you— but this activity can get very tiresome too and a changing mood will bring you back to the joys of exploring craftsmanship again.

Such things as charts and organization may seem oddly out of context in a painter's scheme of things. Generally they are—but only because the professional has learned long ago to put in long hours, day after day and year after year, at the hard work of painting, without surcease. It is only the amateur and student who plays at it, and can afford the luxury of painting when he *feels* like it. For him, a chart can do little harm and it might help him along the way to be a better painter.

Ars longa, vita brevis.

Subject	
1 Drawing	Basic forms, perspective experiments, distortion and emphasis; planes and volumes, line and mass using black and white media.
2 Composition	Space-filling of rectangle and square, organized pattern using horizontal and vertical movements, curved forms; linear patterns on picture-plane, experiments with volumes in spatial relationships — space and depth. A simple theme and its development in black and white, in line, and in mass.
3 Tonal Study	Simple experiments in analysing tone values; two, three, five, and six values between black and white. Texture building with various media; pen and ink, charcoal, black and white or umber — monochromatic oil studies.
4 Basic Techniques	Experiments in the use of oil painting techniques. Sketch panels exploring brush strokes, "alla prima," underpainting, and glazing methods. Various approaches to interpretation; the decorative, realistic, semi-abstract, nonobjective. Different grounds and their qualities, use of sable, bristle brush, and palette knife techniques.
5 Free Expression	All out painting sessions during which anything goes. Paint dribbles, splash and dare in black and white, color; experiments with sponge, rollers, knives. Sessions to loosen up as freely as you wish. Imaginative, daring and uninhibited — a therapy treatment if nothing else.
6 Color	Limited and controlled color schemes, charts of color-mixing, experiments with new pigments. Development of drawings and sketches into paintings and panels using two, three, and full-range palettes. Textural and color qualities combined. Studies in color from nature; the well-planned studio canvas developed.

PROGRESSIVE STUDY

Suggested projects

1 Drawings to be made from simple objects to train eye and hand; still life, landscape, and figure; work in charcoal, pencil, and pen, large, free brush drawings on paper in umber and turpentine. Experimental drawings of streets, up and down hill; sketchbook notes.

8 Sessions — 4 hours each

2 Drawings and paintings in black and white with special attention to relationship of line and mass, spacing and composing. Balance, repetition, contrast. Space-filling exercises using Krylon spray, collage; sketchbook studies developed and abstracted into design forms. Still life and landscape notes developed into expressive forms.

8 Sessions — 4 hours each

3 Studies from objects and landscape motifs using controlled tonal patterns. Four flat tones, four textured tones, etc. Line and wash drawings made as studies for later paintings. Translation of colored objects to black, white, and gray compositions.

8 Sessions — 4 hours each

4 A thorough investigation into materials and equipment, trying various surfaces and grounds. Experiment with brush strokes and knife. Sketching on-the-spot; underpainting and development of a picture in the studio. Glazing and retouch varnish. Problems of interpretation; a still life painted realistically, in limited color scheme, then abstracted. Problems of space recession and composition in color.

10 Sessions — 4 hours each

5 Collage and paint; the large free canvas in loose "automatic" brush work, thin and thick paint. Color you have never used before. Don't let it fool you if one of these efforts gets bought or hung; it happened to a three-year old child — and a monkey! But have fun. The excitement of new textures, scrapings, overpaintings, paste-ups.

1 to 10 hours — or as long as you enjoy it

6 Exploring the color palette and its resources. Limited color schemes, trial of pigments new to you; combinations of thin and thick paint, overpainting, and glazing. On-the-spot sketching from nature on small panels to study painting of light. Studio paintings from still life, flowers, figures. The large canvas developed from notes and studies made in drawing and composition sessions.

8 Sessions — 4 hours each

COLOR

EXPLORING COLOR

What makes a great colorist? How much can be taught and how much depends on our natural color sense? Will an understanding of the science of color —the data on light rays and vibrations, cones and rods by the millions sensitive to light behind our eyes—help us to combine colors which move and delight us or those who view our pictures?

Exploring the world of color is one of the many fascinations which brings the amateur painter to the trials of the paint box. What a thrill when he squeezes out the first full palette of clean brilliant hues of oil color! Why then does he get into such a mess when he starts mixing the pure coils of color together? Why do we find him so often ending up in a frustrating smear of nasty green and billious yellows? Is it the lack of an inherent color sensitivity or because he does not know the basic mechanics of color mixing—not the helter-skelter emotional slapping together of pigment, but the cold practical house-painter science of forming new colors from the basic primary hues?

The answer to this is generally "yes"; the fault of the beginner is that he has not the remotest idea of basic color mixing beyond the elementary fact that yellow and blue makes green. Few beginners have taken time to examine the subtle breakdown of color in a rational and disciplined way, thinking that the

carry over of an intuitive color sense will solve such a simple process as that of mixing colors together. As a result, few have begun to tap the gold mine of their own color resources.

When we are faced with a range of prismatic hues we must know their qualities, how they affect each other, what happens when they are applied thinly, thickly or combined with other colors, and in relationship to each other.

If you have an intuitive color-sense—"I just know that orange curtain will look right against the beige"—don't let it deceive you. Unfortunately, such a gift does little for you when you are in front of a freshly-set palette until you know what *pigment* can and cannot do. Having a good ear for melody will not help you to be a violinist until you learn how to hold the instrument and play the scales. *Afterward*—certainly, it will be a splendid asset.

To begin with, then, you must somehow learn to control the intricacies of the oil paint itself and to master the technical possibilities which are waiting to be utilized. Knowing what happens when certain colors are mixed together may not make us great colorists but the chances are that our intuitions and personal worlds of color will emerge more readily if we have taken some time and care to find out what colors are capable of doing for us.

COLOR MIXING

The ability to measure the potentialities of your colors can be increased greatly by painting experiments such as that reproduced opposite. By taking a color, or a pair of colors and breaking them down into their component tones, or combining them in controlled mixtures, we will gain much valuable knowledge which can be incorporated into our work. With patience and a little skill, we will be rewarded with a wide gamut of colors and tones surprisingly varied when we consider the elementary mixtures from which they are derived.

The two colors used here, Cadmium Yellow deep and Cobalt Violet deep, can be combined to make rich browns and warm tints, enlarging your vocabulary of subtle pastel colors. Burnt Sienna and Ultramarine, Viridian and Cadmium Red light and similar pairs of opposites should be tested in this manner.

Test sheets can be painted on 20" x 16" canvas-textured paper which will serve the purpose quite as well as more expensive panels. If you devote some time to preparing a series of pages of this kind, color-mixing will soon become a natural part of your equipment. Pin them up on the wall and memorize them.

Shown at the top of Page 81 are several ways of applying the pigment and how this affects the luminosity of the color, even appearing to *change* the color. The top rows show what happens when color is used with turpentine, in transparent fashion, opaquely out of tube, and when mixed with white. The tonal steps are painted into progressively lighter values by proportionally adding more and more white to the original colored pigment. A mixture of equal amounts is shown in the first row and the steps gradated more or less in equal intervals. The two pure colors or hues are broken down into *steps* in the next two rows.

On the right hand side we have painted a gradated scale from the darkest dark possible to almost white, with all tones merging into each other.

The palette knife section shows the pure color heavily mixed with white.

The bottom row of rectangles provides a chance to experiment with thin stains of glazes applied over a heavy textured underpainting. This was made with a quick-drying Shiva underpainting white. The thick impasto, applied with brush or knife dries in four hours and the glaze is brushed over in a thin transparent veil with a soft sable brush. Use the glazing medium suggested in the appendix, Page 157. Be sure the brush is clean and free from opaque white before attempting a glaze. Try lifting the color off the underpainting or building up several glazes on top of each other in succession as each dries.

The sectional demonstration on Page 31 shows another use of the glaze over underpainting.

SOME PAINTERS' PALETTES

Here is a list of the colors found on the palettes of some famous painters. Note the divergence of number, from the limited classic selection to the much-expanded lists of Cézanne and contemporary painters. Some of the colors are considered today to be of dubious permanence. Emerald green, for example, should not be mixed with the Cadmiums, but should be used alone, and isolated with coats of varnish to prevent blackening. Used as "local color," and alone it has withstood the tests of time in many Cézanne canvases as well as in Utrillo's. Today, also, the Cadmium yellows are considered safer than the more fugitive Chromes. Viridian and Alizarin Crimson in conjunctive mixtures is not recommended by many authorities.

Velasquez' palette is supposed to have consisted of red, yellow, black and white. *Anders Zorn's* first paintings were done in Vermilion, Yellow, Ochre, Ultramarine and White (Fischer, in "The Permanent Palette").

The Munich Society for the Advancement of Rational Painting Technique listed twenty one colors as being a safe list to choose from, while Mayer in the "Artist's Handbook" lists thirty five plus white from which to choose.

Cézanne's palette, according to Earle Loran in "Cézanne's Composition" was listed by Emile Bernard as having the following colors—an extensive, if not chemically compatible, list; Brilliant Yellow, Naples Yellow, Chrome Yellow, Yellow Ochre, Raw Sienna, Vermilion, Red Ochre, Burnt Sienna, Rose Madder, Carmine Lake, Burnt Lake, Emerald Green, Viridian (Chromium Hydroxide) Green Earth, Cobalt Blue, Ultramarine, Prussian Blue, Peach Black, Silver White (Lead White.)

Bernard Lamotte lists his palette as follows; Silver White, Chrome Yellow, Yellow Ochre, Mars Yellow, Vermilion, Burnt Sienna, Red Ochre, Viridian Green, Terre Verte, Cobalt Blue, Cerulean Blue, Ultramarine Blue, Alizarin Crimson, Ivory Black. ("Bernard Lamotte—Oil Painting and Brush Drawing," by Louis Gauthier, Studio Publications Incorporated.)

John F. Carlson startled his students by suggesting the use of Prussian Blue and no other. His list was similar to the Basic Palette I have suggested elsewhere, with the exception of this lack of blues and the addition of Raw Sienna. Mayer considers Prussian Blue to be one of the "border line" colors being destroyed by high temperatures, but "fairly permanent" when used in thin coats and glazes. As this was Carlson's technique, his choice of blue was a considered one, as he felt that the Prussian blue changed less, when seen in a normal inside light on the wall, than the cobalts and ultramarines. Phthalocyanine Blue, a recent development, commonly known as "Thalo" Blue is recommended today as a more permanent replacement of the Prussian Blue.

Marine Painter's Palette. (Frederick Waugh) listed by Fischer. Titanium White (Permalba) Deep Ultramarine, Cerulean Blue (optional) Ivory Black, Raw Sienna, Deep Alizarin Lake, Cadmium Red, (pale) Middle and Orange Cadmium, Viridian. Mixtures of Viridian, or Raw Sienna with Alizarin Lake were avoided.

Utrillo Palette. Listed by him in 1930. "Maurice Utrillo", by Marius Mermillon, Les Editions Braun and Cie. Cobalt Blue, Ultramarine, Vert Emeraude, Chrome Yellow (Pale and Medium), Deep. Vermilion, Rose Madder, Venetian Red, Black, Burnt Sienna, Zinc White.

Contemporary palettes. The listings given by the artists themselves in the section beginning on Page 100 should give the student a cross section of some typical choices from the vast numbers of pigments available to the painter today. See also the notes on Page 149 "What colors on the palette?"

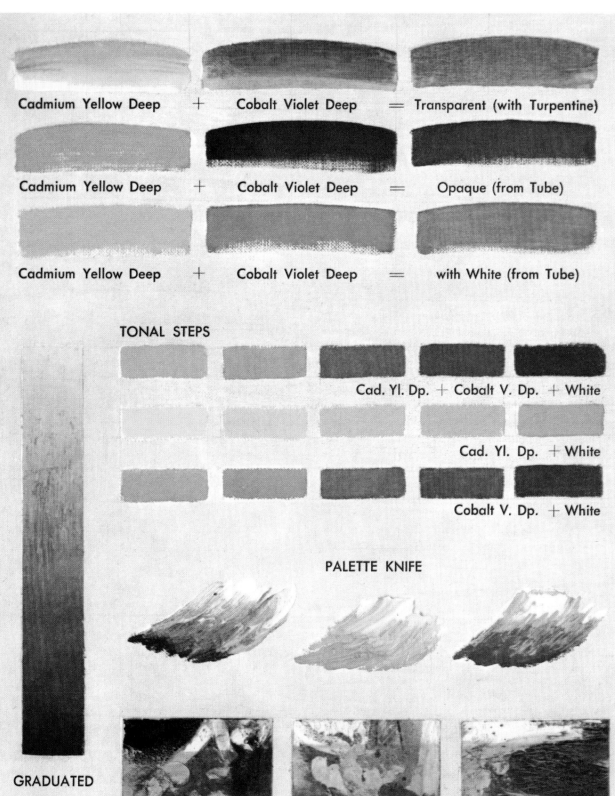

Cadmium Yellow Deep + Cobalt Violet Deep = Transparent (with Turpentine)

Cadmium Yellow Deep + Cobalt Violet Deep = Opaque (from Tube)

Cadmium Yellow Deep + Cobalt Violet Deep = with White (from Tube)

TONAL STEPS

Cad. Yl. Dp. + Cobalt V. Dp. + White

Cad. Yl. Dp. + White

Cobalt V. Dp. + White

PALETTE KNIFE

GRADUATED TONAL SCALE

Glazes over Black and White Textured Underpainting

81

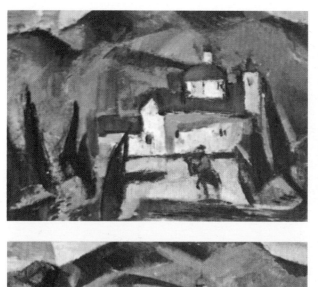

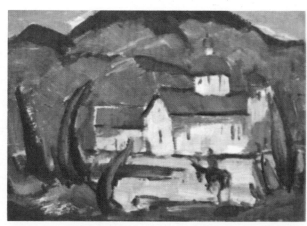

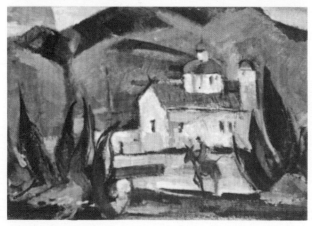

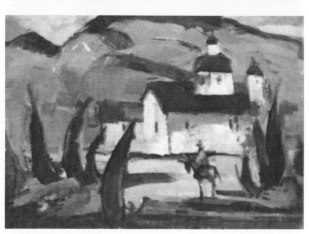

1

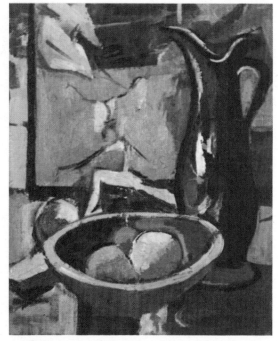

2

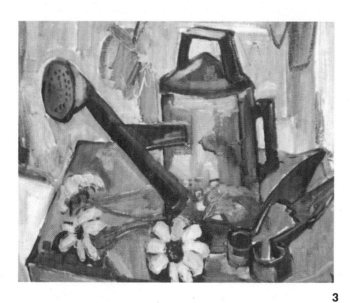

3

1. Limited color schemes—Oil
2 and 3. Color exercise panels—Oil

1 *"Duco" (pyroxylin) on paper*

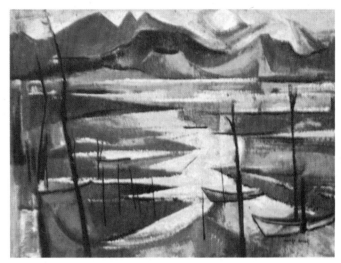

2 *"Duco" (pyroxylin) on Masonite*

3 *Polymer tempera on Masonite*

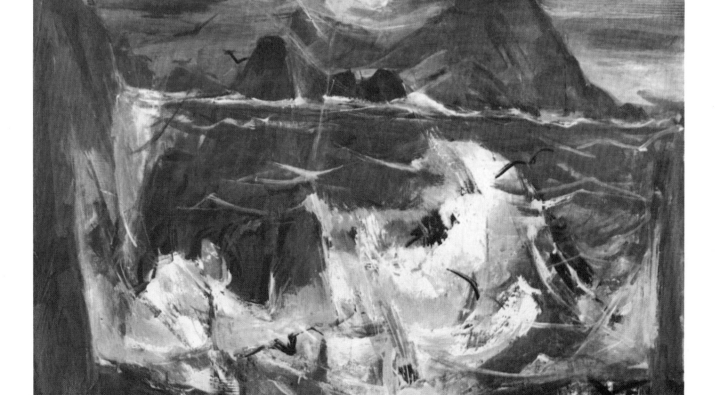

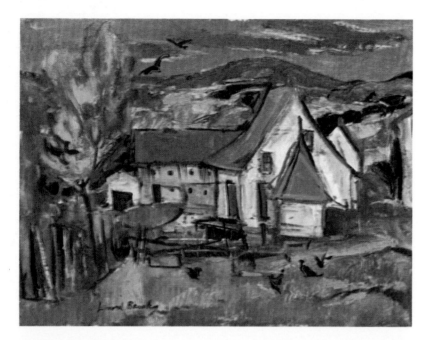

SIX ARTISTS

— SIX VERSIONS

1

Leonard Brooks—Oil

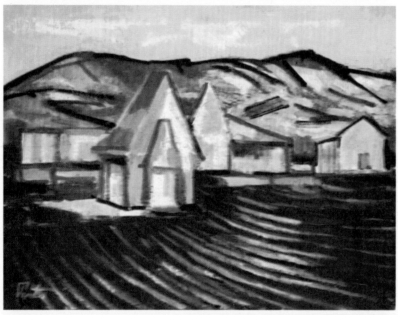

2

James Pinto—Oil

3

Robert Maxwell—Oil

4

Fred Samuelson—Oil

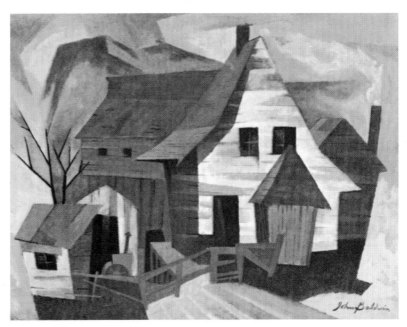

5

John Baldwin—Duco

6

Frederick Taylor—Oil

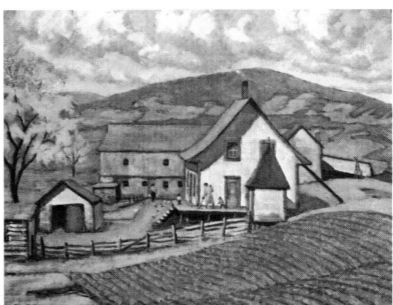

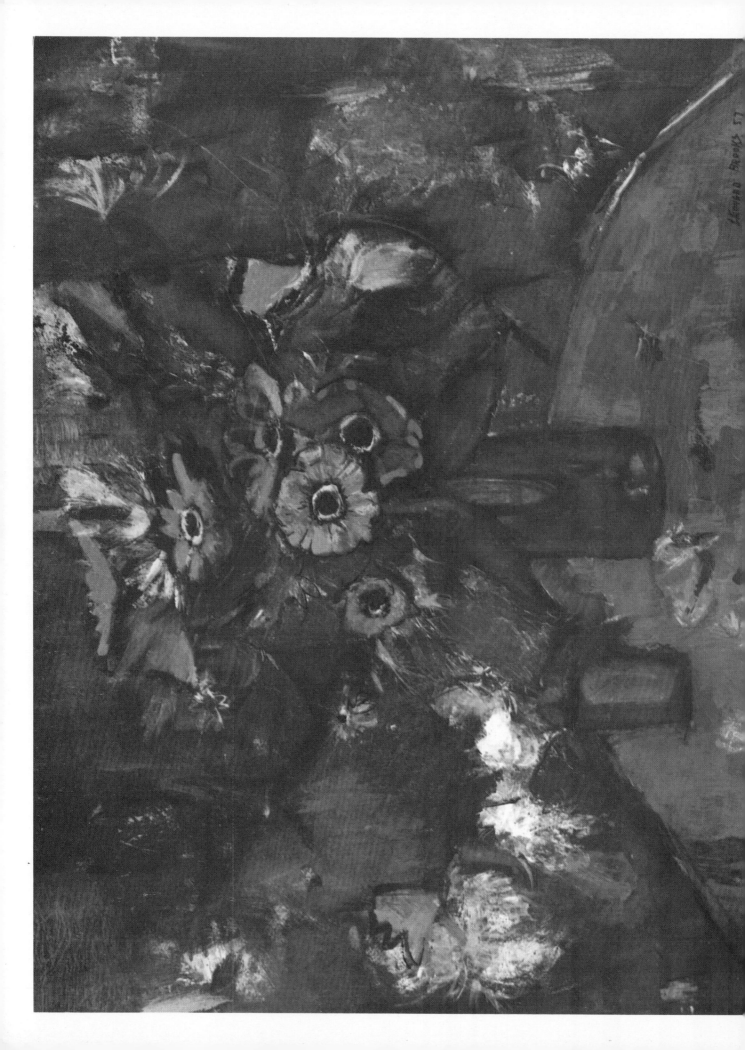

1

4

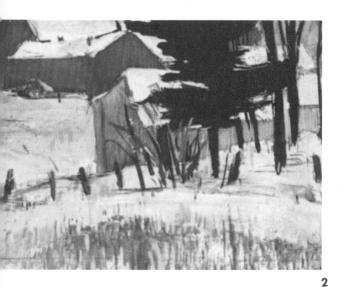

2

5

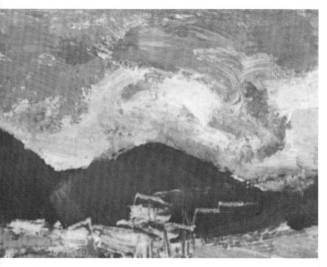

3

6

← *Flower Tapestry*

87

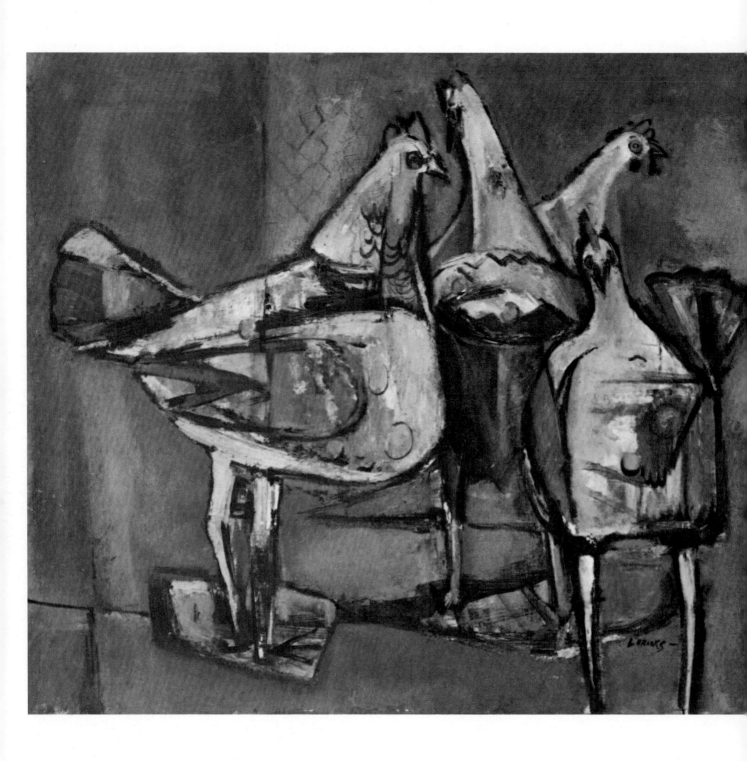

MEXICAN CHICKENS

(Collection Alan Reeve)

An oil painting with a touch of humor. The hens, especially the inquisitive one on the right, pursued me while sketching one day until I made drawings of them. The final version was painted, scraped, and repainted until a unity of color and texture satisfied me. Their design and form is based partly on real chickens and partly on plaster models seen in Mexican pottery markets.

LIMITED COLOR SCHEMES

It is not always necessary to have a full range of colors spread on your palette. By limiting yourself to a combination of two or three colors plus white you can explore some of the countless varieties of mixtures which are possible. If you have taken the trouble to work out a number of test pages similar to that reproduced on the previous page you will be anxious to use some of the information you have gleaned in your pictures.

A useful and practical exercise is shown on Page 82. Here are four small panels each 7" x 10". A simple blocked-out subject from the sketch on Page 18 was chosen and traced on the sketch panel. The large areas were stained in as suggested in the *Basic Technique* exercise. The painting was then carried out directly and simply with brush and painting-knife to add textural interest. The colors used for the four panels are listed below:

Fig. 1. A warm scheme using Raw Umber, Light (or Venetian) Red, Yellow Ochre and white.

Fig. 2. Manganese Blue, Viridian Green, black and white.

Fig. 3. Two opposite or complementary colors used here, the same pair as that shown in the color-test page. Orange and Cobalt Violet deep, plus white.

Fig. 4. Painted with the primary colors—a brilliant Cadmium Red, a Medium Yellow and a Cobalt Blue deep, plus white.

Observe how the hues — the pure orange, for example — has been reduced in intensity by the addition of white, making the tonal value *lighter*. Notice how, by the addition of the pure hue of violet to the pure hue of orange, the tone has become *darker*. Combining white and various additions of these two colors will give us innumerable variations in the scale of light and dark values, plus a change in the hue or color itself.

Fig. 5. An 11" x 14" panel adding ivory black to the palette to give the ultimate contrast between the dark jug and yellow fruit. As a general practice avoid black in mixing grays. More lively and subtle grays come from mixtures of opposites, such as Viridian and Rose Madder.

Fig. 6. Another simple subject for color exercise: 20" x 16" panel painted with a warm palette of Umbers, Siennas, greens, blues, yellows, and no reds.

Remember that in doing exercises of this kind, you are learning how to combine and control color mixing. These studies are the finger exercises which must become automatic when you really start to play. Creating a picture or "self-expression" is a secondary concern at this moment.

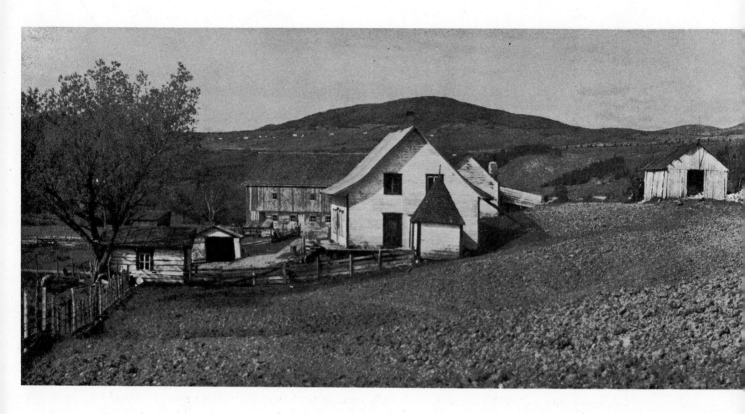

SIX ARTISTS — SIX VERSIONS

The subject was a simple one chosen particularly for its purpose. A white house with red roof, a barn, ploughed field and distant hills. It was chosen from a number of photographs made in rural Quebec.

With the cooperation of six artists, the photograph was used as a basis for six sketches to be done in color. The artists were asked to interpret it in any way they wished, using the elements in the photograph as a starting point.

If it had been possible to have the six painters on the same spot at the same time, something similar to the reproductions shown here would have resulted. Each has taken from the photograph elements of design which appealed to him. Within the limitations of the black and white source, they invented a color scheme ranging from the more accurate colors of a spring day to the restricted choice of a few related warm colors. Some have stressed the design element, retaining only the main structural line and "tidying up" the accidental contours of land and mountains. Others have used the photograph as a suggestion for the rich interplay of broken color and dramatic light and dark interpretation.

These sketches were made to show some of the countless ways open to you when you face your subject. Will you choose the close up view, concentrate on the group of buildings or throw the composition wide, taking in the whole vista? Do the clumps of earth in the foreground attract you with warm repetitions of color areas or will you begin your picture with the foreground eleminated? Does the intrinsic color entice you to use it as it is, or do you feel that a much stronger statement can be made by choosing an arbitrary scheme and limiting yourself to it? Do you want sky included or not?

Do the accents of the windows and doors seem too spotty, do they need added variations to give them interest? Would you paint it with more detail, forcing each texture of faded white wood and shingled roof to its ultimate, using a fine brush and numerous overpaintings to achieve the effect?

On the next page you will find six color versions of the photograph shown opposite.

The Maxwell sketch takes the forms more or less as they are and increases the tonal contrasts for added dramatic qualities. Lights and darks are played against each other much more than in the photograph.

The Samuelson painting extracts the main movements of horizontal and vertical planes and sets them to play against each other, disregarding actual perspective. The flatness of the picture plane is accentuated and space re-created on the canvas. His color has been limited to a warm play of yellows and orange, with little reference to a spring day.

Pinto takes a section of farm and mountain and sets them against a strong dark foreground which has been flattened out with diagonal lines. He has chosen only a part of the panorama, concentrating on a few of the white barns in the middle distance.

The Baldwin painting interlocks form against form, changing the shapes of the house and fence, road and tree, to fit his conception of space filling and design. His color is richly textured by over-painting with layers of Duco.

The Taylor painting is done with subtle deviations from the subject, setting the color mood to a preconceived scheme of spring light and clear northern air.

The Brooks sketch is a loose, direct oil, painted with much pleasure in between pecking at the typewriter to put down these words. It tries to keep a free and lively brush work consistent and alive with gay color.

All of these painters have more serious examples of their work in the section devoted to *Nineteen Painters and Their Work* beginning on Page 101, and their comments there should prove enlightening.

Having seen what the six have done with the photograph, why not try the subject yourself? It might be revealing, too, to jot down on a piece of paper, *your* comments about your work. What are you trying to say in paint, what are your ideas and aims, in brief? What choice will you make when you pick up the paint brush and face the canvas?

Here are several versions you might consider.

The free direct approach: loose, broad, thickly impastoed, with color based on the actual scene—a warm spring day.

The super-real: a tight, classic rendering; surfaces carried to the ultimate perfection of smooth modelling, tonal passages pushed to the limit of accuracy, light and dark in the "old-master" technique.

The flat and decorative: simplified areas, collage-like with spaces set poster fashion against each other, all detail eliminated. A very restricted color mood, perhaps a few greens and grays, a touch of orange, and a white or two.

The Impressionist style: concern here with broken touches of color based on the moment of nature you wish to interpret. Textures painted to give the utmost illusion of light and air surrounding all objects. No hard lines or accents. Translucent sky, vibration of color to give the feeling of the light and air of a Spring day.

A FORM OF CAMOUFLAGE

Many are the techniques which the modern artist may bring to his work to give it freshness and liveliness. Freedom from the tyranny of the exact reportorial eye has allowed him to create new sensations of visual pleasure by the manipulations of space, superimposed planes, movement and orchestrations of lines and masses on the picture surface, the use of the "double image."

As we assemble the shapes and forms of our subject on the flat surface, reducing three-dimensional objects to two-dimensional, new relationships are created. Not only the shape of the object itself— and its outline or boundaries—becomes a newly created form, but the shapes around and outside the object set up new tensions and interlockings. Sometimes nature herself does this and the alchemy of light and shade suggests the composition for us. For a number of years now, I have been fascinated by the changing passages of light moving across the landscape, or along the walls of streets and buildings, uniting or breaking the shapes of things into new configurations of form and color. Areas of brilliant light filtered across a number of surfaces in depth, contrasting with darkly accented shadow forms can change the most humdrum and obvious subject into an exciting theme worthy of a large canvas.

The painting shown here was done over a period of two years. The initial on-the-spot sketch is shown in Figure 1. It was jotted down early one morning in a remote Mexican village as the sun poured over the mountains and down the steep cobbled street.

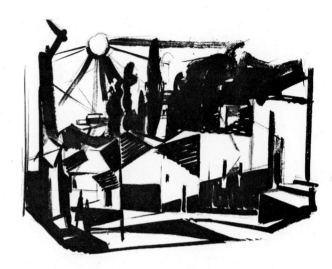

Some months later it was redrawn many times, simplified to main areas of black and white. Figure 2 shows the kind of analysis which preceded the picture. The pattern of integrated light and dark masses was then transferred to a large canvas and the forms then constructed and allowed to grow, changing as the picture demanded its own solutions. An attempt was made to keep every part functioning, that is, lights leading through passages of middle tones to other lights, or darks leading the eye to wander over the canvas from point to point with every inch enriched with fine color and textures.

Large canvases of this kind cannot be dashed off in an hour or two. Sometimes it *can* happen that everything falls into place and the painting will be complete in several sessions. Generally I suspect such paintings, and looking at them a second time, know that more work would probably improve them. It is just not possible to get the quality of surface, the control of all parts the subduing of detail or the textural enrichments without much hard work and building up of the surface with overpaintings and glazes.

The difficult thing, in large pictures of this kind, is to preserve the original idea which inspired the painting in the first place, and yet bring about its full development.

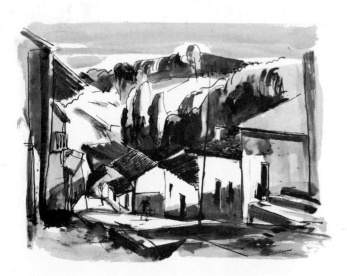

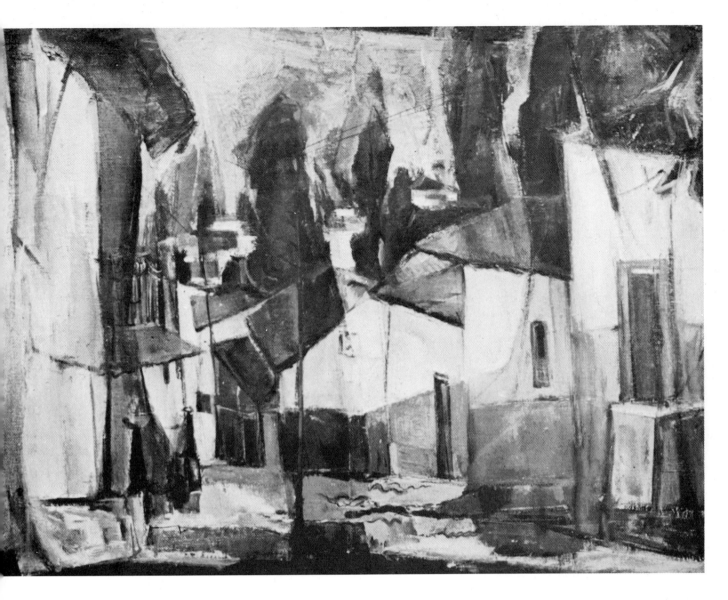

MORNING—EL ORO

OIL 34" x 46"

The practical application of combinations of form and color creating new relationships is inherent in nature—birds, zebras, insects. Have you seen a warship disguised as a wave pattern? The Mexican clown has taken full advantage of the theory, losing the sad little mouth in the new pattern imposed on his face to provide the traditional, eternal smile of the buffoon.

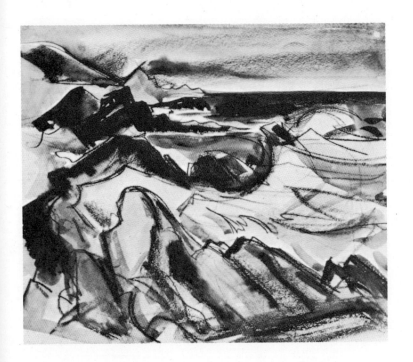

SEA AND ROCKS (Page 83)
Collection Mrs. Wm. B. Pringle Jr.

The polymer tempera painting shown in color on Page 85 was painted in the studio from rough drawings made on the spot. A soft crayon and wash technique was used to try and catch the strong moving forms of waves smashing against the rocks. In such drawings put down only the big lines, the main curves and rhythms needed to convey with impact the feeling of the sea.

Often, if you have let yourself go and have been carried away by the beauty of such a moment, you will, somehow catch a fragment of the moment with even the roughest lines and scrawls. The very crudity of the drawing, made under flying spray and wind will sometimes imprison a touch of salt air in it.

How to develop such a drawing, completing it in color in oil or with a new medium is one of the difficulties facing the artist. How to finish it without "finishing it off" and killing the inspired moment?

FISHING VILLAGE AND PATZCUARO
(Page 83)
Collection Mr. Robert Korner

Two Duco paintings done in a warm scheme using reds, blacks, and earth colors only. The vertical panel was done on heavy paper which was first coated with thin clear lacquer. The other was painted with thick textures on Masonite.

WEED BOUQUET (Page 2) Frontispiece

This was painted with yellows, blacks, and whites in Duco on a primed Masonite panel. It was built up with granulated textures and the final touches loosely painted with a small brush and controlled "dripped" threads of black lines. The small white daisies were stencilled on, using a cut-out cardboard stencil and a spray gun.

FLOWER TAPESTRY (Page 86)

A polymer tempera painting made with dry powdered pigments and polymer emulsion on Masonite. An effort to use rich broken textures of warm hues and low-keyed dark background to suggest flower forms and colors rather than realistic details of a botanical nature.

Actual-size details from Paintings and Sketches. (Page 87)

1. Direct thin painting on thick shellacked cardboard. Foliage suggestion painted with knife smudges into wet gray sky. Note how the gray has been made with broken touches of pink and green-blue brush strokes. This is done by not overmixing the colors on the palette but by letting them "break" on the sketch panel.

2. Here the detailed handling of barns and trees on a small wooden panel called for thin painting with pointed and square sable brushes. A mixture of underpainting white and Flake white produced a semi-mat surface which dried quickly allowing finer detail to be drawn over the snow areas.

3. Section of a 12" x 16" sketch panel showing the broader brush work typical of a spot sketch from nature. Painted with hog-hair brushes on a smooth white-lead coated fibre panel. Note broken touches of color in the warm-tinted cloud areas and thick modelling of the direct brush strokes.

4. A combination of brush and painting-knife technique. This detail is taken from a large market sketch. The use of the knife to touch in pure colorful notes over the brushed in areas is useful to enliven overworked or dead passages.

5. Thin transparent washes of oil color on a white cotton canvas panel. Rich color can be achieved in this way. No underpainting or heavy texture was used but a stained transparent effect maintained throughout. This technique was used in the large painting of fruit and bowl shown on page 42. Dilute the oil colors with a half and half turpentine and linseed mixture, or try the glazing medium suggested in the Appendix.

6. Oil paint on a thick paper which has been sprayed with a fixative first. This is a useful way of making quick studies and for experimentation. Dry-brush (dragged strokes of paint letting the white of the paper come through), then heavier impastos of paint over the thin black underpainting; scraping with knife through the wet paint, staining and smudging; here is a free technique much exploited by the contemporary "abstract expressionists." Related to watercolor painting, it makes much use of the "controlled accident."

WINTER SKETCHING

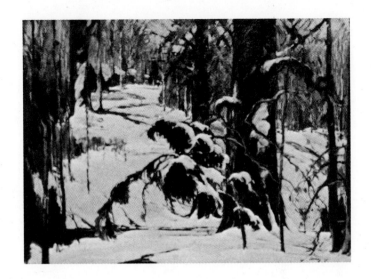

Working in the open has certain compensations as well as drawbacks, summer or winter. At the moment it is slightly out of fashion to do so, though a good dose of such work and study would not do any harm to most students who set themselves up to "interpret" nature and natural phenomena after a casual glance now and then at the subject matter they are going to "abstract." Certainly it is in the great tradition of painting to make studies and paintings from the vast store of subjects out of doors. The dangers, of course, of being carried away by the literal content of a specific "scene" are always present, but no real artist has ever let this deter him from trying to catch, from time to time, the "little sensation" which inspired masters like Cézanne to their daily round of sketching from nature.

The problem is, as always, how to search out the pictorial essence and deeper meaning of the facts before the eyes. The timid soul will flounder in front of the countless details, the changing light, and the cataloging of literal fact will overcome whatever personal viewpoint and vitality he may have. It takes considerable training for the student to learn how to cut through the minutiae of detail to the meaningful heart of his subject. This ability to dominate in terms of design, color, drawing, and over-all conception is not easily acquired and is only gained after assiduous practice.

Working in the open, with all the distractions of weather, onlookers, and changing light, will help you to sum up rapidly what you have to say and to put it down without too much fussing or indecision. In frigid weather there is no time to hesitate.

To work! And perhaps some life and spirit will emerge in the rapid brush strokes which will capture the exhilarating moment. Time enough to worry about the "right approach" or precious esthetic formulae when we are back in the studio.

Most of the winter sketches shown here were done on the spot. They range from small "pochade" birch panels of 8″ x 10″ to large canvases up to 40″ x 50″.

A few tips on winter sketching

A drop of benzine (coal oil) mixed with white paint will stop the pigment from stiffening in very cold weather. And setting the colors out on the palette before venturing outside saves time and chilled hands later. Don't worry if the snow falls on the panel. It will melt and leave the oil paint undisturbed when brought inside.

Be sure to take a canvas-carrier or protective device for the large panel or canvas. I have had tree branches whip across my painting as I walked back to my car; I have slipped and seen the canvas fly out of my hands and smear itself across treacherous ice or snow patches.

Don't try to paint too large in the winter until you feel yourself capable of working quickly and surely. The sketch shown above was made on a small 12″ x 16″ panel. Using medium-sized brushes, a panel of this kind can be completed often within an hour's concentrated work.

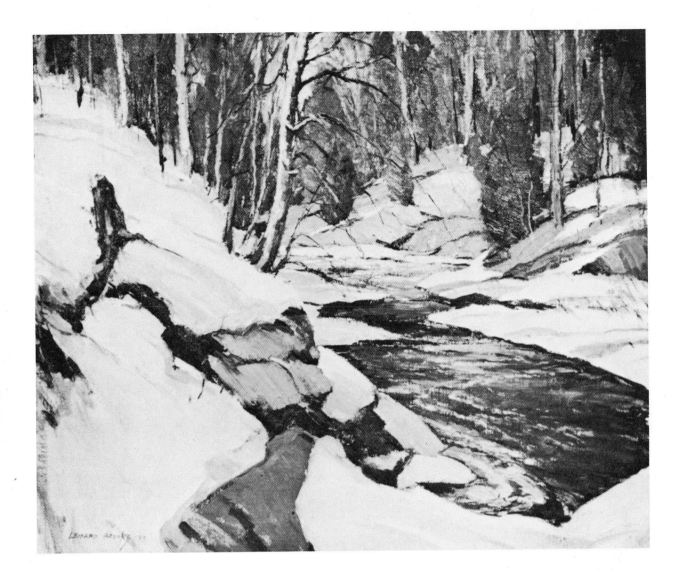

WINTER RIVER

Collection—Art Museum, London, Ontario

Shown above is a straightforward transcription painted from nature some twenty years ago. Such paintings often have a charm of their own, an appealing surface of direct brush work, a feeling of "moment caught" which studio paintings often lack. Frankly descriptive and without the enrichments of a more thoughtful development of the theme, they are not as easy to produce as they may appear.

How to add to this naive and simple approach, retaining enthusiasm and zest while progressing into more significant interpretation, has turned many a painter's hair gray.

YELLOW HOUSE

The painting on page 98, a 40" × 50" canvas in oil, was an early attempt to paint within a restricted tonal range of whites, grays, ochres, and yellows. A 12" x 16" sketch panel was used as the source material and the canvas was developed in the studio, building the textures with palette knife and a thick impasto of white. When these areas were dry, thin glazes of broken color were brushed over the paint to give vibrancy of color. Careful attention was paid to the edges of trees against the sky as well as the weed forms in the immediate foreground.

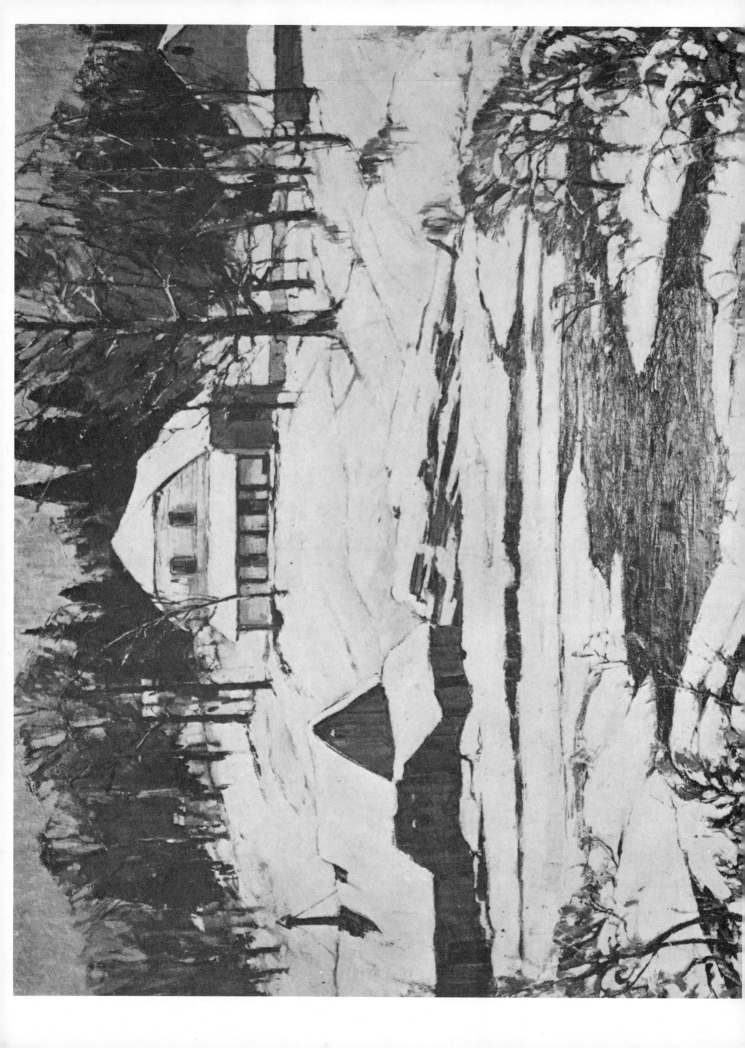

NINETEEN ARTISTS, Their Work and Comments

Through the following 28 pages are reproductions of paintings by a number of different artists from Canada, the United States, and Mexico. Through their kindness I am able to include their comments and thoughts about *what* painting means to them as well as notes on personal preferences of technique and style. All of them have contributed examples of paintings which may help you—the student—to see and understand the many ways of working open to you. It is unfortunate that they are not in color for much of their quality is lost in the translation to black and white.

Included in the list are successful practitioners of the brush, professionals who are highly successful in the field of creative painting, from broad free canvases to the careful delineations of the figure and portrait painter. All of them are interested in skillful craftsmanship and technique, drawing, and the use of visual matter as a starting point for interpretation. I have made no effort to include examples of paintings where any form of discipline or skill is considered a menace, or where the ego is expressed only with a "splash and a smear."

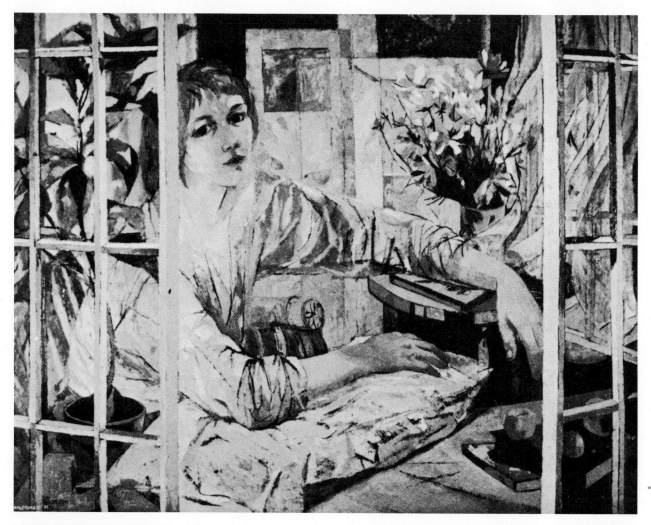

OPEN WINDOW. Oil, 36" x 49"

Painted on gessoed Masonite which was sized with a thinned out (with turpentine) Damar varnish underpainting. The painting medium was one-third *Damar varnish, one-third linseed oil, and one-third turpentine. The picture was varnished, six months after drying, with Damar varnish.*

Ghitta Caiserman

Artist's comment:

The feeling I wished to paint is that of "opening outward," a kind of flowering. The idea was to have the painting permeated with light, golden in feeling and color.

The color scheme moves from grayed whites and Naples Yellow in back, through a transitional center that is deeper in color, to the pure white and Cadmium Yellow of the outflung window in the front of the picture space.

Generally, the yellows—Chrome, Cadmium, Citron Naples and Cadmium Oranges and Ochres—are played against the grayed greens and mauve and whites, with the occasional clear note of a small area of Vermilion or bright pink. The picture is developed rather tentatively with a moderate use of underpainting, glazing, and scumbling. The underpainting is a loose, thin color arrangement intended as counterplay (shape and colorwise) to later developments. Textures are not built up arbitrarily but rather as the developing logic of the painting demands.

It seems to me that "the how and what" of painting are completely interlocked. To deny the rich associative experiences of the objective world and the role of the conscious would be just as exclusive as trying to deny the role of chance, or mystery of the intensely subjective. The heart doesn't exclude the brain.

For me, one of the many possible functions of painting today is in the enlargement or extension of the horizon of reality, sensuously, formally, and emotionally.

NINETEEN ARTISTS, Their Work and Comments

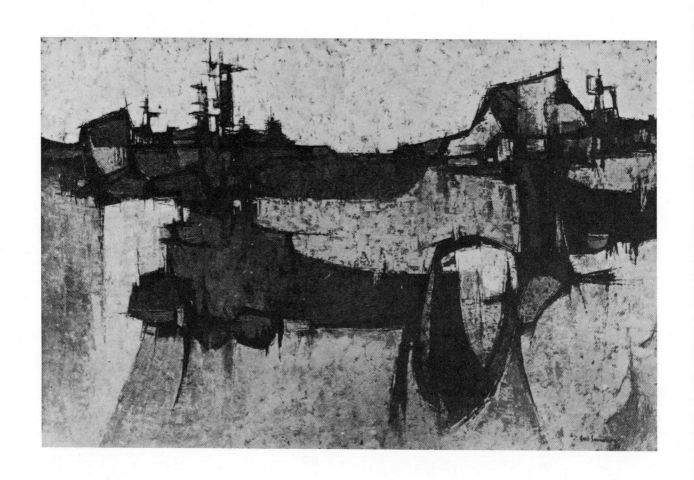

STRANGE COAST. *Oil on canvas, 30" x 46"*

Oil on canvas laid in with thin transparent washes first. All textures and final painting were built up in direct impasto with palette knife only, no brushwork or glazes used.

DESERT FORTRESS. *Oil on canvas, 18" x 48"*
(Collection Sr. Ernesto Javelly, Jr.) (Page 101)

Oil on canvas using a combined brush and palette knife technique. Medium used is a mixture of stand oil, Damar, and turpentine, one-third of each.
Palette
 Cadmium Red Light, Alizarin Crimson,
 Ultramarine, Cobalt Blue,
 Viridian
 Yellow Ochre, Burnt Sienna, Raw and Burnt
 Umber, Black
 White, underpainting white at times; prefer a
 Titanium and Zinc mixture for the regular
 white.

Clare Bice

Artist's comment:

In this painting, as in most of my recent work, I have been more interested in suggestion rather than in literal representation, because I believe it is possible to make a much more interesting and effective statement by *suggesting* weather, buildings, movement, etc., than by describing them too plainly.

In technique, I think one can obtain most of the pleasurable qualities of non-figurative painting and still keep the added interest of subject matter. I'm interested in paint quality and exciting surface texture with lively use of paint for the sake of rich color and movement—a sort of tone and color counterpoint, purely apart from what the paint represents.

Bice, Curator of the Art Gallery and Museum, London, Ontario, gives the following palette which he generally uses.

Titanium and MG. White
Cadmium Yellow Pale
Mars Yellow
Vermillion
Rose Madder
Light Red
Raw Sienna
Viridian

Opaque Oxide of
 Chromium
Ultramarine Blue
Cobalt
Cerulean
Cobalt Green
Raw Umber
Black

Medium: 2 parts linseed oil
 1 part Damar varnish
 4 or 5 parts turpentine

ST. IVES RAINSWEPT . Oil on Masonite, 30" x 40"

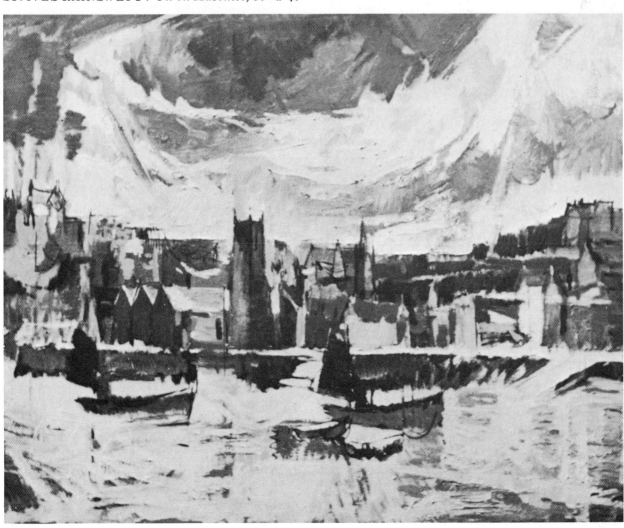

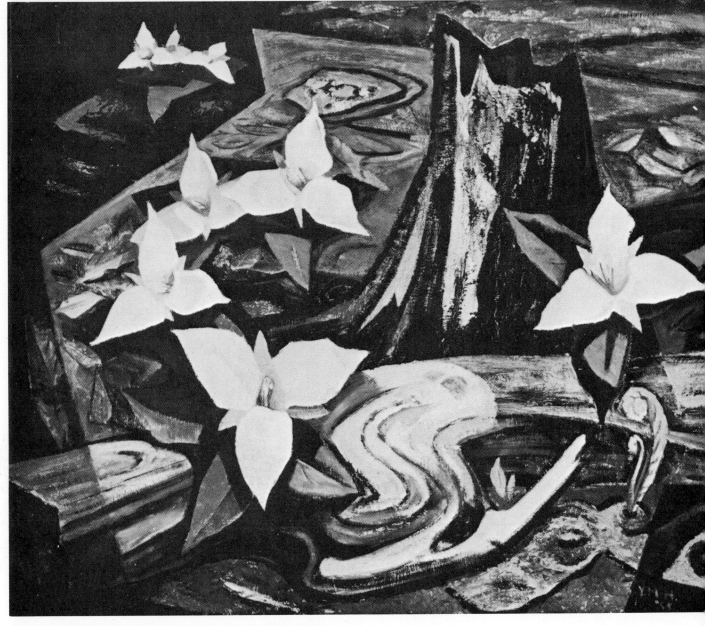

SPRING PATTERN . Oil on canvas, 40" x 30"

Yvonne McKague Housser

Artist's comment:

My general aim is to try to translate into paint the exciting visual experience. The word visual includes the emotional and intellectual excitement that has been stimulated by one of those "alive" moments when even an ordinary subject becomes something vivid and new. After this moment of awareness comes the problems of composition, quality, and movement of color—problems which are in themselves challenging and of interest. Always my hope is that something of the original idea and impetus will live through the travail of birth. The pattern of the ground in spring is rich in texture of earth, old wood, lichens, and forms a background foil for the startling whiteness of the trilliums so typical of the Canadian woods. I hoped in this picture to put down my pleasure experienced while walking in the woods in spring, avoiding at the same time a soft and sentimental rendering, by the use of an integrated pattern of locked planes and diverse textures. Palette; Cerulean Blue, Raw Sienna, Cadmium Yellow Medium, Viridian, Brown Madder, Ultramarine Blue, Alizarin Crimson, Cadmium Orange. Sometimes I make a ground using Kemtone, (water-based) mixing one whole egg plus an egg shell full of best linseed oil. These two ingredients are beaten slowly into the Kemtone. If the ground seems too absorbent, I rub over a thin film of Damar varnish thinned with turpentine before painting.

Cleeve Horne

Artist's comment:

Everything in life seems to present a challenge. Expression through the art of painting is a great challenge. To me, portraiture is the greatest challenge, simply because there is an added hazard to the "free" painters' basic concept of art content. In other words, add the characterization of an individual to the esthetics of good painting *and* keep both within the realm of a commissioned portrait and there beginneth a challenge of considerable

magnitude. Too many so-called portrait painters depend upon the visual hypnotic value of the character of the subject—often an important public or world figure—to shield their lack of ability as a true painter. Straight portraiture as such requires no other talent than the full facility to mechanically reproduce the "sitter," but to pull the painting out of the proverbial "fire" by maintaining your own personality and integrity as a painter is a most difficult and intriguing task in itself. To make it work as a painting over and above the subject is, perhaps, my basic aim.

The portrait of Bob was painted with the palette knife, for it semed to be more sympathetic than the brush for what I wanted to say of my sitter . . . an expression of revelation, a touseled young man with five whole years of experience behind him gazing out upon the mysteries of the old world around him.

Generally I try to cut the number of sittings to a minimum—four to six. I don't remember particularly what happened in Bob's case, but I doubt whether I had longer than an afternoon.

As with most things of this size, I often begin with a very suggestive brush and color wash drawing (thinned with turpentine) which is later sealed with a light coat of retouch varnish. Then the fun begins, using an average size painting knife and drawing and painting directly with the paint, using no medium.

There are many variations to this approach.

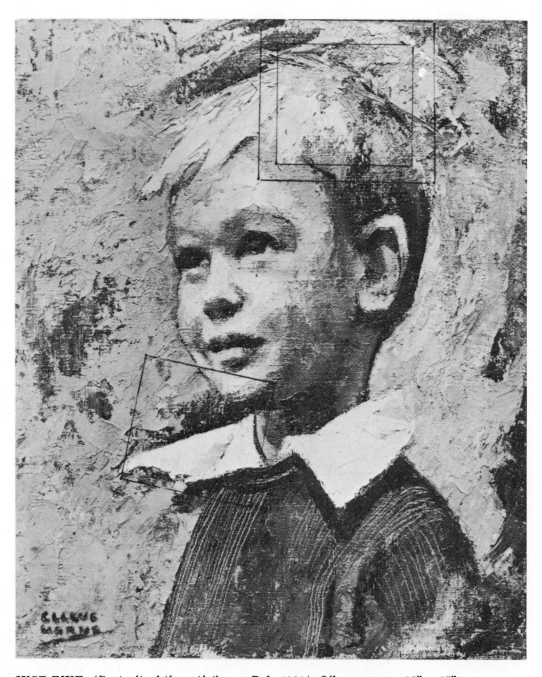

JUST FIVE (Portrait of the artist's son Bob, 1949). Oil on canvas, 18" x 15"

Often a new commission suggests a new attack. Sometimes I may make a drawing first, or begin directly with charcoal or brush on the unstretched canvas. I may complete the painting with thin washes or use heavy impasto with brush or knife. The intriguing part is that I honestly do not know what character of paint quality will develop until the second or third sitting, although I must admit that this freedom does not eliminate the strict discipline imposed by the medium.

I have experimented with the new mediums and enjoy doing so, but inevitably return to oil. My basic palette during the last few years is very simple: Zinc Yellow, Yellow Ochre, Venetian Red, Vermilion, French Ultramarine, Flake White #2, and Ivory Black.

Albert Jacques Franck

Artist's comment:

A 12″ x 16″ study of old houses in Toronto which provided plenty of opportunity for textural qualities.

It was painted on a Masonite board which was prepared with a ground of Alkyd flat white with whitening added for absorbency. The stucco houses were underpainted and pretextured with pumice powder and Titanium white. Some brush work was used as well as palette knife on roofs and foreground. When dry, the walls were glazed with thin color and then sprayed with an intermediate varnish of polyvinyl acetate in alcohol (Gelva 15).

The medium used was two parts of "Lucite" 44, 1 part stand oil, turpentine added to the consistency desired. A final varnish of "Lucite" 44, diluted in turpentine was brushed over the painting when completed.

LATE AFTERNOON, SCOLLARD STREET

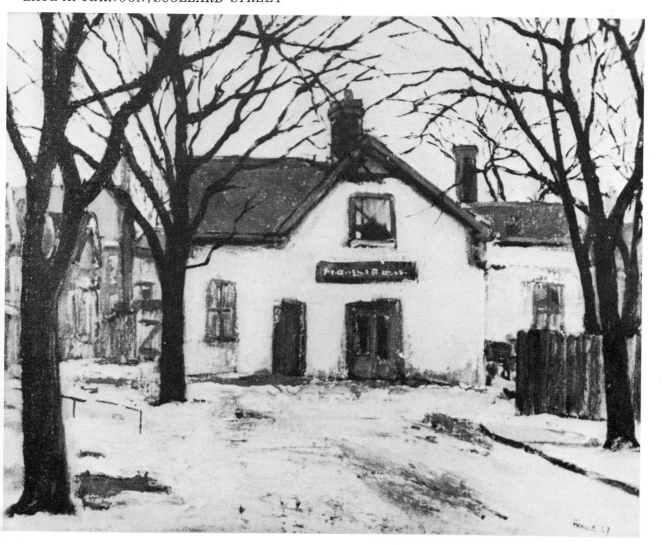

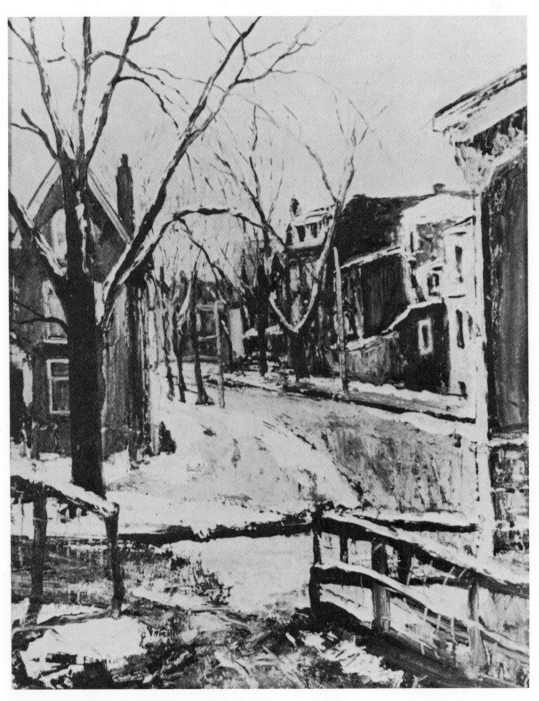

WEBSTER AND HAZELTON. Oil, 20" x 16"

Basic information as above. The underpainting was put in with black and Burnt Umber. The intermediate varnish dries overnight for further painting with strong accents of high values and knife-technique textures. A tonal picture with gray-blue pervading light. The foreground strongly stated, the tree pattern understated for more suggestion of space.

Palette. All earth colors, black and white.

Ultramarine Blue.

Cadmiums are used only where corresponding local color is required.

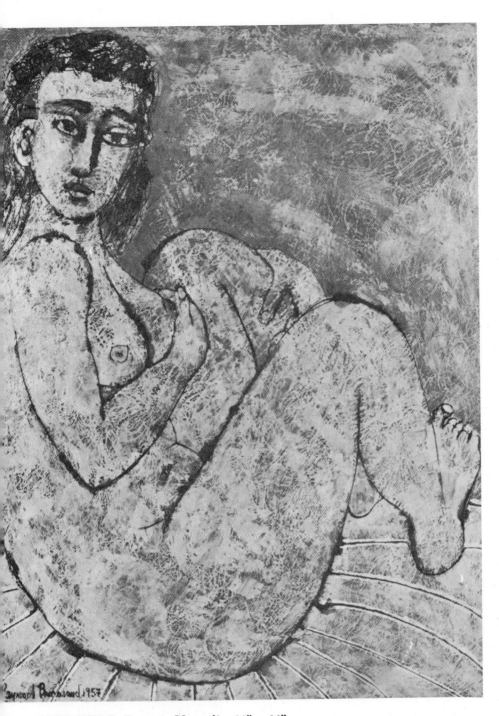

Raymond Brossard

BLUE NUDE. *Duco on Masonite, 28" x 36"*

Artist's comment:

The painting is in pyroxylin on Masonite (tempered) and was painted on the board *without* a prepared ground, although this might be misleading. I usually prepare a Masonite panel by brushing and dripping lacquer on it in such a way as to make an interesting and imaginative surface to work on. Indeed, sometimes the backgrounds themselves might suggest the painting. In this case, however, I had a sketch of a nude which I thought would make an exciting composition; to curl up the figure, so to speak, life-size in an area 2¼ by 3 feet. Having a pale mottled surface to work on, I drew the figure in first and then painted the flat areas thinly afterward. I wanted to get the feeling of a pen and wash drawing so that here and there the lacquer lines would blur and bleed. Above all I wanted to get the feeling of texture that had movement, while apparently flat. The colors vary slightly with the painting mainly in three shades of blue.

Sydney H. Watson

Mr. Watson is Principal of the Ontario College of Art, Toronto. He has recently completed murals in the Imperial Oil Building, Toronto, and in the chapel of the Toronto General Hospital.

Artist's comment:

I attempt in my painting to arrange material in an orderly and concise manner, treating my subjects broadly and simply, relying on details or texture to create added interest where I feel it necessary. My approach to building a picture is somewhat architectural, whether the subjects be still life, figure or architecture. I use a limited palette, and fall, I think, into the category of a tonalist rather than a colorist. My pictures do not attempt to make any social or moral comment. I paint the things I love—not the things I dislike.

Painted on a glue-sized raw linen ground, mounted on plywood.

Palette used: Burnt Sienna, Raw Umber, Prussian Blue, Lemon Yellow, Rose Madder, Yellow Ochre, Ivory Black, Flake White.

CITY, BACK ELEVATION. Collection Hart House, Toronto. Oil on canvas, 25" x 35"

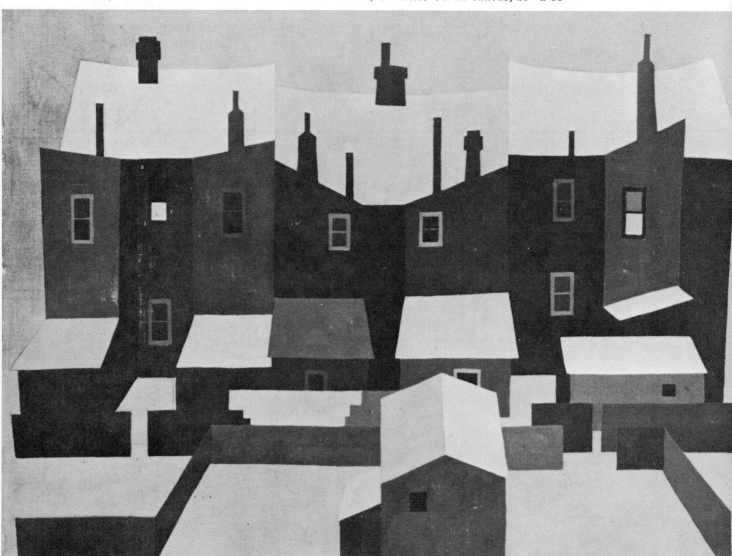

Artist's comment:

I find the task of writing about my ideas and aim in painting very difficult, since to do this, one has to detach oneself from his true personality—that of a painter—to express oneself in the unfamiliar world of words.

There are many approaches to painting. Mine is fundamentally emotional, following an experience and continuous engagement with problems of execution of ideas in painterly terms.

Like so many painters before me, I look to nature to keep my creative impulses alive, trying to express my feelings about it in terms of paint and in terms of my own personality. Since painting is an organized attempt to express ideas about things, it has, like any other organized form of expression, problems particular to this expression; space, form, design, etc. To achieve a working control over these and to gain complete dominance of paint over subject matter in expressing my ideas—in paint—is my goal.

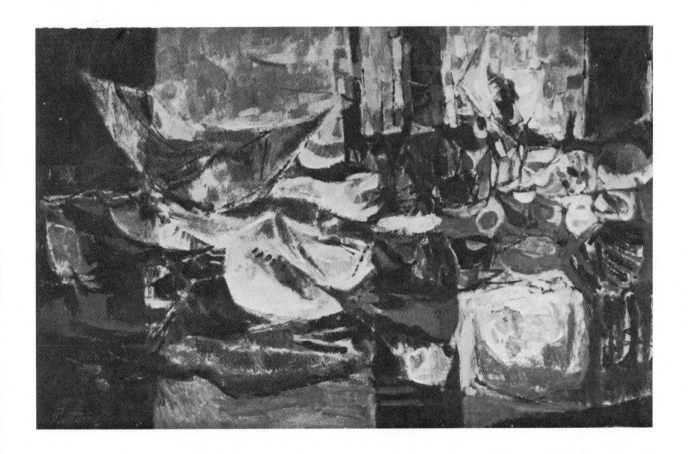

STILL LIFE, NUMBER 2. Duco, 30" x 40"

A full palette of Duco colors used here with thin glazes built up over each other in rich passages of color. The pyroxylin technique allows the retention of pure hues and the colors retain their identity with much less chance of "muddy" color than in oil painting. I also like the drying qualities which allow a rapid building up of the painting from textures to glazes and thin overpainting of lines and details.

THE WITNESS

Duco on Masonite, 24" x 36"

Underpainted in heavy textures using white and warm neutral tones. Darks built over this thinly with glazes. A limited palette scheme was used, mostly green, ochre, black and white.

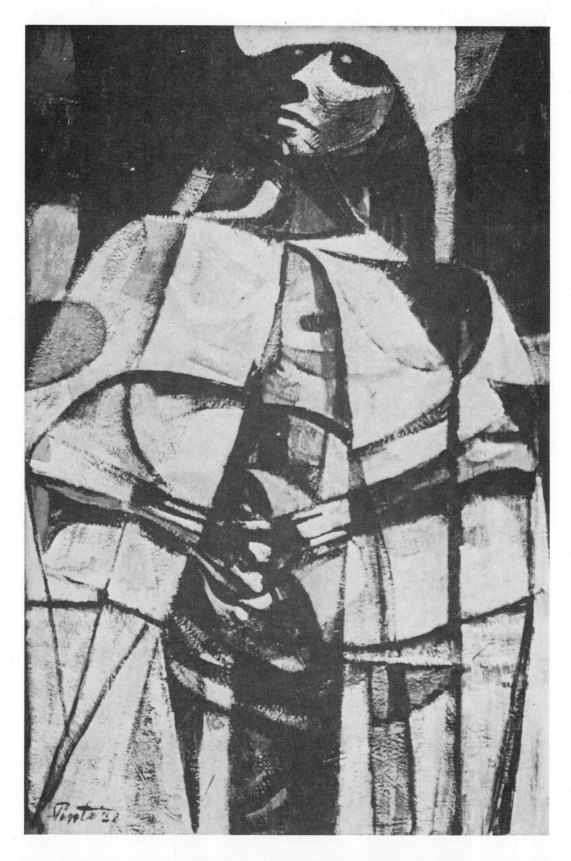

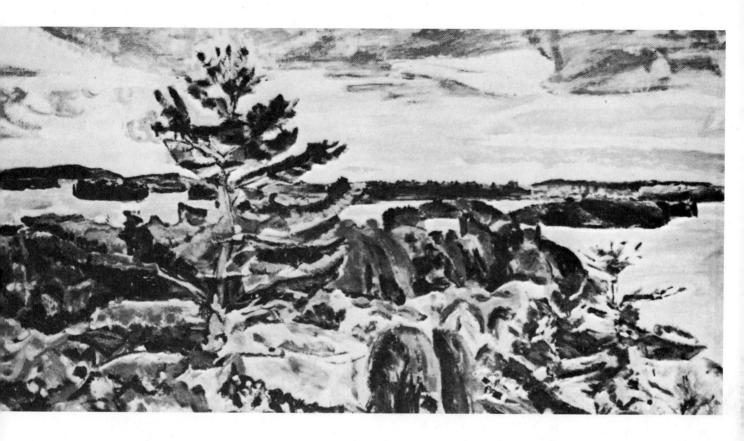

EVENING OVER MUSKOKA LAKE

Oil on canvas, 24" x 50"

Paraskeva Clark

Artist's comment:

What I am after: to produce a painting which incarnates the wonderment, the enchantment of a particular visual experience and declare the love inspired by the subject of the painting. I am always arrested by the abstract design of a subject and the main task in the painting is to make this underlying design clearly apparent, in spite of the wide use of details.

To produce a beautiful painting, to create a miracle! That is probably what we all hope to do.

Painted on linen canvas. Underpainted with thin monochromatic underpainting using only turpentine for medium. Overpainted with varied impasto and textures. Varnished later with a mixture of fifty percent Damar and turpentine.

Palette. Viridian, Thalo Green, Prussian and Hooker's Green, Cadmium Green, Veronese, Ultramarine, Cobalt Blue, Manganese, Monastral Blue, Cadmium Yellow, pale, medium and deep, Cadmium orange, Cadmium Scarlet, Vermillion, Madder, Geranium, Magenta, Carmine, Windsor Violet, Indian Red, Van Dyke Brown, Yellow Ochre, Umbers, Payne's Gray, Superba or Flake White.

113

COME TO THE FAIR . 1947, 12" x 19"

Artist's comment:
 Technique is a personal thing. The best technique is the one which enables you to say what you want to say. It is the means, not the end.

Dan Lutz

ROME Collection of Albert Dorne. Oil on canvas, 36" x 48"

Joe Lasker

Artist's comment:

Painting is as necessary to me as speech. It is an avenue towards understanding and a grasping at life. I paint primarily because I'm hoping something will happen in paint. I do not seek consciously for mood, timelessness or sentiment. If these things are present they come in by themselves.

I choose a subject because it excites me, but frequently the excitement vanishes before completion of the canvas, leaving me high and dry. Painting then becomes like banging my head against a wall.

I proceed on sheer faith and bull-headedness, making changes until a new excitement flows again. When this does not happen, weeks and months of work must be abandoned.

I can't see myself as a non-objective painter. I have tried it and become bored. The human image fascinates me too much. Of themselves, design, tension, space, have no importance for me. I respect my own instincts more than the canvas.

Both canvases were painted in Connecticut when I was still nostalgic for Italy. In *Rome* I combined

structures and images that I saw in Italy, but I was also excited about doing a "green" picture. It seemed to capture the air and clarity of Rome. Source materials were snapshots and souvenir post cards.

Piazza, oil, 30″ x 24″, started out being something else and innumerable changes were made. It also started from a post card, this time of the Piazza Fontana Trevi of "Three Coins in the Fountain" fame, in which there was also a stone angel.

Both are painted on linen which is first glued to Masonite. I like the surface of linen plus the security and stiffness of the board. Sagging canvas on a stretcher due to damp weather or careless

handling destroys all the plasticity and solidity of any painting for me.

Rabbit-skin glue was used to adhere the canvas to Masonite. The panel was then sized with a half linseed oil and white gesso ground. Sometimes this white ground receives a colored "imprimatura" before the painting proper begins. I often use a painting-knife and single-edged razor blade to scrap down layers of colors to obtain textures.

Palette: Viridian Green, Thalo Green, Cadmium Yellow Lemon, Deep; Yellow Ochre, Cadmium Red Lightest, deep; Alizarin Crimson, Manganese Violet, Ultramarine Blue, Burnt Sienna, Ivory Black, Zinc White.

PIAZZA. Oil on canvas, 30″ x 24″

Robert Maxwell

NUDE. Oil, 24" x 32"

Artist's comment:

Believing that a painting itself should clearly contain each artist's particular endeavour, suffice it to say that the content of my own art is people—unpretentious within their daily environment.

My approach varies, sometimes drawings or studies precede the actual execution, at other times the painting is done directly from the model.

The early work is basically linear, attacking the canvas with a darkish color in a scumbled technique. I use no painting medium and turpentine only occasionally for the early lay-in. The masses are painted next, rather thinly, and the canvas is frequently scraped to prevent undesirable piling up of pigment. The color tends to be monochromatic at this stage.

From here on as the painting develops and the image defines itself, technical procedure becomes a matter of subtle adjustments. Spatial values, volume, plasticity, etc.—all must be considered. Brush work becomes more fluent, color more decisive, the impasto builds up slowly, but always, draftsmanship must underlie the whole.

Throughout I keep a constant eye to the large forms, aiming at simplification. At all times I try to be as clear as possible and consciously avoid the obscure, striving for an intimate tangibility.

LUCHA
Oil, 24"

118

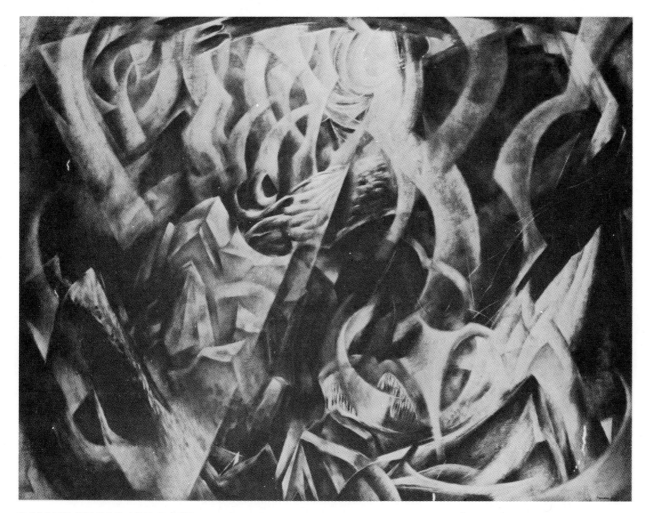

BALLET OF FOG AND ROCK Mixed media on Masonite, 30" x 40"

L. A. C. Panton

Notes on the painting:

A studio painting carried out by the mixed medium method somewhat similar to the Schaefer description on Page 127.

This was painted on a Masonite support with a gesso ground carefully prepared to a smooth finish with six to eight coats brushed on at right angles. Dry powdered pigments were used with an egg emulsion medium and the textures and values built up in neutral tones. These were then glazed with oil glazes.

Working in this method demands a craftsman's approach as it is a long slow process. The late L. A. C. Panton was a leading exponent of this technique, painting large panels with its exacting means. Many preparatory sketches were made, as well as drawings and paintings, before a synthesis of this kind was begun.

The paintings reproduced here are the exact size of the originals. Painted by a Mexican, a pioneer in the sound-movie industry in Mexico, they show what imagination can do to produce a world of fantasy in a small space.

Exploiting the rich transparent values of enamels and dyes, controlling the reticulations and modelling of space, the artist has been able to create an appealing world of textured landscapes which might have come from another world, far below the sea or on another planet.

With the limited means of one or two colors and much experience of controlling the textural "accidents" a strange new world of form is opened up for us. It is worth noting that a ten-foot canvas was not required to produce the illusion of immense depth and space. The relative size of the textures indicate for us vast panoramas and distances, although the picture-plane is so restricted in size.

Tello uses enamels, textile dyes, and experiments with diluents and formulae of his own devising. The pictures shown here were painted on smooth white-grounded Masonite. Eye droppers, small brushes, and scratched lines help shape the details he requires.

MINIATURES

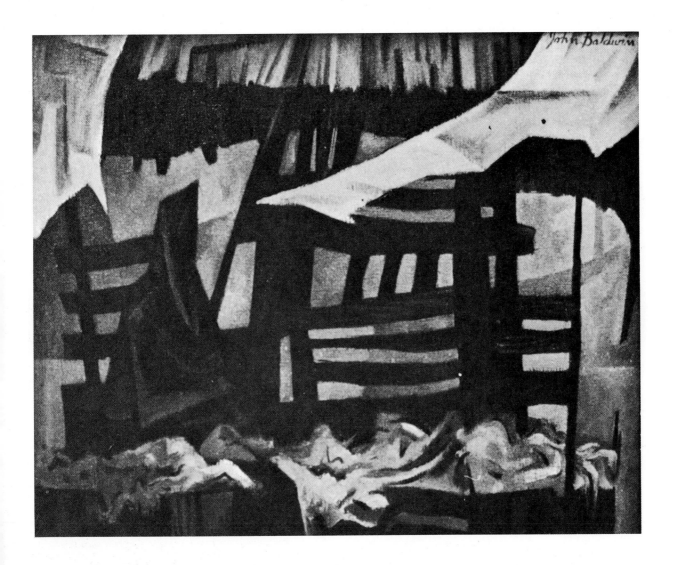

Artist's comment:

After years of working with a wide variety of painting media and teaching their various techniques, I have become well aware of the limitations and possibilities of each. However, the characteristics of each are rapidly breaking down and it is becoming increasingly difficult to distinguish between an oil and watercolor or many other techniques.

Not long ago I was a juror at a large regional watercolor show and when the pictures were hung, many asked where the watercolors were. The truth is that very few contemporary artists are concerned with "pure" media. Many are using mixed techniques. Today there is nothing to prevent an artist from using watercolor, ink, chalk, tempera, casein, and oil in the same picture. All of the wonderful plastic sprays for fixing, isolating, and varnishing are readily available. Moreover, pigments ground in these new plastics provide artists with infinite means of expression never before possible. Too often, however, the exploitation of new effects becomes the painter's only purpose and he displays nothing but cold virtuosity.

**MEXICO THROUGH
THE AGES**
(Size 24" x 36" Duco)

An early attempt to explore the textural gamut and colors of Duco. The techniques used include dry-brush, glazing, pouring, dripping and even the use of stencils. The Masonite surface was roughened and built up with sand, gravel, and pieces of broken pottery. →

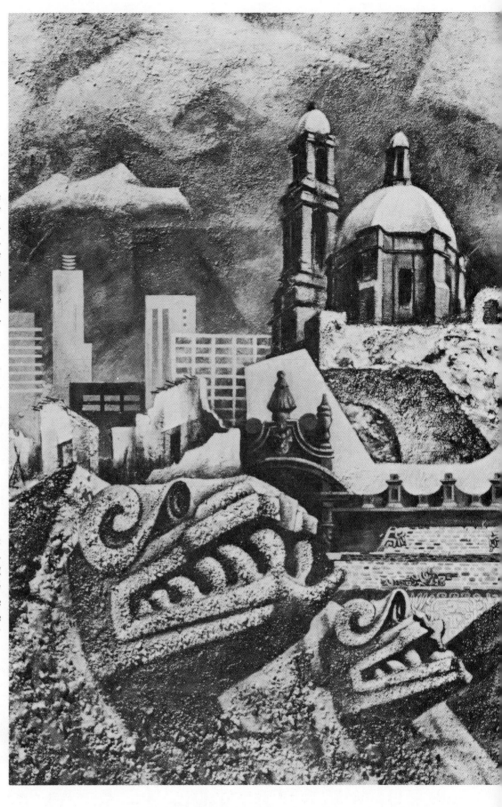

"MORNING MARKET"
(Size 16" x 20" Oil on Canvas)
(Page 121)
A direct oil made from market sketches, one of a series concerned with large patterns and controlled color schemes, using "closeup" details to interpret the excitement I have felt in the Mexican market place.

When talking with the great Mexican painter Orozco he did not try to hide his annoyance when he dismissed my question concerning the new technique he had used in one of his last murals. What he told me, in effect, was that the work would have been just as effective if he had used charcoal sticks. The important thing was what he had succeeded in expressing.

York Wilson

Artist's comment:

Some of the enjoyment of painting is lost when too much concern is given to its reason for being, its message or its intention. It is not necessary for a painting to have a meaning that can be translated into words. Consequently I paint what interests me without feeling any need for justifying the selection, even to myself.

Neither completely literal not completely non-figurative painting is entirely satisfactory to me. I prefer something that comes between these two classifications which might be called figurative abstraction. The subject matter may be quite obscure, but it should be there for the person who puts forth a little effort to discover it. Any painting should be more interesting to the viewer who has some knowledge about the subject matter.

To an audience familiar with the subject, the painting would need no title as a guide, however, the same painting to an audience unfamiliar with the subject could appear to be non-figurative. Thus, depending on the viewer's previous knowledge, the painting will be seen either way—as a figurative or non-figurative work. To be completely successful it must be up to the test of being evaluated in either category.

Recently I have painted with "Lucite" 44 and oil color. It has the advantage of quick drying and can be used on canvas. The "Lucite" 44 is useful for underpainting, is fast drying, and if one wishes, the traditional slow-drying oil method can be used in completing the work.

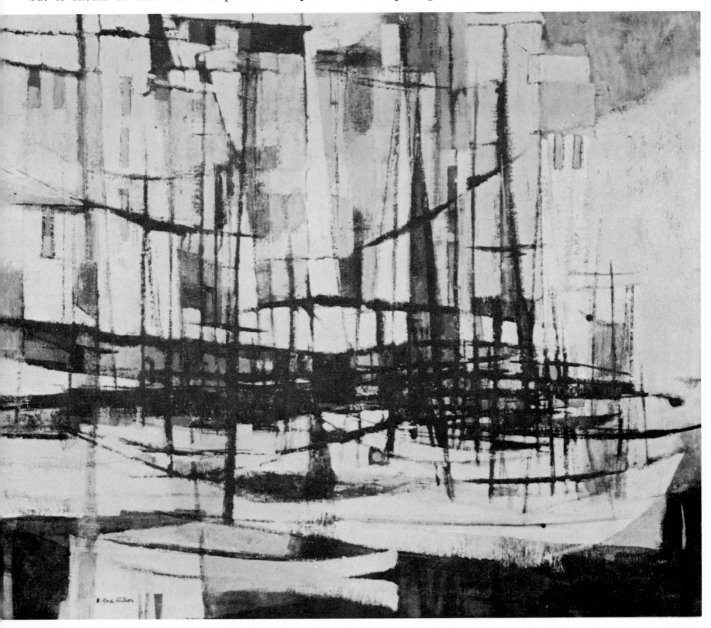

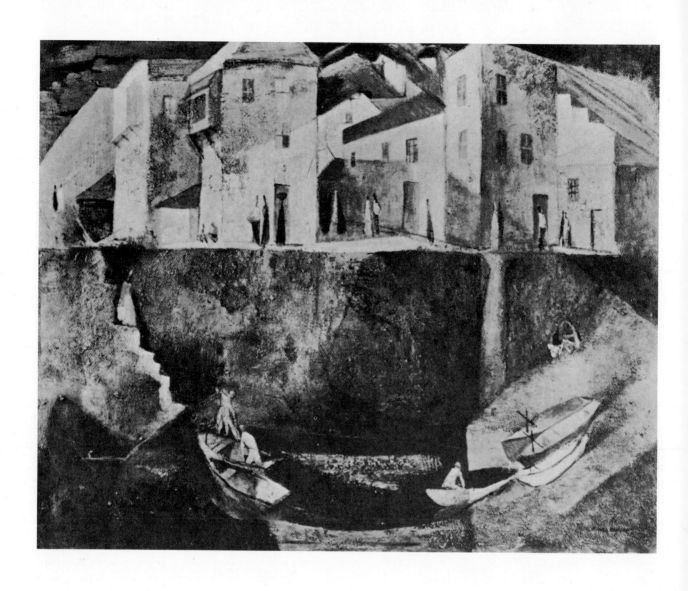

PUERTO DE LA CRUZ, ISLAS CANANARIAS
1952. Size 24" x 32" Duco pyroxylin on Masonite

The reasons for selecting pyroxylin as a painting medium are quite numerous, but they all revolve around the fast-drying element of the pigment. The opportunity to cover a board with the total painting effect in color in only a few minutes makes it possible to assess an approximation of the final result almost immediately.

To be able to test glazes, to add or delete large areas without destroying the whole, gives the ultimate latitude for experimentation. With a medium as flexible as this, a special kind of organization is possible that grows out of the painting itself as it is being painted. It is the kind of orchestration that cannot be planned ahead, but must develop with the painting. Pyroxylin offers probably the greatest variety of textural variations through the addition of untold numbers of inert materials.

(Page 123)

PORTOFINO, ITALY
Collection C. S. Rand

Lucite 44 and oil on canvas, 30" x 40"

124

Frederick Taylor

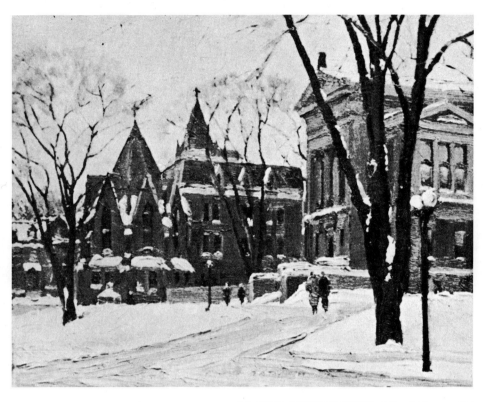

McGILL UNIVERSITY. Oil, 8⅜" x 10⅜"

HÉLÈNE. Oil on canvas, 30" x 24"
(Page 126)

Artist's comment:

As always, I wished to paint simply and worked from the model until the painting gave back to me as close an approximation of my feelings as I believed possible at the time. It was important to me to achieve this result in an active sense. I feel I have been successful in this respect and that the "life," psychological tension or call it what you will, wears well, leaving much to the observer's imagination in what might be described as the imponderable or infinite sense. I believe that it is on this kind of feeling that the merit of such works depend—good design, color, etc. being taken for granted.

The painting was done on a canvas which had been painted on previously with generally "thin"

color. The lower left-hand area had, however, been heavily impastoed and some of the texture which resulted when this area was scraped with a serrated edge of a palette knife is retained in the tablecloth. I seldom paint over old canvases, but needing one in a hurry, I hastily scraped this one and went to work on it.

I worked from the model in three-hour sessions on five consecutive days, and after an interval of a few days, completed the painting in three half-day sessions during which I worked only on the background and table cover without touching the flesh tones of head and hands. I find that I usually do my most telling work in the final half hour of long sittings.

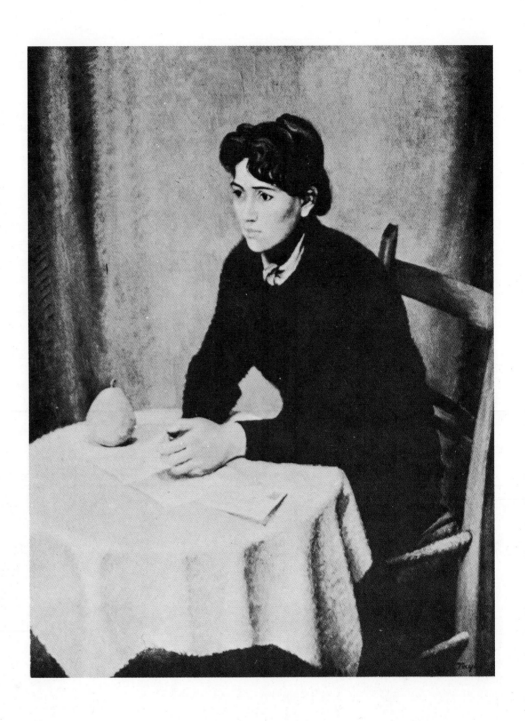

The canvas is a fairly fine-grained prepared linen. The palette used throughout this painting:

Rose Madder, Cadmium Red Light, Yellow Ochre, Raw Umber, Cadmium Yellow Pale, Deep Naples Yellow (draperies only), Viridian, Ivory Black, thin Flake White.

In laying out the canvas I used Raw Umber slightly thinned with turpentine. Thereafter, as is my custom when using thin Flake White, I used no medium.

The painting was thinly coated with retouching varnish one month later, with great care so that the large areas of black did not "lift" and smear.

Carl Schaefer, Head of the Drawing and Painting Department, Ontario College of Art

STILL LIFE. Mixed media on Masonite, 11" x 15"

Artist's comment:

After working in oil for some years and finding it laborious, slow drying, etc., I took up watercolor which because of its immediacy and speed I still pursue. Later, experimenting with tempera emulsions I found a working technique combining the qualities of both—the mixed medium. It is a tempera medium, an aqueous mixture of egg and water emulsified with oily ingredients. This technique fitted perfectly the abstract and esthetic conceptions of the early Italians and Flemish painters of the 15th and 16th centuries. I prefer to use variations of this method which combines the quick-drying qualities of tempera capable of building up textures, with the slow drying qualities of oil.

The ground is untempered Masonite with a sized and gessoed ground on both sides, sanded smooth after four or five coats of gesso. A line drawing in ink follows and then a thin transparent wash of oil color using Terre Verte with ten parts of turpentine and one part of Damar varnish. Over this I paint a monochrome painting in thick and thin textures, using an Umber and Titanium white mixture of opaque dry color and emulsion (Page 155). Hog-hair brushes and painting knives are used and grays built up high in key to allow for the later transparent glazes.

An important step is to isolate this underpainting. On the following day, when the painting is dry, I brush over a thin coating of a fixative made from ten parts methyl alcohol and one part white shellac. Glazes are made from standard tube oil colors with the glaze medium. Tempera may be painted directly into this wet surface or glazes allowed to dry over a series of thin glazes. Wet oil should never be painted into the tempera.

I lay out two palettes, one of dry pigment powders, the other oil pigment on a sheet of plate glass or white enamel surface. The painting was executed swiftly, trying to convey the fragile nature of the basket against the forms of fruit in a deeper and richer color, contrasting a series of planes in space. The success of the painting for me was due to the expressive handling of these elements, using a medium which did not resist, but worked with maximum flexibility.

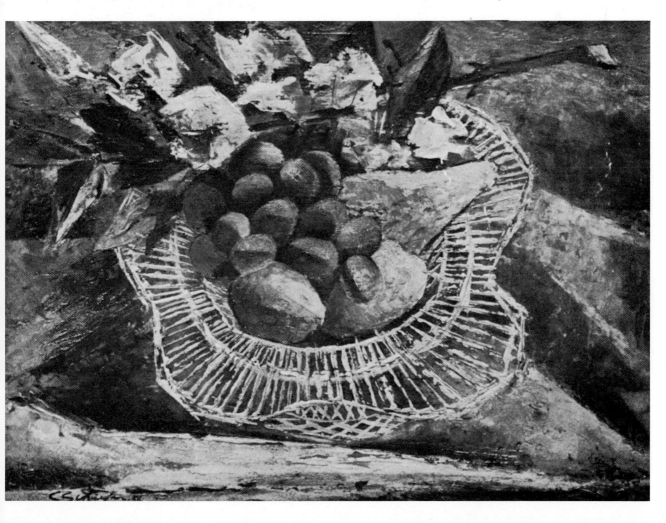

NEW MEDIA AND TECHNIQUES

CREATIVE SEEING

MEMORIES OF HOUSES AND STREETS. Freely conceived design forms based on recollections of shapes and lines from a Mexican village street.

Knowing how to work from nature in a constructive sense—taking from the reality only what will serve us as painters—is an acquired ability and one which we must constantly develop. We need a system of study and a conscious realization of the problems involved in truly creative seeing.

Before it is possible to use the myriad forms and impacts of nature—before we can make a meaningful statement in plastic terms—we must know what we are seeking. The casual contemplation of a scene has little meaning to the artist, who must filter this actuality with its countless details through his personal thought and vision. He must select and emphasize, calling on his own individual mannerisms and reactions, which are as distinct as his handwriting. These are the things that bring life and vitality to our work, and we must preserve them jealously while absorbing an understanding of the many basic esthetic principles that underlie all fine creative expression.

Periods of study, in which we consciously and deliberately experiment to deepen our understanding, may not allow the exciting freedom of undisciplined expression; but they will pay great dividends later, when we can put aside such deliberations and use our knowledge freely.

First we might consider the elements of our composition separately: shapes, forms, colors, details of texture. The weight and blockiness of houses—their essential dimensionality, disregarding light and shade—the large outlines of trees, the planes of flat road and vertical walls—all these are observed and fondled in our mind and eye, much as we might pick up a set of children's blocks and turn them about in our hands.

Further, we might note how they interlock, are set one behind another, how they merge and form new shapes. Braque said that it was not the shapes of things he loved but the spaces around them, a thought that can be a clue to creating new forms from very ordinary material, making new visual combinations of line and mass.

Perhaps we will isolate our material and visualize it as it will be placed on the flat surface of our paper—the

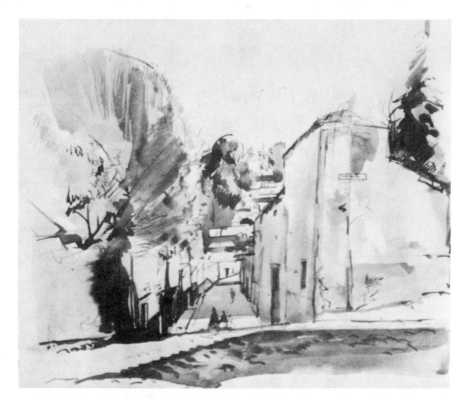

SUNSHINE AND SHADOW. A pen-and-wash drawing makes a factual report in a traditional straightforward technique.

WALLS OF SAN MIGUEL DE ALLENDE.

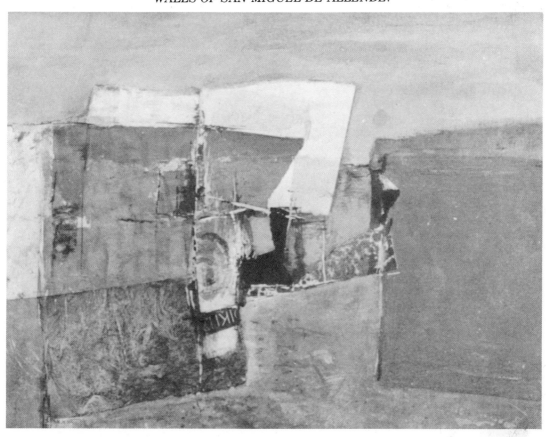

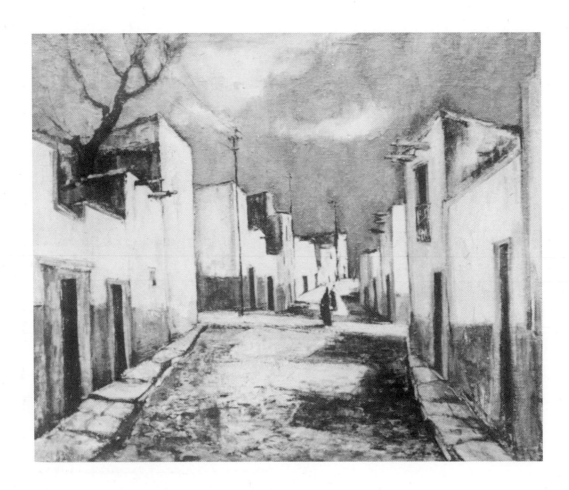

WALLS AND STREETS. *A carefully painted street in which lights and shadows on old walls emphasize the basic black-and-white design. Traditional perspective is used, with no distortions, and the textures of the street and houses are studied in detail. From such early works have come later paintings based on walls and streets. Other interpretive sketches removed from literal seeing are illustrated in this section.*

Studies for WALLS OF SAN MIGUEL DE
ALLENDE *(Page 129)*

picture plane. We will think of the shapes now as having stresses and thrusts of direction and movement, for we must translate the three-dimensional objects we see in front of us into two-dimensional shapes on the flat paper surface. Overlapping planes can be used to indicate that one object is behind another. The convention of perspective allows us to lead the eye back along the street if we wish, or we can disregard its rules and use an isometric rendering which, in this instance, may perhaps give more "reality" to our drawing.

Beyond this we have the overall concept of what we wish to express about what we have seen. How far do we wish to remove it from the literal fact? Are we thinking in terms of the Impressionist flicker of light and broken color, or are we thinking of a formal, hard-edged presentation, a more than real super-camera eye? Perhaps we should consider a cubist design, or a "fractured image" seen from several viewpoints at once, or we may wish to take it beyond all these to the abstract and imaginative reaction that we may paint later as only a remembered sensation of space and color.

These are some of the things to be considered as we try to give pictorial order to our subject, knowing that we must ask ourselves many questions before we can develop a clear idea of what we want to do and say in our work.

Here a tabletop composition is made on a large canvas. The pictorial possibilities of the subject—a bottle, flowers—have been analyzed as for the street scene. Background shapes, objects, and table are used to invent exciting visual relationships. A pattern of circular and vertical movements uses dribbles, spatters, and scrubbings to create textural brush work. A strong, contrasting tonal and color scheme completes the work.

TABLETOP COMPOSITIONS

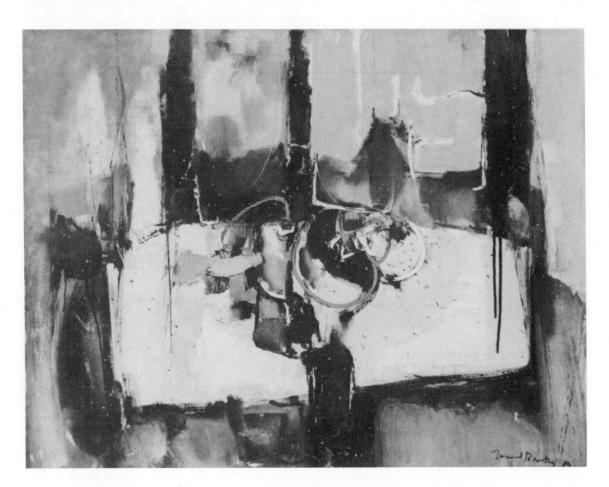

A BASIC OIL-SKETCHING TECHNIQUE

Figure 1. An 8″ × 10″ canvas-board panel is roughed in with charcoal and sprayed with a thin fixative solution.

Figure 2. A thin stain of turpentine and pigment sets up the main tonal areas. A neutral warm gray was made with blue and burnt sienna.

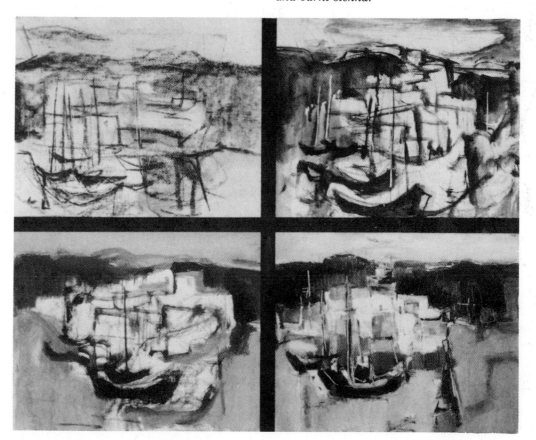

Figure 3. Opaque white is added to the transparent stain and the three pigments— blue, sienna, and white—are combined to form thicker impastos of the tone required. Large forms are brushed in or applied freely with the palette knife, and detail is left to the last.

Figure 4. A panel painted in limited color, using only the above three pigments, is completed as an exercise in rapid sketching.

A corner of the studio shows an easel, painting table, and rough sketches pinned up on a board. Large canvases are painted from such studies. Ordinary house-painters' brushes as well as finer artists' brushes are used.

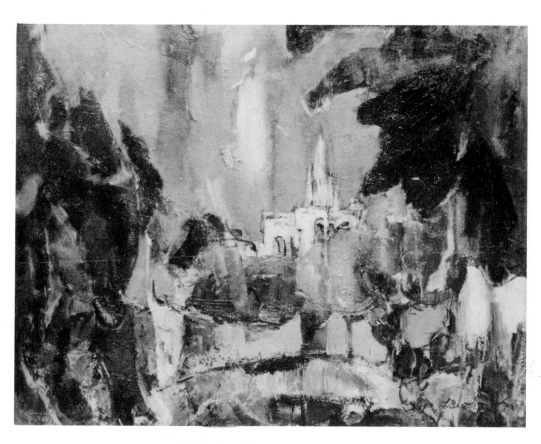

STORM AND GARDEN by Leonard Brooks.

A rapid dry-brush note made for STORM AND GARDEN was the beginning for a richly impastoed canvas developed in the studio. The large forms of trees and shrubbery were painted and scumbled over many times with varied brushwork. An effort was made to avoid detail and to preserve the interlocking of big shapes suggested by the first quick drawing. The subject, as always, called forth its own techniques and methods of handling paint.

Figure 2. A traditional imprimatura as it looks when made as the beginning step in sketching from a subject out-of-doors.

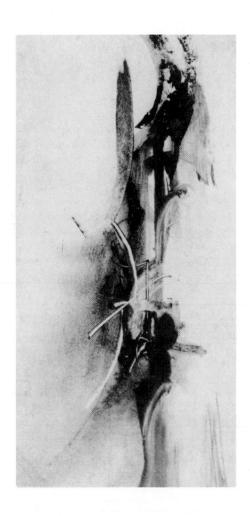

Figure 1. The imprimatura, or thin staining of the canvas, is often used to establish the drawing and composition as well as to indicate the tonal plan of the painting. Some painters today like to use this technique as a finished way of working, producing either a controlled or accidental stained quality much like a watercolor. Large flat color-fields of thinly brushed oil pigment and turpentine washes are used in preference to rich impastos (thick brush or knife work). Traditionally, the imprimatura was a basic underpainting for what was to come; the old masters often began paintings with chiaroscuros of neutral colors that were then glazed in tints of color or weighted with thick pigment.

Figure 3. A thickly painted abstract panel in brilliant colors. Many varieties of brush and knife techniques give richness of texture and accomplish the "broken-color" of the pigment. The design was first stained-in as in figure 1.

MONOTYPES

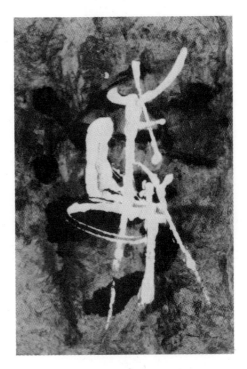

Effective one-print images can be made by using oil diluted with turpentine on a smooth surface such as a piece of glass or a marble-topped table. A piece of absorbent paper is placed over the wet paint film and the paper rubbed with a spoon or flat object. When peeled off, the print will show a reverse image of the design. This one-print image will have controlled and accidental surfaces that are exciting and that may suggest other interpretations or the making of new prints over the original offset image. It is interesting to experiment with different kinds of papers, washes, and layers of paint film. Loose brushings, washes combined with heavier pigment, scratching through the paint with the end of a brush or with a knife, and stippling are ways of varying the textures.

Offsetting color from a page onto canvas to form a sharp edge and defined shape can be used on larger paintings. A circle painted on paper with thick oil can be pressed down over another oil-paint ground, imprinting a surface that has its own quality that differs from a painted brushstroke. Stencil cut-outs can be made, and the forms stippled onto the painting to produce hard edges; tapes and stencils can be combined; there are many inventive ways of applying paint other than with a brush.

A heavily textured bark paper is the background for overprinting in white-and-black calligraphy offset from painted acrylic papers.

A wave motif is achieved by textures of heavy acrylic paint pressed against and pulled away from the paper.

COMBINES

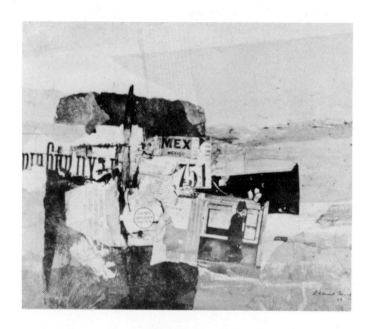

JOURNEY by Leonard Brooks.
A combine using collage,
photomontage, printed
materials, and brushwork with
oil paint. This assemblage
gathers the souvenirs of a
journey to form a semiabstract
design. Such experiments will
call on all the resources of
inventive placing of shapes and
accents to form a unified
composition.

AUTUMNAL by Leonard Brooks.
Collage textures were built up on
the canvas to give variety to the
surface before oil color stains and
glazes were applied. The canvas
was isolated with a coat of
transparent polymer emulsion
(opaque white acrylic gesso could
have been used instead) before the
papers and cloth pieces were glued
down with acrylic emulsion. Oil-
grounded canvas should never be
used for this technique, as the
acrylic emulsion will not adhere
properly. Raw canvas or the
reverse side of oil-primed canvas
should always be used.

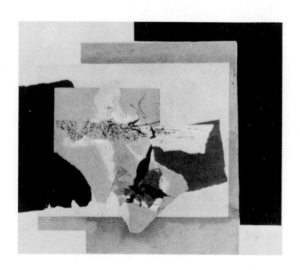

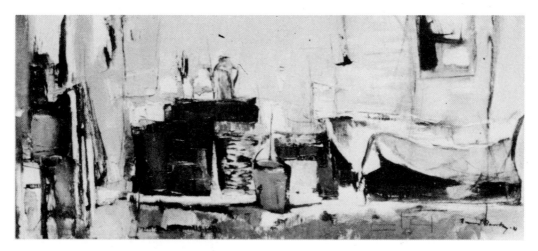

Figure 1. STUDIO CORNER, a small horizontal panel. The forms found in a studio interior are used in a rapid sketch thinly painted and brushed. Such subjects offer unlimited possibilities for tonal and color studies.

Figure 2. STUDIO WINDOW. A vertical composition in a large oil sketch with rich textural surface stresses the lines of an open window.

COLLAGE AND OIL

The illustration shows the building up with polymer gel and paper textures as the starting point for the finished painting. These surfaces are used as varied areas which suggest in themselves abstract interlockings of pictorial space. Sharp edges and ragged torn shapes bring about their own inventive suggestions for the development of the painting. They give a good start, an impetus to free the inhibiting feel of a large, blank, white space which so often intimidates the painter. Carefully prepared colored papers or cut-up sketches which have failed and been discarded (if they are not oily or greasy) can be built up in layers with the binding gel or polymer emulsion. The final painting in oil can be done over this sealed-in textured collage. It is wise not to use cheap colored pulp papers or magazine clippings, which will fade. Rag paper, good quality Japanese rice papers, and white tissues are excellent. Colored sheets of brilliant hues can be prepared beforehand with casein, oil, or acrylic brushings. These will insure the permanence of the color and prevent fading.

Moving shapes of color over the painting as it is in progress will help the development of the picture. Forms can be cut from colored paper and stapled or tacked down for trial before making changes or corrections in the final oil paint. A touch of accent can be tried out this way, especially on a large canvas. You

Experimenting with color patches.

can move and change an accent and its color until, by stepping back and overseeing the whole composition, you can visualize the final solution before putting it down in final form.

FORGOTTEN DAYS by Leonard Brooks. A large abstract canvas using textural collage background of papers with superimposed calligraphy—actually ancient pages from old bank ledgers. Large contrasting areas of blacks and grays with touches of yellows make strong patterns and repetitions of flat shapes. The tonal differences provide movement in depth on the flat surface of the canvas.

140

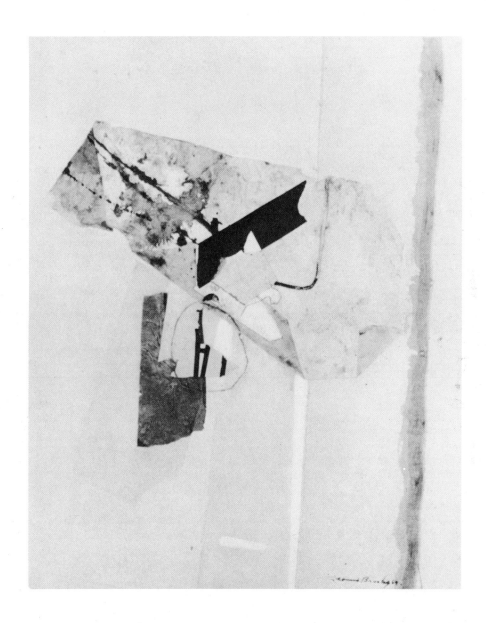

YELLOW AND GRAY by Leonard Brooks. *The textures of stained and cut canvas, a pipe cleaner, papér, cloth, and wire—all these were used to shape a harmony of yellow and gray into an open composition with strong dark accents.*

FORMAL OR FREE?

Sometime in your investigations you will find yourself facing the question of how you really want to express yourself. Do you lean toward carefully controlled manipulations of paint, pen, or brush, or do you feel an urge to free, energetic expressions where the "controlled accident" comes into play? This is something that only you can answer and generally only after much work and experiment. Until you try the approaches suggested, you will not truly be able to find your own individual path.

Figure 1. A controlled and calculated series of lines form a pattern of repeat design.

Figure 2. The spontaneity of the free calligraphic gesture.

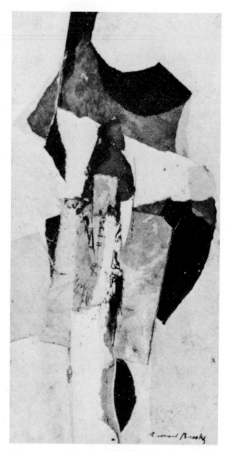

Figure 3. A little of both figures 1 and 2—considered, controlled forms with the added contrast of free accent and gesture lines.

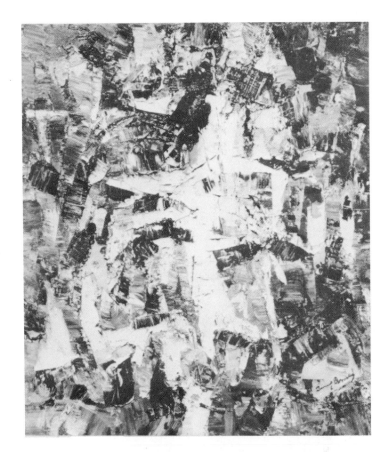

Textural design in oil. Palette knife technique is used to form patches of brilliant color in broad knife-strokes. By picking up touches of several colors with the knife and applying the strokes directly with very little mixing, the pigment will provide lively "broken" color with sparkle and animation.

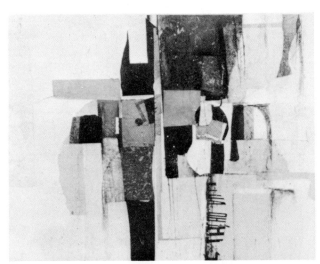

PLAZA GENOA by Leonard Brooks. Collage and oil on canvas. Shapes and colors from an Italian city fuse open areas of whites and grays as a background for bright red and gold angular and curved accents.

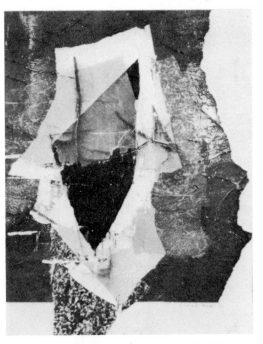

CRETAN MOOD by Leonard Brooks. The dramatic dark cliffs and coast of Crete suggested the design and color mood. Some marble dust and textured papers are combined with glazes.

143

PRIMORDIAL FORMS — A SYNTHESIS

Here is a demonstration of one way of working when you feel ready to forget exercises, trials, and experiments and wish to carry out a complete statement of some theme that has interested you. You may, of course, sail into a large canvas impetuously, disregarding preliminary sketches or preconceived thoughts about your subject and with a virtuosity and impetus that hold everything together at one go. The chances of this are slight, however. It is doubtful whether you would be reading this book if you can paint this way, and a dash of organization may be useful to you.

For a number of years, I have been going to a gorge—a magnificent canyon where great sculpturesque rock-

Above and opposite
Studies for the painting PRIMORDIAL FORMS. Pen, brush, rollers, and sponges were used. The search for the underlying structure, the large overall design that gives force and strength to the vast sculpture-like rocks is made by seeking the tensions, rhythms, and sensation of timeless organic forms.

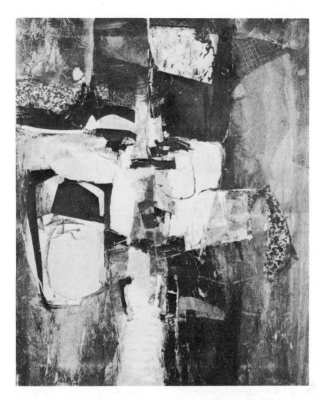

PRIMORDIAL FORMS by Leonard Brooks. A synthesis of the many forms drawn and studied was made; there was an effort to go beyond the literal copying of one view or one drawing. The abstract design should be the result of many experiences in front of the subject if the expressive mood is to be valid.

formations pile and tumble over each other in primordial splendor. Invariably, compositions cry out for sketching, and I have done literally hundreds of drawings and notes from this magic spot. Recently I have felt I could develop some of these feelings and notes about this rugged subject. The danger of falling into making renderings of a romantic kind, of copying the forms and surfaces in a literal manner, had been an inhibiting factor before this. I felt that there was a need to research the material in depth before it could be interpreted. What I was after was a synthesis, a totality of statement about the feeling of timelessness—the structural thrust and compelling impact of the immense stone forms piled up from some gigantic upheaval in centuries past.

One of the problems was to try to convey a sense of the size of the immense rocks, some larger than houses. Without plant forms, a comparative figure of a man, or some indication of size, the drawings often resembled nothing more than a pile of pebbles on a beach. Yet these smaller elements seemed to steal away from the large design and dynamic interlockings which moved me. Finally I was forced to concentrate on the vast jux-

taposition of the forms, to try to grasp the movement, tensions of lines and forms, the projection and sensation of weight and spatial coherence. Elimination of detail became the key; the best drawings became simpler, more spontaneous. A return to the study of Japanese and Chinese master drawings of rocks and valleys impressed me once again with the need to simplify—to sit and think, to study and *feel* the underlying construction and organic principle that gave such forceful visual impact to the scene.

The illustrations show the kinds of drawings I found of value in seeking to understand the strength, the dynamic relations of line and mass, which would be the basis for a transcription into the painting *Primordial Forms*. These ink drawings were made to explore shapes, textures, and interlockings of space. Sometimes shadows cast across the rocks gave a clue, and these helped to define the horizontal and vertical thrusts; often the pattern of the silhouette demanded variations of thick and thin line; washes of ink could indicate tonal differences; spatters and drippings made with rollers or sponges suggested textures. Compositions were tried in long vertical panels, horizontal formats. From these came the day when I was able to put all these experiences into one and try to capture a synthesis of the forms and rhythms, the integrated reshaping of many studies into one painting. The result was, alas, not what I had hoped, and the problem remains a challenging one which I am still hoping to solve. I show two of the interim efforts, however, only to illustrate how a painting may come into being. They are examples of one of the many ways the artist seeks to project as best he can what he feels about the objective world, filtering his feelings through the details to the essence, beyond mere illustration and copying of bare fact.

The elements of rock forms reduced to flat shapes in a simple design.

145

Studio-size tubes

Cobalt blue

Ultramarine blue

Viridian

Cadmium yellow deep

Cadmium yellow pale

Cadmium red light

Yellow ochre

Alizarin crimson

Burnt sienna

Raw umber

One pound tube

Zinc or flake White

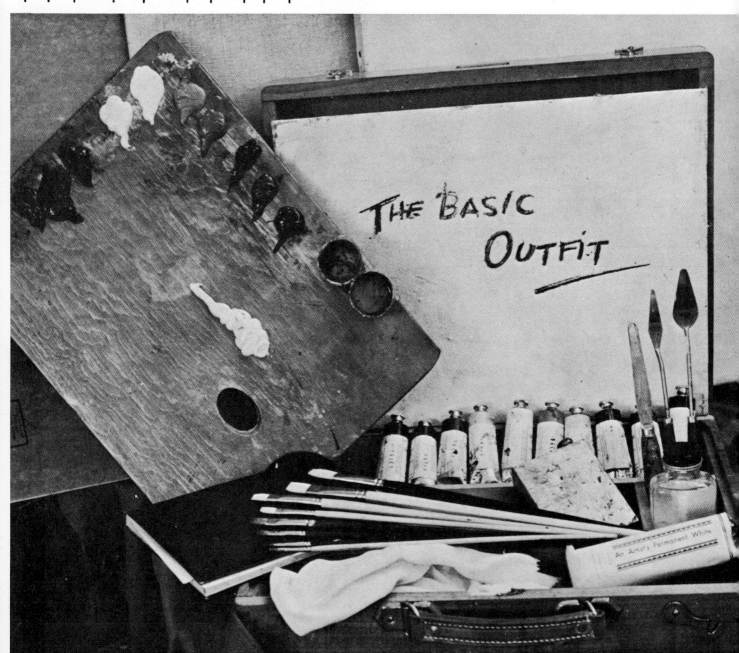

THE BASIC OUTFIT

APPENDIX . . . MATERIALS AND EQUIPMENT

THE BASIC OUTFIT

Illustrated here is the basic equipment for oil painting. I have listed the minimum material required and my personal preference in colors, style of brushes, etc. Naturally you will add to the list of colors, selecting your favorite type of brush, painting knives, sketching panels and other gear as you gain more experience in their use. An augmented list is given further on in the appendix from which to chose.

———————— Cotton or linen panels 20" x 16"
20" x 24"
24" x 30"

———————— Sketch panels 12" x 16"
Cotton on cardboard or white lead ground

———————— Cup for turpentine

———————— Palette knife, painting knives

———————— Ten colors and white as listed

———————— Turpentine can and linseed oil
———————— Hog-Hair bristle brushes (longs and short)
———————— Sable brushes assorted sizes (square)
———————— Sketchbook Paint rags
———————— Charcoal sticks and pencil

———————— Sketchbox 12" x 16" (with strap)

When buying equipment for the first time do not skimp on quality. The initial investment in good brushes, sketch box, and first-class colors will pay dividends in the long run. Make it a point at the outset to look after your painting gear. Brushes should be rinsed in turpentine or benzine and then washed out thoroughly in warm, not hot, water, with a strong but pure soap. Some painters "set" their brushes, shaping them to a sharp edge before putting them away to dry. This is done by leaving a thick soap solution in the hair of the brush and moulding the bristles with the fingers. If this is done consistently the brushes will dry with a well-preserved shape and edge, and last much longer. When the soap has dried be sure to powder it out thoroughly before using the brushes.

Squeeze out generous coils of pigments on to the palette. Do not get in the habit of putting out pinpoint touches of color; you have plenty to think about while working without having to continually renew the palette. Do not be too anxious, either, to save what is left over when you are through painting. Generally the paint gobs will be dirtied or mixed with other colors. If you have a generous amount of untouched color left over, and wish to save it, lift it off with a palette knife and put it back after you have cleaned the palette. Some painters place unused paint in a tray, covering it with water until they are ready to use the paint again. I have found this more of a nuisance than an economy, preferring to start the day with a freshly set palette. Others, especially those who work every day without fail, leave all the colors in their regular order on the palette, cleaning off only the mixing space, and squeezing more color out each time on the old. I have seen palettes of this kind piled up inches thick. This only works for the studio palette or table, as the weight and thickness of paint would be impractical for the sketch box palette.

Set out your colors in some kind of order and keep them always so. This will enable you to reach automatically for a color from habit, as a pianist touches the keys without looking. Some painters prefer to put all the cold blues and greens down one side of the palette with the warm range along the top edge, putting the brilliant reds and oranges in close proximity for convenience of touch. This is your choice, but after experimenting *do* establish a system and adhere to it.

A CHECK LIST OF BASIC MATERIALS

BASIC EQUIPMENT

1. *Sketch box.* Twelve by sixteen inches is a good standard size panel to use for sketching out of doors. Make sure that it is strong and durable with mitered corners. It should have slots in the lid for three wet panels and not be too heavy. Tin linings only add weight and serve no useful purpose. There are aluminium boxes made but somehow they have always seemed unfriendly and coldly indecent to me. For some reason, few boxes come equipped with a carrying strap, only a handle. The addition of a web or leather strap is easily made and I find it useful not only to sling over the shoulder for carrying but to act as a holder and support when I am sitting sketching with the box on my knees. I have it attached in such a way that it is easily undone and adjusted around my back when seated.

2. *Cotton or linen-covered panels.* You can buy these made up to fit the slots in the sketch box or you can easily prepare your own with sturdy cardboard and a few yards of your favorite textured canvas of a thin variety. Panels with other types of grounds are discussed on Page 154.

3. *Brushes.* Number 2, 4, 6, 8, bristle or hog-hair brushes. Try those known as "Brights," short and square; "Flats," longer and square; include too, several sizes of soft sable brushes of the same shape and size. "Filberts," oval shape, and "Rounds," pointed, are not essential and seldom used for sketching, though a pointed sable or "rigger" may be found useful for drawing in fine detail such as tree branches or figure suggestions.

4. *A palette knife* for scraping paint from the palette. Also a painting knife, shaped to a finer point. Select a spade or diamond shape of medium size to begin with.

5. *A tin of rectified turpentine* or spirits of turpentine. You can buy small bottles of pure turpentine from the art dealer but it is much more economical to buy the pint or quart tin from the paint store. Make sure that you get the pure *gum* type and that it is labelled as such.

6. *Linseed Oil.* Pure artist's quality from the art store. This is a cold-pressed, clear, light-yellow oil unlike the heavier and cheaper commercial variety. It is useful, added in small quantity to the turpentine, as a painting medium, although most tube oils have more than enough linseed oil in them to give a "buttery" stroke.

7. *Charcoal sticks.* Valuable for sketching your subject on the panel. Be sure and dust it off before painting, or carry a bottle of fixative and a blower to fix the drawing.

8. *Sketchbook and pencil.* A small book which should always be with you. In it composition can be analyzed and decided before beginning a painting, or details noted for further reference in the studio.

9. *Paint rags.* Don't leave these scattered behind you when you leave a sketching spot. Cows have been known to eat them with sad results, and the farmer will not thank you for being a litterbug.

10. *Studio-size tubes of artist's quality paint.* A good quality oil will go much further than a cheap "students'" paint which is made of part filler and less pure pigment. A one-pound tube of white, zinc or flake. A minimum list of ten colors, more than enough to begin with.

Reds:	Cadmium Red light, Alizarin Crimson
Yellows:	Cadmium Yellow light, Cadmium Yellow deep, Yellow Ochre
Blues:	Cobalt, Ultramarine
Browns:	Burnt Sienna, Raw Umber
Green:	Viridian

11. *A tin cup or "dipper" for turpentine or medium.*

Not shown on the essential list are such things as sketching stools, umbrellas or large-brimmed hats to keep the sun off. Do not encumber yourself more than need be. Several hours of concentrated painting out of doors can be very tiring without the burdens of a pack horse awaiting you at the finish.

Below and on Page 159 are variations on the sketch-box suggested here. These have their advantages; the easel and easel-type box being imperative for painting larger canvases on the spot. The equipment here should start you off with a professional selection for serious work.

WHAT COLORS ON THE PALETTE?

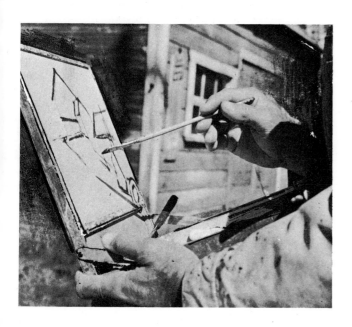

Thumb Box

A useful and light (one pound) thumb-box made and used by Fred Taylor for sketching on small wooden panels. Its size is designed for an 8 3/8" x 10 3/8" American Whitewood panel. It is carefully planned so that when set with colors, panel, sawed-off brushes and palette knife, it weighs only 24 to 26 ounces and can be held in one hand while standing up to sketch.

It has been used to advantage in making small oils on crowded city streets and in factories and foundries where space is at a minimum.

This box is not obtainable in the art stores but a rough and compact version of this box can be made by anyone with ingenuity and a home work-shop.

One of the top color makers in England list in their catalogue of oil pigments the staggering number of one hundred and fifty-one varieties of colors! Not all of these are included in their recommended "permanent" listing, and some are almost duplicates of similar mixtures, with slight variations of tint and tone. Many are admittedly fugitive and will fade rapidly. Others act chemically on other pigments—for example, Emerald Green cannot be mixed with the Cadmiums, Naples Yellow or the Vermilions without blackening, and many other combinations, being chemically incompatible, will change the colors from bright clear hues to drab and muddy tints in a very short time.

Somebody, however, must buy and use such colors as "Steel" or "Flesh tint," or they would cease making them. For the beginner, bewildered by the vast choice before him, faced with the conflicting warnings of what can and cannot be mixed together, I have suggested the *Basic Palette* as a starter, ten colors which are more or less safe to use and accepted as good mixers. The weak sister on the list is the Alizarin Crimson, a Lake prepared from artificial Alizarin. The English company states that fairly strong washes of this color exposed to ordinary daylight over a period of ten years will lose 50% of its strength. Mayer considers it "permanent" although it is the only organic pigment on the approved list. In any case it is almost a "must" on most palettes, as it provides a cold bluish-crimson hue unlike any other red. It is possible to substitute a Rose Madder, which is also prepared organically, but I have found this color almost too "sweet"—it does not have the bite and strength of the Alizarin (which should be used sparingly).

Apart from such details the list given on Page 148 should start you off without too many colors on the palette. With time and experience you will

149

add to the list new colors which appeal to you. The palette listings given by other painters throughout the book may suggest to you a series of colors to try. If you are working more with figure than landscape your palette will perhaps lean toward the earth colors, reds, and blacks.

Below are additions which I find useful for a full palette listing, though some of these are only used on certain occasions as I generally prefer to mix my own greens rather than use the tube colors.

Additional yellows: Cadmium Orange
Cadmium Lemon*
Raw Sienna
Naples Yellow*

Additional reds: Cadmium Scarlet
Venetian or Light Red
Rose Madder*

Additional blues: Cerulean Blue
Maganese Blue*
Thalo Blue*

Additional violet: Cobalt Violet*

Additional brown: Burnt Umber

Additional greens: Transparent Oxide of
Chromium*
Emerald Green*
Thalo Green*
Ivory Black

*very occasionally

The paints without asterisks provide seven colors which added to the ten you have, is a grand total of seventeen colors, probably requiring more space and weight than your box will take. Those marked with an asterisk are studio luxuries and all worth trying. With these added to the list we have twenty five colors—a vast choice to choose from.

Beside this list, there are some pigments made by Ramon Shiva which are intense transparent glazing colors known by the trade-name of "Permasol." A selection of primary colors from a list of seventeen of these super-brilliant colors will be found useful for making glazes.

When buying colors, select a reputable maker and try and use all of his colors rather than mixing

brands. This is safer than having too many types of color with consequent differences in oil content and grinding methods which does not help the compatability index and drying time.

A Check list of Basic Material

Studio-size tubes

Cobalt Blue	Cadmium Red Light
Ultramarine Blue	Yellow Ochre
Viridian	Alizarin Crimson
Cadmium Yellow Pale	Burnt Sienna
Cadmium Yellow Deep	Raw Umber

Zinc or Flake White One-pound tube

Cotton or Linen panels 20″ x 24″ inches
24″ x 30″ inches and larger
Canvas on Stretcher 20″ x 16″ inches
Sketch Panels 12″ x 16″ inches
Cotton canvas or white lead ground on cardboard
Cup for turpentine and medium
Palette knife, painting knives
Ten colors and white as listed
Turpentine container and linseed oil bottle
Sable brushes, assorted sizes (square) one pointed
Hog-hair bristle brushes (Brights and Flats)
Sketchbook, paint rags
Charcoal sticks and pencil
Sketchbox, 12″ x 16″ inches with shoulder strap
Supports and Grounds, Painting Mediums,
Varnishes, etc.

Listed in the following pages are some recipes and formulae for preparing painting grounds and surfaces, making painting mediums, glazes, varnishes, etc. These do not pretend to be "studio secrets" and they are common knowledge shared by most experienced painters. Variations on the exact amount and manner of formulating the recipes are endless, even to the point of contradictory data by respected authorities of the craft. Given here are a few of the practical and useful basic methods which have been tried and proven in many studios by practising artists. Preparing some of the materials for painting, instead of always buying them ready made, can be an enjoyable task, as well as an economical one. In many cases, it is impossible to buy the kind of ground or canvas with your own particular and preferred surface; often it is important to know how to dilute an overshiny varnish, or to mix your own glaze medium.

GROUNDS

The choice of a surface on which to paint is a wide one. Looking around my studio I see paint which was applied a hundred years ago on a piece of copper (on a "retablo" showing a religious scene); a portrait on three-ply wood; paintings on Masonite; thick paper; various canvas surfaces, cotton and linen, mounted on board or on stretchers; paint on gesso ground, white lead, polymer, birch panels, even a sketch someone did on a textured blotting paper.

What do we look for in a good support and ground? Simply this: A durable, rigid surface which will not expand and contract perceptibly, nor warp or bend; a surface which will not discolor the paint put on it by exuding oils or acids; a surface which will not cause cracking or flaking in various temperatures, and one which is not too heavy for practical purposes, storing and shipping.

Within these requirements the artist chooses his favorite support: some prefer canvas on stretchers, some the more rigid wood or composition board, others combine the two by mounting canvas on a firm, solid surface. The wallboard known as "Masonite" or "Presdwood"—a compressed cellulose composition board—is a popular choice today. The "untempered" variety is the best as it contains less oil. It may be purchased from a builder's supply house, cut into any proportions desired. The smooth side is often used, but the rough stamped side, which is impressed with a rather mechanical pattern resembling in some ways a textile or canvas, can be used to advantage when properly coated and prepared. For large sizes especially, Masonite is safer than the big sheets of three-ply woods and veneers which inevitably have knots or unevenness of surface. These should be reinforced or framed by "battening" the back.

Isolating the board with a coating, priming with a size or sealer, is important before painting in oil color. In the case of certain other paints from the new media list, the need for priming is not so great, for the board and the paint are compatible materials and unite as one. Some of the standard ways of preparing the isolating coat—from the traditional white lead priming to the synthetic resin coating—used for canvas as well as Masonite, wooden, and cardboard grounds, are listed here. In most cases, with the exception of the plastic resin coating, it is wise to prime the board or other surfaces with a thin sizing of glue first before applying the final coats of gesso, white lead, etc.

Glue Size

Buy the best grade rabbit skin or high-grade skin glue, preferably in powdered form. If in sheet form, break into small pieces and let soak overnight using fifteen ounces of water to one ounce of glue. Heat in double boiler, but do not allow to boil. Stir well and test strength by mixing some of the liquid size with a touch of whiting. If, when dry, it is too powdery, add a touch more glue; if too hard and brittle, add a touch more water.

Gesso

A basic gesso recipe (a mixture of unslaked plaster of Paris mixed with a solution of glue): When glue size is cool, pour a small quantity into a pot or can of chalk or whiting. Stir to make a smooth paste. If whiting is slightly yellowish, add one-third Titanium or Zinc White dry pigment. The mixture should have the consistency of cream. This mixture should then be brushed over the ground which has been previously coated with a priming of glue size without the addition of whiting. Brush the first coat one way, the second at right angles to the first, applying enough coats until the panel is smoothly opaque. Let dry overnight and smooth the surface with sandpaper. Gesso is not water resistant until it has been covered with tempera, varnish or an isolating coat. For this reason the straight gesso ground is for some painters too absorbent, needing a thin coating of Damar and turpentine before being suitable for direct painting. This again is a matter of personal choice, and experiments must be made until the right amount of glue and whiting is combined to make the kind of brilliant white surface required. The more glue, the more brittle and less absorbent.

Half-Chalk Grounds

A variation of the straight gesso ground which is a less absorbent surface and resembles the oil ground found on ready made canvases. It is more suitable for grounds which are on canvas, having more resilient and flexible qualities, and involves the addition of oil to the basic gesso recipe.

Mayer (see page 155) suggests a mixture of half chalk and half zinc oxide powder emulsified by pouring in (with constant heating and beating) linseed oil to the amount of 25 to 50% of its volume. The best quality artists' linseed oil should be used to prevent yellowing later. Emulsion grounds of this type are not considered as safe, being more sensitive to the atmosphere, as the straight gesso grounds, and need careful and expert preparation and experienced application.

White Lead and Oil Grounds

A ground used by quite a few painters is simply a coating or two of a good quality white lead paste as it comes from the can. Dutch Boy brand is recommended as being of suitable quality and of the right kind. It can be applied with palette knife, over a glue-sized canvas or board, or brushed on. It can be diluted with spirits of turpentine if too thick. It should be left to dry thoroughly, at least two weeks for a medium coating, and can be sanded down if the surface is too rough. Zinc white has a tendency to yellow if left in the dark; white lead is preferable, or a mixture of the two. Titanium, being inert, is least likely to change. (White lead is of a poisonous nature and should be handled with care.)

Casein Grounds

There are a number of commercial casein products on the market which can be used for grounds, as well as prepared gesso mixes. Many are of dubious quality and should be tested for yellowing, cracking or flaking before depending upon their permanence.

Polymer Tempera Ground

A ground recommended by Polymer Tempera Incorporated, made as follows:

Polymer Tempera Gesso Recipe

Polymer Tempera Medium	4 parts by volume	
Titanium White	5 "	"
Whiting	5 "	"
Lithophone	5 "	"
Water	10 "	"
Polymer Tempera Retarder	1 "	"

The retarder may be omitted but it will assist brushing out qualities. Mix the polymer tempera medium, water and retarder. Mix the dry ingredients and sift into the liquid, adding a little at a time and stirring thoroughly before adding more. When all of the dry mix has been added, stir gently to avoid creating bubbles. Strain through a wire screen. Dilute with water to desired consistency. Stir occasionally to prevent settling.

Inert powders or aggregates such as pumice, sand, etc. may be mixed with the gesso to provide a textured surface for drawing and painting or pasteling.

Polymer Tempera Gesso on Masonite

After the board has been sanded, size it with a solution of one part medium to two parts water. When this coat has dried thoroughly (about 20 minutes) apply a second coat. When this is dry, apply the polymer tempera gesso. Unlike some gesso, there is no danger of cracking or shrinking during the curing process. Use the same procedure for preparing a gesso surface on canvas.

An interesting variation of the gesso ground may be made by putting cheap muslin or burlap over plywood or Masonite. Stretch the muslin over the board after applying the gesso ground, or a thick coating of the emulsion medium, overlapping the ends and gluing them to the back of the panel. Sometimes the muslin can be spread or bunched to give a variation to the mesh. Several coatings of the polymer tempera gesso ground can then be applied over the muslin until the required texture is obtained. Thinner coatings of the gesso solution brushed over the strong paper makes a fine surface for drawing or painting in transparent techniques.

Pyroxylin (Duco) Ground

An effective ground which has been used with success by many painters is the application of a thin coating of clear lacquer (diluted if too thick with the addition of Duco thinner) directly on Masonite board. Textures, such as sand, marble dust or inert material can be brushed or dropped in to the lacquer while it is still wet. This will make an interesting surface to paint on. A coating of thin white Duco can be brushed over the textured surface or the Duco can be applied to the warm brown surface as it is. Some painters apply burlap, netting or cheesecloth to the panel with a wheat paste or glue before brushing over the lacquer and the white priming, which gives a rich, textural, linen effect.

York Wilson prepares panels by sanding the rough side of the Masonite with sandpaper, saving the powdered dust. This is brushed into a thin solution of pure Duco thinner tinted with white Duco pigment, enough to make the solution opaque. This is brushed over the panel allowing the powder to settle unevenly on the surface. When dry, an inviting semi-textured surface is ready for painting.

The same surface can be made on large panels for murals using an electric sander instead of sandpaper.

The Brossard painting on Page 112 shows how the ground and painting are built up together.

Vinylite and Other Plastic Resin Grounds

The recent developments discussed under *New Media* may suggest other ways of making secure and permanent grounds. Many of the white paints made from the emulsion or with the vinylite medium will suggest coatings which can be used for priming board or canvas. A polymer white can be textured at will by scraping or with brush marks and grainy surfaces prepared with inert clay or sand additions for textural qualities. It is useful, when coating boards or cardboard with a priming, to coat the opposite side of the board at the same time. This will prevent warping or bending.

Combinations of cheesecloth or burlap sacking set in a wet coating of polymer or vinylite medium will dry tightly and safely to the board or panel. This can then be coated with a white polymer tempera emulsion or be stained with a thin *imprimatura* of color and pigment. The field of plastic paints is wide open for experimenting in attractive and tempting grounds on which to paint.

PANELS

Wooden Panels

For sketching purposes and small paintings, panels made from wood of birch, maple, bass or whitewood are excellent, as well as mahogany or cedar. Generally these are seen in art stores in small sizes up to 12″ x 16″. Larger sizes must be specially made and "cradled" or supported with cross pieces on the backs of the panel, to prevent buckling. Panels must be carefully chosen from well-dried stock and handled with care to prevent splitting. They are not seen as frequently in the sketchbox since the invention of the pressed wood and Masonite panel has been available.

I have sketches done years ago on panels made from various woods, prepared by myself. Single-ply birch, coated with a thin size of glue, shellac, or rubbed lightly with linseed oil on both sides; three-ply boards, sanded and stained with a diluted retouch varnish with a bit of color added; maple panels, one-quarter inch thick, unprimed, with direct oil paint notes on the wood. All of these have stood up well, and after varnishing at a later date and set in a frame, they have remained in perfect condition over the years.

Such panels are difficult to buy ready made, as difficult to find as the "pochade"—the small 6″ x 8″ and smaller panel beloved by the French painters in the past—but it is still possible to find lumber yards where they are willing to cut up a good sized order of wooden panels in assorted sizes, even bevelling them at the edges to fit the slot in the paint box. Once accustomed to sketching on such panels it becomes difficult to change to other types. There is a lovely "feel" to the brush stroke and pigment on the wooden surface which canvas never attains.

Cotton and Linen Sketching Panels

For ordinary sketching in oils, the prepared canvas boards sold in all art stores are convenient and safe. Too often, however, the white priming is thin, too absorbent and the texture of the cotton is dull and uninteresting in weave. A coat or two of white lead priming will help create a more sympathetic texture. Such boards are practical up to a 20″ x 24″ size. Larger than this dimension, a wood stretcher should be used, or the canvas glued to a heavy board or Masonite, coated with priming on both sides to prevent warping.

PAPERS

Recently there have been textured heavy papers, with an imitative canvas grain on sale in art stores. Unmounted, or in pads, they are useful for making experiments and charts or for rapid interim sketches from life or nature. Properly mounted after painting, there is no reason why they should not stand up well for reference purposes but it is doubtful if they are suitable for serious or permanent work as their content is partly pulp and cheap stock. Fine rag content papers such as Whatman watercolor paper should be used for a safer permanent ground. Sized and mounted on a heavy cardboard, there is no reason why these cannot be used by the artist. Rouault often painted on papers mounted on top of a stretched canvas.

Smooth, medium, and rough
unprepared Belgium linens

PREPARING AND STRETCHING CANVAS

Most amateurs are startled when they are told the price of a good quality piece of linen canvas, especially if it is prepared with a white priming and stretched on wooden strips which are pegged at the corners and can be tightened by tapping the pegs. After comparing the cost of a fine heavy-weight linen with a lightweight cotton or jute (which looks attractive and enticing to paint on) beginners generally end up with the cheaper variety, which is often badly primed with a coat of cheap white over it, and will sag badly with damp weather when it is framed and on the wall—if it ever reaches that exalted spot.

Good quality linen, carefully woven and primed, heavy enough to stay taut and well-stretched for years, *is* expensive. The raw linen is often imported and its initial cost, even before preparation and stretching, is high, even for a comparatively light weight.

In spite of the disadvantage of the cost, if you have covered a number of cotton boards and stretched cheap canvases you will feel, sooner or later, like trying a fine professional canvas. The virtues of a finely textured linen, properly stretched cannot be denied; once you try it you will know the difference. It is a similar sensation to using a heavy handmade watercolor paper after painting on a cheap student variety.

With some time and care, it is possible to prepare canvases yourself, using unprimed pieces of fine linen cloth. Once you have learned how to do this you will find that excellent surfaces can be prepared to your own preference of texture, weight, and proportions, at a considerable saving over the price you pay for commercially made canvases.

Utrecht Linens, (listed on Page 144) is a company specializing in materials for making your own canvases. From them it is possible to obtain a catalogue listing linens, glues, priming, etc. as well as concise easy directions for preparing the canvas. They offer a choice of Belgian linen, woven to smooth, medium, and rough weaves, of different weights, and will send sample clippings for inspection. A bolt of linen yardage, enough to make a group of canvases is a worth-while investment if you intend to work on canvas.

The simple time-tested method of preparing the canvas consists of stretching the unprepared cloth on a stretcher, sizing it with a finely ground gelatine or high-grade rabbit-skin glue (one pint of very hot, not boiling water to four level tablespoons of either one) then priming it with a white lead paste, such as Dutch Boy, after reducing the paste to a semi-liquid consistency with turpentine.

Several coats of this priming are brushed on or put on with a palette knife. The second coat can be applied in a day, and within a week, but preferably longer, the canvas is ready for painting. A variety of textures, smooth or grainy can be made by varying the brush marks or knife strokes.

PAINTING MEDIUMS

Painting Mediums

We have written elsewhere in this book of the use of turpentine as a diluting agent for the tubed oil paint, and of the linseed oil and turpentine mixture used by some painters. Other types of painting media which have found favor with oil painters are listed here. Among them you may find one which suits your particular way of working.

John F. Carlson's painting medium.

Half-and-half turpentine and oil of copal varnish. To this he added a small percentage of linseed oil to retard the drying, or for slower drying still, a touch of poppy oil. It is important that the "oil of copal" be used, not "picture copal." Winsor and Newton make an excellent copal concentrate. This mixture is also used as a final varnish on the picture, and in a more diluted form with more turpentine and less copal varnish, as a "retouch" varnish. There is a similar painting medium manufactured by Permanent Pigments which was formulated by Frederic Taubes. It is listed as "Taubes Copal Painting Medium, Light" and is highly satisfactory if you do not wish to make your own copal medium.

A variation on the above formula will provide a simple but effective medium for those who prefer a flexible diluent for mixing oil paint.

Stand Oil (sun-thickened Linseed oil)	2 parts
Spirits of Turpentine	4 parts
Damar Varnish	3 parts
Venice Turpentine	2 parts

This can be used as a glazing medium as well as for painting. Experiment with the amounts of oil and varnish until you obtain the consistency and density you prefer. The *leaner* mixture—with more spirits of turpentine and less varnish, stand oil and Venice turpentine—is most often used. Some painters recommend using a drop or two of a drying agent—preferably cobalt linoleate—to help the drying of the oil, but I have never found this necessary and have avoided dryers whenever possible.

"Lucite" 44

A recent innovation in the preparation of a medium to be used with tube oil paints involves the use of a plastic. This is substituted for Damar varnish which is often used with a linseed oil and turpentine mixture.

This medium gives body and luminosity to the pigment and helps retain the crisp marks of the brush stroke. It has the advantage of reducing the brittleness of the paint (invaluable for rolling and storing canvases) and adds a flexible and fast-drying element to the oil paint.

To prepare this medium dissolve the fine solid beads of plastic in toluene or xylene, add linseed oil and dilute this mixture to the consistency desired with turpentine. Suggested proportions: equal parts of "Lucite" 44 crystals with oil and solvent.

Brushes can be rinsed in turpentine and washed with soap and water.

"Lucite" 44 and 45 acrylic resins may also be used for glazes and varnishes.

Mixed Technique Medium (Egg emulsion)

The Schaefer painting on Page 130 mentions the use of the mixed technique, using an egg and water emulsion. Dry colors, powdered pigments are combined with the prepared emulsion which serves as the binding medium. This emulsion is a time-honored one and has many variations. Preparing the emulsion is a delicate operation, and detailed instructions should be consulted in the Mayer volume "The Artist's Handbook."

The formula used is given as follows;
To one whole egg add *slowly*, and shake well in tall bottle,
1/2 part sun-thickened linseed oil
1/2 part Damar varnish
Add *slowly* up to 2 parts of distilled water.
One and three-quarters parts is sufficient but *never* more than two parts.
If a lean emulsion is desired use more varnish; if a fat emulsion is required, use more oil, but always to the total of one full part.

This is a carefully balanced emulsion and must be strictly adhered to, and the ingredients added in order given. Be sure to *shake well* and add the materials a little at a time. This emulsion will keep in the refrigerator for at least one year.

Mayer gives a standard recipe used by American painters.

2 parts whole egg
4 parts water
1 part stand oil
1 part Damar varnish

He also lists emulsions in which the egg yolk alone is used.

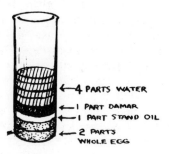

GLAZING

The technique of glazing used during the Renaissance by Venetian painters, gave a glow and richness of surface to the paintings of such masters as Titian, Veronese, and El Greco. Though practised by contemporary artists, until recently the complicated methods of underpainting in monochrome and overlaying glazes became of lesser importance in painting techniques. The direct method of painting, so beloved by the Impressionists, discarded many of the traditional techniques of the old masters and concentrated on the fresh, unsullied brush stroke of pigment.

Glazing consists of putting a thin, transparent layer of varnish medium and thinned-out pigment over a dry, opaque area of underpainting. Thus a white textured blob of paint could be stained with a warm flesh color, or a greenish-tinted area modeled and painted fully before the warmer flesh tones were painted on top. Theoretically a glaze is like putting a piece of colored cellophane over a lighter substance so that the white glows through; in some ways the glow of watercolor on white paper is similar.

Glazing can be a useful aid for the tyro but it can be a dangerous one, especially if we depend upon it to correct our color values. It is best used to modify a passage which is badly out of tone, too light, or perhaps too warm or cold. For example, if we have an area in the foreground which jumps, such as a pool of water which is much too light and needs subduing. Perhaps we have drawn it well, the textures are convincing and the paint lies right. But it is too blue, harsh, and out of key with the rest of the picture. A touch of the glazing medium with a bit of warm pigment (Burnt Sienna might do the trick) brushed over the blue area when it is dry, will modify the coldness and set the area in its place. If we do not like what it does, we can wipe off the glaze with a clean rag and try again. This procedure can be useful to modify a raw green passage of foliage.

Used as a corrective measure the glaze will serve to unify unruly passages. Generally if you are painting in oil in the "alla prima" manner, your pictures will have more consistency of paint quality *without* the use of glazed passages.

Today, the glaze is coming back into prominence as an enriching factor in making color glow and sing. In pyroxylin, polymer tempera, and other new media, glazing is a most valuable technique, for the underpainting surfaces can be made quickly, as thick textures dry at once and are ready for thin transparent glazes (made with the same media) to enrich the color.

The following recipe for a glazing medium for oil painting is more or less a standard one.

9 parts Damar varnish
9 parts turpentine
4 parts stand oil
2 parts Venice turpentine

The copal concentrate medium mentioned previously can also be used for glazing.

Synthetic Varnishes

The natural varnishes, Damar, mastic, etc., are made by dissolving resins gathered from various types of trees. These liquids, solidified and purified, are dissolved in various solvents such as turpentine, alcohol or oils.

Today, many synthetic varnishes are being used in place of the natural resin varnishes—liquid coatings such as vinylite, polymer emulsions, and lacquers.

Though many of these varnishes are, at first glance, complicated to prepare, it may be of value to list one or two which are readily obtainable and which should be used in conjunction with the new media paintings. It is sensible for example, to use

a polymer varnish coating over a polymer tempera painting, rather than to use a less compatible varnish which will not unite chemically with the under-layers of pigment.

Elsewhere we discussed how to isolate a polymer tempera painting with a brushed on layer of the same emulsion used as a painting medium. Clear lacquer Duco can be used over a Duco painting or it can be polished with a rubbing of wax.

A recipe used by restorers and museums for a spray formula is as follows:

12½ ounces of original solution*
12½ ounces of alcohol
5 ounces of Cellosolve acetate
2 ounces of diacetone alcohol

*The original solution for making the varnish is made by dissolving an 8 ounce cup of the dry crystal—polyvinyl acetate—in 25 ounces of ethyl alcohol, or denatured alcohol (rubbing alcohol).

The acetate crystals listed as "Gelva 15" can be obtained from the Shawinigan Resins, Springfield, Massachusetts. They come packed in five pound lots. Cellosolve and diacetone may be purchased from large drug houses. The small pellets of crystal are then dissolved to make the original solution, using 500 parts alcohol to 100 parts of crystal pellets. The solution is then diluted to make a spray solution by adding the Cellosolve and diacetone alcohol. This solution should not be brushed on.

This spray solution is used as an interim varnish to freshen and bind the colors, much as a Damar retouch varnish is used.

A final varnish which can be brushed on is made from "Lucite" 44. It is made as follows;

Dissolve the solid plastic with turpentine, using 25 ounces of turpentine to 8 ounces of "Lucite."

This solution is stored in a bottle, and can be diluted further with turpentine to a needed consistency.

Permanent Varnish

A Damar varnish less diluted with turpentine is often used for a final varnish after a picture has been dry for six months or more.

Retouch Varnish

Retouch varnish can be bought in small bottles already prepared. It is generally known as a five pound cut. That is, Damar crystals have been diluted in turpentine to the proportion of one gallon of turpentine to five pounds of crystals. Damar varnish can be easily made by suspending clean fresh crystals of Damar in a bottle or a glass jar of turpentine. The crystals will dissolve in a day or so and the liquid is ready for use. A formula for a small amount is one ounce by weight Damar crystals and 2 ounces of pure spirits of turpentine. Make sure that you use a clean, wide brush when applying the varnish and that you are in a dust-free room. Spread the varnish out as thinly and evenly as possible to avoid patchiness and overshiny areas.

When you look at sketches which have been dry for a week or more, you will notice that the pigment has dried-in. In some areas the paint will have gone dull and lifeless and in other spots it has retained some of the original oily or glossy qualities. This is because the oil in the paint has been drawn unevenly into the ground of the panel. Some of the colors seem to dry out more than others which hold the "fatty" content of the linseed oil in suspension longer.

This semi-opaque and flat quality will be seen where the thin washes of turpentine are apparent. Whatever the chemical reason, there is an unpleasant and inconsistent "feel" to the picture surface which did not exist when the sketch was freshly painted. If you have used a very absorbent ground, perhaps a half-chalk or gesso ground, the colors will have more of a unity of surface when dry than when newly painted, with a kind of dry casein-like patina without any shine. Properly controlled this can be a pleasant quality, in fact some painters try for this type of surface by preference, even squeezing their oil colors on to blotting paper overnight to take the oil out of the pigment as much as possible, before using it. This is safer than constantly diluting the oil color with too much turpentine which can weaken the binding ingredient to the point where the paint may flake off later.

If you find that the cotton or linen panel of your sketch has dried in patchy fashion you can enliven the color and bring back its freshness by varnishing with retouch varnish. This is not a permanent varnish, but a temporary or in between expedient. If you intend to do further work on a painting after

it has dried, it will bring back the darks to their original lustre and will help bind the layers of paint to each other. Retouch varnish is a Damar and turpentine mixture (see preceding Page 157) and is brushed lightly over the surface of the sketch with a clean soft brush, being careful not to disturb any semi-wet paint. This gloss should not be too shiny, but evenly distributed over the surface, brushed out *thinly* to give a uniform brilliance. The sketch should be placed flat on a table in a dustless room and care taken that the varnish does not run into globules or thick "lines." If done well, the re-touch varnishing will last for a year or so before the dulling process begins once again. It may be necessary then to clean off the retouch varnish re-moving it with turpentine (but this is very danger-ous!). It can then be varnished with a final strong Damar varnish, less diluted in turpentine. Other versions of the varnishing procedure are given else-where in the Appendix and in several of the artists' comments on their painting methods in this book.

Even though the paint film *appears* dry, it is wise to check the thick impastos before retouching. Press a fingernail into the heavy strokes of paint to see if the outer skin of paint is dry enough. Some colors dry quicker than others, blacks, Alizarin and Umber for example dry rapidly, while some of the Cadmiums and whites take days.

While on the subject of varnishing it may be of value to consider the problem of painting *over* paint. Unless you have some idea of what happens chem-ically when you place layers of paint over other layers which are dry or semi-dry, it is almost certain that your pictures will crack, peel or change their appearance in a short number of years.

A traditional saying, and a good one to remember, is that it is wise to always paint "from thin to fat." This simply means that you may be more sure that the various layers of paint applied to the canvas will bind and unite as one if you observe a simple rule: use less oil or medium in the first layers than the last. It is much safer to have the final coatings of paint oilier than the first. In this way the under-layers dry first, from the inside out. Painting thinly with turpentine *over* a thickly enriched oily passage will cause the top coat to crack or even peel off. I know this, for as a student I had the embarrassing event of having a patron bring back a painting I had overpainted in this way, three years after he bought it. The thin turpentine strokes of branches and trees were flaking badly, the picture had ob-viously deteriorated.

Be careful too, of painting thin dark areas over impastos of white or light tonal passages. The white will work its way through, and unless the white was very, very dry, the blacks will crack. There are many other ways of ensuring a reasonable permanance, but most of these you can dig up for yourself by perusing Mayer or other authorities on the chem-ical reactions of pigment.

Perhaps, like so many students today, you have a disregard for such things as permanence, work-manship of a durable order and care little if your pictures fall off unprepared cotton, or fade to a ghost of themselves in a few short years. Or, as a beginner, you may feel that it is a waste of time to bother with such things as permanence. You are just having fun; why take it too seriously?

If you do feel this way, I would advise you to change such an attitude. The loving use of your materials is at least available to you at the very start of your "fun" and will add to your satisfaction of working with paint and brushes. Forming the habit of painting intelligently in the beginning is not too difficult and it will become second nature to you to use your materials sensibly and with care. I assure you that it will not inhibit the forces of your "self-expression" but will only add to them. Controlling rationally the mechanical manipulations of paints is part of every professional painter's art and one which you will enjoy acquiring.

AUTUMN SKETCHING

A crisp autumn day, tantalizing rich color everywhere; a hundred motifs to choose from. This is the great moment!

The portable studio is set up with a 20″ x 16″ panel, the palette is set with brilliant colors, the brushes are clean and sharp edged. Now is the time to forget the doubts and distractions of the classroom and studios, the formulae, the styles, the "isms." It is too late now to find out why colors can turn to muddy mixtures or why the strong composition can turn into a weak and derivative calendar subject. The battle is on—it's all yours—and no helpful brush or persuasive word can save you at the brink of failure, or push you to success.

To work then, intensely, sincerely, with a prayer that the gods are with you. Perhaps today will be *the* time, and you'll come back to the hum-drum affairs of every day guarding with your life a bit of canvas or a panel with color daubed on it.

Frustrations and bad moments will all seem worthwhile, the study, the reading, the charts and experiments will have paid dividends. Good painting!

INDEX